RENÉ
MAGRITTE

RENÉ MAGRITTE

THE FIFTH SEASON

Edited by Caitlin Haskell

San Francisco Museum of Modern Art in association with D.A.P./Distributed Art Publishers, Inc., New York

CONTENTS

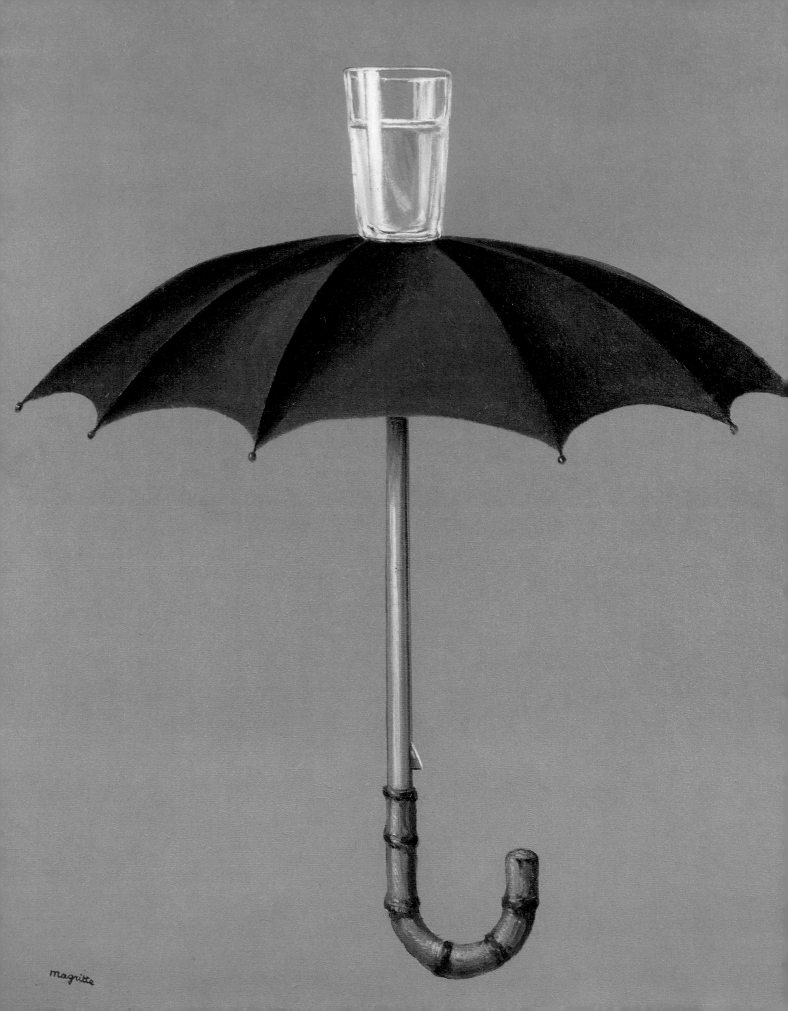

DIRECTOR'S FOREWORD

It was long after his break with Surrealism that René Magritte produced one of his most revelatory canvases. Exceptionally refined brushwork renders enigmatic imagery in *Les valeurs personnelles* (Personal Values) (1952, plate 20), as oversize personal items fill a bedroom whose walls resemble a cloudy sky. Magritte's analytical approach and meticulous composition yield a nonetheless poetic picture, exploding conventions of space and perception, the mundane and the fantastic, gravity and weightlessness, seen and unseen.

René Magritte: The Fifth Season, organized by Associate Curator of Painting and Sculpture Caitlin Haskell, delves into these and other paradoxes Magritte explored from World War II until his death, in 1967. On the twentieth anniversary of the acquisition of *Les valeurs personnelles* by the San Francisco Museum of Modern Art (SFMOMA), the exhibition and publication immerse viewers in the themes and techniques, whether wholly new or imbued with new meaning, that distinguish the artist's late production. The selection of approximately seventy oil paintings and works on paper encapsulates the touchstones and shocking departures that transformed Magritte from modernist to forefather of contemporary art.

Magritte's sunlit surrealist and vache periods, in which he briefly abandoned his polished style in favor of impressionistic and expressionistic brushwork, open the exhibition. From saccharine to satirical, these pictures are little known to American audiences in particular and represent surprising breaks and continuities with the rest of his oeuvre. The thematic galleries that follow include paintings of canvases on easels that merge with the vistas behind them, the artist's iconic bowler-hatted men, and

René Magritte, *Les vacances de Hegel* (Hegel's Vacation), 1958 (detail, plate 41)

buoyant juxtapositions of birds and boulders floating against sky and sea. We are pleased to present rare models for the 360-degree panoramic mural of quintessentially Magrittian imagery known as *Le domaine enchanté* (The Enchanted Domain), along with related compositions, as well as the complete set of motifs in the hypertrophy series, depicting enlarged objects. We are also proud to make an important contribution to Magritte's exhibition history with the largest gathering to date of works from the series *L'empire des lumières* (The Dominion of Light), where nighttime cityscapes encounter sunlit skyscapes. Named for a canvas that exemplifies Magritte's interrogations of the art of painting, *René Magritte: The Fifth Season* offers a unique opportunity to step inside the artist's world and discover a Surrealist moving beyond Surrealism to capture realities beyond reason.

This publication evokes and expands on the gallery presentation. Caitlin sets the stage with a look at Magritte's approach to picture making as problem solving and his interest in the fissures between what we see and what we know, as well as those between artist, artwork, and viewer—a topic she pursues further in a text examining the bowler-hatted man. Michel Draguet and Abigail Solomon-Godeau consider the context of the sunlit surrealist and vache works, while Clare Elliott explores the hypertrophy series and Sandra Zalman traces the development of *L'empire des lumières*. Finally, Katrina Rush offers a conservator's insight into the techniques underlying all of these works, illuminating the subtle artistry behind the bold images for which the painter is known.

I extend my congratulations to Caitlin and my gratitude to staff and colleagues who were instrumental in this project. Charly Herscovici, President of the Magritte Foundation, lent invaluable support to the curatorial and publications teams, continuing his legacy of collaboration with SFMOMA from the 2000 exhibition *Magritte*, organized here by Elise S. Haas Senior Curator of Painting and Sculpture Gary Garrels and Thomas Weisel Family Curator of Painting and Sculpture Janet Bishop in partnership with the Louisiana Museum of Modern Art, Denmark. I thank Michel Draguet, Director General of the Musées royaux des Beaux-Arts de Belgique, Brussels, and Rebecca Rabinow, Director of the Menil Collection, Houston, for their contributions and the many ways their institutions helped us achieve this ambitious undertaking. I am also deeply grateful to the lenders, listed on the facing page, who parted with treasured objects for this spectacular presentation.

Finally, I thank the following for their generosity: Carolyn and Preston Butcher; The Bernard Osher Foundation; Pat Wilson; Jean and James E. Douglas, Jr.; Melinda and Kevin P. B. Johnson; Nancy and Alan Schatzberg; Sheri and Paul Siegel; the Robert Lehman Foundation; the National Endowment for the Arts; and Furthermore: a program of the J. M. Kaplan Fund. The exhibition and publication would not have been possible without their support.

Neal Benezra
Helen and Charles Schwab Director

LENDERS TO THE EXHIBITION

Albertina, Vienna

Art Gallery of Ontario, Toronto

The Art Institute of Chicago

Colección Telefónica, Madrid

Collection Lucien Bilinelli, Brussels and Milan

Esther Grether Family Collection

The George Economou Collection, Athens

Koons Collection

Los Angeles County Museum of Art

The Menil Collection, Houston

Minneapolis Institute of Art

Miyazaki Prefectural Art Museum, Japan

Musée des Beaux-Arts de Charleroi, Belgium

Musée d'Ixelles, Brussels

Musée national d'art moderne/Centre de création
 industrielle, Centre Georges Pompidou, Paris

Musées royaux des Beaux-Arts de Belgique, Brussels

Museum of Contemporary Art Chicago

The Museum of Fine Arts, Houston

The Museum of Modern Art, New York

Museum Würth, Künzelsau, Germany

National Gallery of Art, Washington, D.C.

Peggy Guggenheim Collection, Venice (Solomon R.
 Guggenheim Foundation, New York)

Saint Louis Art Museum

San Francisco Museum of Modern Art

Utsunomiya Museum of Art, Japan

Virginia Museum of Fine Arts, Richmond

Yale University Art Gallery, New Haven, Connecticut

Private collections

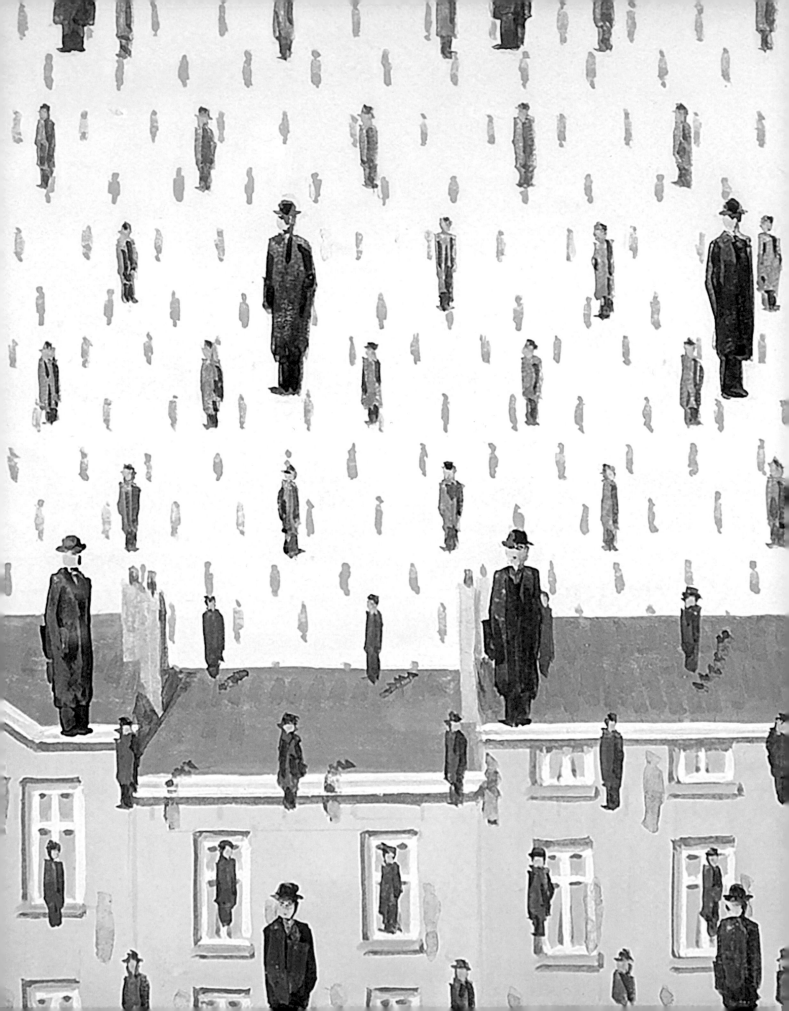

ACKNOWLEDGMENTS

"Everything we see hides another thing." So said René Magritte in a 1965 interview, adding with characteristic insight, "We always want to see what is hidden by what we see, but it is impossible."

It is an open secret that exhibitions and publications such as this, which feature just one or two names on the spine, are really the efforts of dozens of individuals behind the scenes, and I am grateful for the opportunity to acknowledge some of the people who worked alongside me. Their personal commitments to Magritte, to the San Francisco Museum of Modern Art (SFMOMA), and to fostering new scholarship and new art experiences have been expressed in countless ways, from letter writing and editing to color correcting, logistical management, and the many other vital tasks that transform a curatorial vision into a reality.

A full history of *René Magritte: The Fifth Season* would begin in 1998, when *Les valeurs personnelles* (Personal Values) (1952, plate 20) found a permanent home at SFMOMA. A more abbreviated account would date to 2013, when the museum was closed for expansion and *Les valeurs personnelles* was sent to Brussels. During the two and a half years it was exhibited at the Musée Magritte, Elise S. Haas Senior Curator of Painting and Sculpture Gary Garrels and I started to imagine an exhibition that would focus on the artist's late work, from the period of our painting forward, and correct the misconception that it was, for better or for worse, a return to his Surrealism of the 1920s and 1930s.

To tell the story of late Magritte as something other than an about-face, however, we realized that we would need to examine his works from the World War II era. Reintegrating this largely unheralded chapter into the broader arc of the

René Magritte, *Golconde* (Golconda), 1955 (detail, plate 40)

painter's career has been a deeply stimulating endeavor. While it's true that Magritte has not wanted for attention in recent decades, we hope this exhibition and publication might help redress his absence from the most pressing conversations about the art of his time.

A debt of gratitude is owed to many colleagues for their help in this undertaking. At SFMOMA, my deepest thanks go to Neal Benezra, Helen and Charles Schwab Director; Ruth Berson, Deputy Museum Director for Curatorial Affairs; and Gary, all three of whom have been unwavering in their advocacy.

Beyond the museum's walls, Charly Herscovici, President of the Magritte Foundation, worked tirelessly to ensure that the artist's legacy would be well served by this presentation. One could not ask for a kinder or more experienced guide through the world of Magritte than Charly, who, along with Paolo Vedovi, helped cultivate the relationships necessary to mount a major loans exhibition. Michel Draguet, Director General of the Musées royaux des Beaux-Arts de Belgique, Brussels, and Rebecca Rabinow, Director of the Menil Collection, Houston, also deserve special recognition for their extraordinary partnership in this project. As the largest European and American lenders, respectively, they have enabled us to make a lasting and necessary contribution to the field.

Many other colleagues went above and beyond to make artworks available to this exhibition. In addition to the distinguished institutions and individuals listed on page 9 who shared treasures from their collections, I would like to thank the following for their generous help with loans: Erika Abad, Coraly Aliboni, Abigail Asher, Stephanie Barron, Brent Benjamin, David and Linda Benrimon,

Lucien Bilinelli, Bernard Blistène, Isy-Gabriel Brachot, Olivier Camu, Manelle Chatelan, Sabine Colombier, Harry Cooper, Iris Costa, Susan Davidson, Emmanuel Di Donna, Alice Dugdale, Clare Elliott, Brad Epley, Kaywin Feldman, Jennifer Field, Pamela Franks, Glen Fukushima, Michael Govan, Alison de Lima Greene, Madeleine Grynsztejn, Valérie Haerden, Jun Ishikawa, Stephan Jost, John Junkerman, Laurence Kanter, Sandra Karlsson, Avi Keitelman, Simon Kelly, Sharon Kim, Sonja Klee, Jeff Koons Studio, Bernard Lagrange, Claire Leblanc, Chantal Lemal-Mengeot, Jessica Lewis, Victoria Sancho Lobis, Glenn Lowry, Mitchell Merling, Kenjin Miwa, Patrick Noon, Alex Nyerges, Didier Ottinger, Mark Pascale, Maurizio Petta, Rusty Powell, Monica Proni, Jock Reynolds, Patricia Robeets, James Rondeau, Akiko Sasaki, Yoshiharu Sasaki, Klaus Albrecht Schröder, Simon Studer, Michael Taylor, Ann Temkin, Dominique Terlinden, Christy Thompson, Gary Tinterow, Hiroshi Tobita, Karole Vail, Sophie Van Vliet, Robin Vousden, C. Sylvia Weber, and Oliver Wick.

There are many to thank within SFMOMA as well. Lily Pearsall, Curatorial Project Manager in Painting and Sculpture, joined me in the summer of 2017 and quickly became a valued partner. In addition to deftly managing a crush of loans work through the summer and fall and serving as curatorial point on our USGI indemnity application, she helped supervise the research and administrative support provided by Gabriella Moreno and Alex Zivkovic.

Emily Lewis, Co-Director of Exhibitions, oversaw the day-to-day management of this project, ably assisted by David Funk and Annie Hagar. Olga Charyshyn and Eliza Chiasson in Registration provided outstanding logistical

support, and Paula De Cristofaro in Conservation was equally indispensable to our team. I was fortunate to be able to rely on Brandon Larson, Rico Solinas, Greg Wilson, Travis Kerkela, and Alex Dangles to frame and install the artworks, and their colleagues in Exhibitions Design, Kent Roberts and Sarah Choi, deserve special thanks for making countless iterations of floor plans and maquettes.

Kari Dahlgren, Lucy Medrich, and Brianna Nelson in Publications are to be commended for superlative work on the exhibition catalogue and gallery texts. This in-house team collaborated with designer James Williams, who brought a keen and considered eye to every element of the publication; Fabienne Adler; Kate Norment; and Elisa Nadel and her colleagues at D.A.P., who lent enthusiastic support as co-publishers.

It has likewise been a pleasure to work alongside Chad Coerver, Chief Content Officer, and Jennifer Northrop, Chief Marketing Officer, and their teams, including Keir Winesmith, Claudia La Rocco, Sarah Bailey Hogarty, Erica Gangsei, Stephanie Pau, Ana Fox-Hodess, and Maggie Wallace in Content Strategy and Digital Engagement; Bosco Hernández, Carrie Taffel, and James Provenza in the Design Studio; and Tracy Wada, Jill Lynch, Janet Ozzard, Chris Pacheco, Clara Hatcher Baruth, Rebecca Herman, Magnolia Molcan, Clara Sankey, Kathryn Booth, and Camille Johnson in Marketing and Communications. Thanks go out as well to Layna White and Sriba Kwadjovie in Collections Information and Access; Christopher Lentz, Katherine Wallace, and Kelly Bishop in Visitor Experience; and Jana Machin, Anne-Marie Conde, and Tobey Martin in the Museum Store.

Through their work with school groups and museum guides, Dominic Willsdon, Leanne and George Roberts Curator of Education and Public Practice, and Julie Charles, Deena Chalabi, Mary Biggs, Claire Bradley, and Tomoko Kanamitsu ensured that anyone desiring a chance to learn about Magritte would have that opportunity.

On our Development team, Riccardo Salmona, Samantha Leo, Caroline Stevens, Elizabeth Waller, John Robinson, Sara Pinto, and Misty Youmans did tremendous work securing grant funding, completing a complex USGI indemnity application, and enlisting the support of private donors. I also wish to thank their colleagues Leigh Brawer, Jacqueline Rais, Suzanne Field, Richard Havens, Julie Knight, Elizabeth Yeatman, Lanlian Szeto, Bailey Sharrocks, Brennen Ogawa, and Christine Mettel.

My sincere appreciation is due to Adine Varah, General Counsel; Janet Alberti, Deputy Museum Director for Administration and Finance; and Nan Keeton, Deputy Museum Director for External Relations, who do so much to help SFMOMA realize its potential in all endeavors. I would also like to recognize Noah Bartlett, Rick Peterson, and Jeff Phairas in Operations and Engineering.

Very special thanks are owed to the scholars whose essays fill the pages of this catalogue. To Michel Draguet, Clare Elliott, Katrina Rush, Abigail Solomon-Godeau, and Sandra Zalman, it is an honor to have our work preserved together in this volume.

Finally, I am grateful to Kirk Nickel, discussant in residence through many months of work on this exhibition and catalogue. No more disappearing acts, I promise.

Caitlin Haskell
Associate Curator of Painting and Sculpture

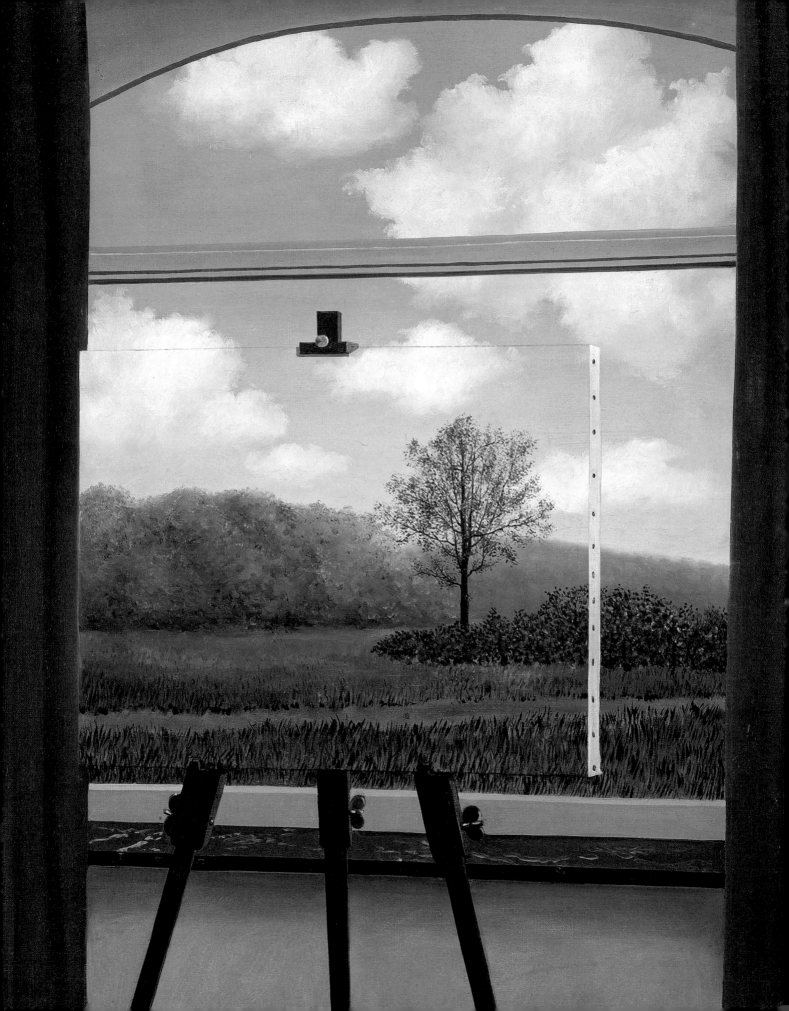

The Fifth Season

CAITLIN
HASKELL

The blue sky isn't black anymore.

—René Magritte, "Surrealism in the Sunshine,"
November 1946

Belgians Bearing Gifts

In the summer of 1934, when René Magritte (1898–1967)
was living in Brussels, he wrote to a colleague in Paris about
La condition humaine (The Human Condition) (plate 14),
a painting he had made the year before. The artist was
nearing the end of his "essential surrealist years," and he
had devised a new pictorial construction that he felt was
worthy of describing to the movement's founder, French
poet André Breton.[1] Conspicuously a painting *about*
painting, *La condition humaine* was among the first works
in which Magritte approached picture making not as the
highly personal act of expression we often ascribe to
twentieth-century art but as the pursuit of a solution to
a "problem" posed by a given object or idea.[2] Magritte
employed this method, known today as *problematology*,
to great effect in the mid-1930s, when, by his own
characterization, he solved the problems of the tree, the
sea, fire, and rain, among others; and it continued to serve
him well into the 1950s and 1960s, when he produced, for
instance, *La corde sensible* (The Heartstring) (1960, figure 1)
as a solution to the problem of the cloud.[3] In *La condition
humaine* Magritte's premise was the problem of the
window, something he would return to and enhance in
later variations (see plates 15–16 and figure 2).[4] The solution
he found struck him as an apt, if unsettling, demonstration
of how our minds contend with the ambiguities of
representation. It showed, as Magritte put it, "How we
see the world."[5]

The contents of *La condition humaine* are commonplace,
but they activate a striking chain of visual and cognitive
slippages. Inside a room, an easel supports a painting
that merges with the landscape seen through the window
behind it. The painting's edges align with the vista so fluidly
that we are inclined to read its imagery as part of an
unobstructed view. Magritte's interest, as he explained in
his landmark lecture "La ligne de vie" (Life Line) (1938),
lay in this tendency to identify the contents of the easel
painting as simultaneously inside and outside, real and
represented, natural and artificial, original and copy.[6]
Its elicitation of synchronous thinking made *La condition
humaine* an accurate embodiment of how we interact with
the world around us.

This was not quite the gist of Magritte's message to Breton,
however. In addition to the happy paradox presented in
"La ligne de vie," this earlier exchange contained the germ
of a more deceptive, but also more liberating, reading of
the mise-en-scène. As the painter confessed, he had been
preoccupied for some time with the idea of false recognition.[7]
This should come as no surprise to those familiar with

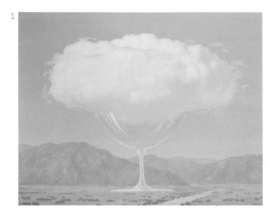

Magritte's celebrated painting of a pipe that bears the words "Ceci n'est pas une pipe" (This is not a pipe) (figure 8), or his later sculptural construction of a painting of cheese in a glass stand, *Ceci est un morceau de fromage* (This Is a Piece of Cheese) (1936 or 1937, figure 3). The nested illusions of *La condition humaine* and its subsequent variants were productive territory for Magritte precisely because they offered opportunities for erroneous judgment. As he knew well, people generally come to an artwork expecting a faithful disclosure—the clear delivery of a message or candid expression of a feeling—rather than an obstruction. Yet even without the overdetermined declaration "this is" or "this is not," the scenario of *La condition humaine* presents a few reasons to doubt its trustworthiness as an image with a single, stable identity.

First, there is the matter of who painted the picture within the picture. There is no question that the brushstrokes at the center of the canvas were in fact laid down by Magritte, but by depicting the easel alone, he leaves us wondering about its absent author. Is there a notional artist who inhabits this world and has just stepped away? The imagery within the inset scene—a narrow dirt path with a single off-center tree—is sufficiently unengaging and underdeveloped as to give the impression that it may still be in progress. After all,

easels are typically where paintings are made, not put on display. And even a generous viewer would have to admit that it's a rather dull picture.[8] Far more pedestrian than Magritte's work at the time, the humble landscape, which appears unsigned, is an act of artistic ventriloquism—the creation of a clever painter deliberately emulating someone else. This consideration, as we will see, bears significantly on Magritte's production of the following decade.

Second, there is the striking and delightful continuity of the interior and exterior landscapes mentioned above. The shared illusionism across the two planes is uncanny: notice the way the contours of the clouds transition seamlessly from the window to the canvas, and the way the blades of grass within the inset composition seem to generate from the same source as those outside. But while *La condition humaine* might at first appear to be about the superficial theater taking place within the depicted canvas and at its margins, the construction also opens up the question of what is concealed behind it. As Magritte acknowledged to Breton, "It can be supposed that the scene behind the picture is different from what is visible."[9] Unlike the totalizing clarity offered by the easel painting in *Les promenades d'Euclide* (Where Euclid Walked) (1955, plate 15), a highly developed cognate that speaks to both

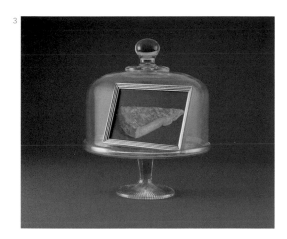

the fiction and the science of illusionism in the history of art, the canvas in *La condition humaine* might also be read as something solid—a device that leaves a hidden compartment to be filled in by the viewer and that shifts this zone of the painting from the optical to the imaginary.

Within five years of producing *La condition humaine* Magritte had already offered two variant interpretations of its inherent dualism. In the main, the composition would seem to be about the illusion of transparency. But read in terms of concealment, it opens up an unseen but specifically posited space liberated from the constraints of conventional picture making, in which every artwork comes into being with predetermined imagery and is bound to one unchanging material form. It inaugurated a new chapter in the history of art where painters could broach fresh intellectual territory by being less trustworthy—or rather, less predictable, less law-abiding.

The idea of building a painting with a distinct alternative set of signals embedded within it—a second channel, as it were—had occurred to Magritte in 1931 while working on *La belle captive* (The Fair Captive) (figure 4), a picture closely related to *La condition humaine* and that he similarly revisited later in his career (see plates 17–18 and figure 5),

but one in which the absent artist has been working *en plein air*.[10] Magritte's titles tend to be more evocative than descriptive, but in this case the composition does suggest the possibility of captivity—if not within the depicted space of the work on the easel, then in the space we can imagine on the other side. Once again, in this pictorial twist, "The agent of concealment is a canvas which reveals—or so we are led to suppose—that which it conceals."[11]

The caveat "or so we are led to suppose" is significant. Our habit as viewers is to assume that the picture on the easel is an image, in perfect registration, of the real thing behind it. But this is a comically far-fetched idea. Who or what, we might ask, has led us to believe this? We can hardly be more specific than to say it is a result of the same cultural conventions that allow us to read and interpret any representation. Magritte, like other artists of his generation, was highly attuned to pictorial languages that encourage us to conceive of artifice as if it were natural. The rectangular shape of a canvas support, the perceptual buffer provided by a frame or tacking margin, and the uniformly matte or glossy appearance of a painting's surface all incite a "picture seeing" mode of cognition, which tends to hold in suspension other elements that would instantly assert an artwork as a material object—a thing in the world.[12] Built over centuries,

3 René Magritte, *Ceci est un morceau de fromage* (This Is a Piece of Cheese), 1936 or 1937. Oil on canvas board in gilded wood frame set in glass dome and pedestal; framed painting: 4 15/16 x 7 1/4 in. (12.5 x 18.4 cm); glass dome and pedestal: 12 x 10 x 10 in. (30.5 x 25.4 x 25.4 cm). The Menil Collection, Houston

4 René Magritte, *La belle captive* (The Fair Captive), 1931. Oil on canvas, 14 15/16 x 21 5/8 in. (38 x 55 cm). Private collection

these conventions amount to a tacit agreement between
artist and viewer. But Magritte was rarely willing to abide
by these unspoken rules of engagement and instead found
generative ways to transgress them, demonstrating along
the way how the so-called fictions of pictures might come to
bear on real life.

To paraphrase philosopher Ferdinand Alquié, Magritte's
Surrealism was not so much about losing reason, but
rather a concerted recovery of what reason makes us lose.[13]
He took advantage of moments when our subconscious
inclination to trust in pictorial transparency would leave
us susceptible to loss and cast a spotlight on the hidden
realities that exist alongside those we are aware of. A viewer's
propensity to believe in the congruence of a canvas and
what lies behind it allowed Magritte to operate a mode of
two-channel communication: a painterly version of what
contemporary artist Julia Scher, who is known for work on
themes of surveillance, would call a "fake feed."[14] By deftly
splicing manipulated video footage into what would appear
to be actual security tapes, Scher creates feeds that seem
legitimate until other contextual cues undermine their
claims to truth. Though the fake feed was born in late
twentieth-century media art, the concept applies equally
well to the reality effects employed by painters of Magritte's

era, who modulated image, style, and compositional
structure with a keen attention to the beliefs that underlie
our interpretive judgments.[15] It was Magritte's gift, and his
great pleasure, to identify the cracks between a painting's
imagery and a viewer's assumptions and then slip a second
"feed" into that perceptual blind spot.

In the cases at hand, Magritte's second feed is plainly
evident, held up for inspection on an easel. But he recognized
that everything that triggers our inclination toward "picture
seeing" is potentially a Trojan horse providing cover for
new, unsanctioned ideas to sneak into our consciousness.
The painting-within-a-painting motif is one demonstration
of this, but in practice, such concealment is also possible on
a smaller scale—even on the level of the brushstroke.

Enter Renoir

Commenting on one of the most consequential developments
in modern art—the invention of painterly abstraction—
Magritte once explained that "the art of painting was replaced
by a so-called abstract, non-figurative, or formless art—
which consists in depositing the 'material' on a surface with
varying degrees of fantasy and conviction."[16] While this
statement was made in 1963, it is clear that the possibility

5 René Magritte, *La cascade* (The Waterfall), 1961. Oil on canvas, 31 ⅞ x 39 ⅜ in.
(81 x 100 cm). Esther Grether Family Collection

6

of painting with varying degrees of conviction, in representational as well as abstract pictures, was an idea that had preoccupied him for some time.

In his paintings made during and just after the German occupation of Belgium (1940–45), for example, Magritte began to question the sincerity of the artistic mark—a device that, since the impressionist revolution of the 1870s, had become an all-in-one carrier of color, sensation, and emotion.[17] Magritte's remarkable yet often misunderstood pictures of this era (see plates 1–13 and 19), discussed further in this publication by Michel Draguet and Abigail Solomon-Godeau, are sufficiently despised that their defense—intellectual, if not aesthetic—takes a bit of unpacking.

It can be conceded from the outset that the works made under the rubric of sunlit surrealism, also known as the Renoir period (1943–47), and during the vache period (1948) do not look at all like Magritte paintings, popularly conceived. They are not rendered in the classic, clear, impersonal manner his dealer Alexander Iolas described as his "compact" style.[18] And yet they *act* unmistakably like Magritte paintings through their operations of concealment and negation, as well as the demands they make on viewers to hold in mind concurrent yet at times contradictory streams of information.

Magritte took dead aim at what he saw as the fraudulences of modern picture making, from the decadent brushwork and saccharine palettes of Impressionists such as Pierre-Auguste Renoir to the boldly naïve and emotional gestures of Expressionism, and dismantled their conventions of communication just as he had challenged more traditional systems of painting in *La condition humaine*.

Consider *La cinquième saison* (The Fifth Season) (1943, plate 19 and figure 6), a modest composition that relates to *La condition humaine* through its inclusion of two framed canvases depicting sky and trees. The figures in this sunlit surrealist painting, like the more clearly Renoir-inspired and fantastic figure in *La moisson* (The Harvest) (1943, plate 7), obviously exist within a painting themselves. They are rendered with the same dash-like strokes that typify the artworks they hold. At the same time, the capriciousness and mindless patterning of the brushstrokes suggest that they convey almost no reliable information. There is no trace of their maker's temperament, feeling, or disposition. Despite their association with plein air painting, they are far from the sensory registers of Paul Cézanne, the sensitive social descriptions of Édouard Manet, or the visual spectacles of Claude Monet. More to the point, they lack all the splendor of late Renoir, a body of work that critics cooed

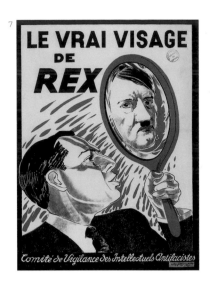

over in Magritte's youth, describing, for instance, the melted forms and colors as pools of "iridescent loveliness . . . fixed by a touch of the master's magic—lightly frozen over by an enchanting frost."[19] Indeed, there is so little conviction behind Magritte's rapid brushstrokes, executed as a pantomime of Impressionism, that they hardly speak at all. They in fact obstruct communication in a manner analogous to *La condition humaine*, denying any recourse to the intentions of an author.[20] In this moment of artistic adoption, Magritte short-circuited the logic of the technique he borrowed. With the protective cover of sunlit surrealism's staccato style and saccharine hues, he broke the brushstroke as an expressive tool, bypassing the transmission from the eye and hand of a sensing subject to the eye and mind of a sensing viewer.

By dismantling the basic unit of Impressionism, the mark that holds within itself the illusion of natural or transparent communication, Magritte took the first step toward an art of arch artificiality. Effectively, he seized upon a dark lesson from his "essential surrealist years"—that we have a propensity to be deceived by representations of all sorts— and used it as the foundation for his own art of enchantment.

Among the most sympathetic responses to Magritte's sunlit surrealist paintings in the twentieth century has been their categorization as a body of work that began in depression and ended in mania. Art historian David Sylvester commented, "I do not understand why Magritte's quasi-impressionist period is so poorly regarded. It came at a time in his career when his work was in the doldrums—as every artist's is at some time in his middle age, for a few years, unless he never recovers. It produced a handful of great pictures and a score more of good ones."[21] Unquestionably, these paintings began when Magritte hit a personal low. In the late 1930s the artist was at the helm of a journal that opposed the war and felt energized to protest, denouncing fascism in writing and anti-Nazi posters (see figure 7).[22] But he fled to France on May 15, 1940, just five days after Germany invaded Belgium, leaving behind his wife, Georgette, and taking off for Carcassonne via Lille and Paris. He would not return for more than two months.[23] Things were also going poorly on the professional front. Magritte struggled to support himself as a painter and had failed, most recently, to secure a long-term commission from the English patron Edward James. As James wrote in 1938, despite owning some of Magritte's most impressive works, he would not be able to provide the artist with a steady salary.[24] He couched the decline in callous terms: "If you suddenly became a bad painter—nothing is impossible—then I would be buying . . . from an 'artistic fabricator' instead of from an artist."[25]

7 René Magritte, *Le vrai visage de Rex* (The True Face of Rex), ca. 1937. Lithograph, 31 ⅞ x 22 ¹³/₁₆ in. (81 x 58 cm). Archives of the City of Brussels

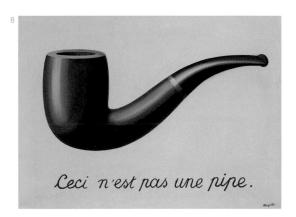

While it is uncertain whether James's letter reached Magritte, it is tempting to think that the painter could have taken this suggestion as perverse motivation for the works that came next. Scholars continue to debate the objectives of his sunlit surrealist style, but, as Solomon-Godeau contends, any historical analysis must consider the possibility that Magritte chose to become a "bad" painter, or at least decided to deploy a flamboyantly *retardataire* mode, as a guise no more or less impersonal than the anonymous look of his classic, compact style.[26] In addressing these pictures we would do well to remember that Magritte, more than any other artist of the past century, made it his project to subvert our faith in visual similitude. It was no lapse in judgment when this painter chose not to resemble himself.

Changing the Use of Painting

There were also other, more readily documentable reasons Magritte may have wanted to find a new style in the 1940s. As he was quick to point out to his colleague Marcel Mariën, a painting with his classic look could have had disastrous consequences in Europe during the war years, when Nazis were declaring much modern art degenerate: "I am not very inclined . . . to show 'the pipe' [see figure 8]," he confessed, "which might be used as a pretext for shutting me up in

a lunatic asylum."[27] These conditions fostered a desire to engage with style in such a way as to, in Magritte's words, "change the use of painting."[28] In addition, there was his view that Surrealism, in its attempts to reorder the world, had largely failed.

In "La ligne de vie" Magritte described Surrealism as a direction by which humanity could perform "research into fields which have been consciously neglected or despised and which nonetheless concern man directly." Through these efforts practitioners could "[claim] for waking life a freedom similar to the freedom we have when we dream."[29] By the time he published this lecture, eight years after he first delivered it, he had honed his stance in a series of treatises published under the title "Le surréalisme en plein soleil" (Surrealism in the Sunshine) (1946–47). Here Magritte described the necessity of paintings to declare themselves as representations. He emphasized the need to assert the gap between ourselves as viewers and the contents of a canvas before us quite literally by "shedding as harsh a light as possible on what we can see"—the world available to our senses, which Magritte called "our mental universe." This would in turn reveal a more precise sense of its inverse, the "extra-mental" or "amental," which we cannot know more than to say that it exists.[30] "We must go in

8 René Magritte, *La trahison des images (Ceci n'est pas une pipe)* (The Treachery of Images [This Is Not a Pipe]), 1929. Oil on canvas, 23 ¾ x 31 ¹⁵⁄₁₆ in. (60.3 x 81.1 cm). Los Angeles County Museum of Art, purchased with funds provided by the Mr. and Mrs. William Preston Harrison Collection

search of enchantment," Magritte implored, "revealing the unknown quality in each object presented with unambiguous delight."[31]

The brunt of Magritte's attack on Surrealism, as it had been practiced until that time, fell on three areas—automatic drawing, trompe l'oeil, and the art of the insane, each of which he saw as fraudulent in its own way for failing to announce itself as underpinned by convention. Much like the impressionist brushstroke, they traded on the assumption that they were more natural than other modes of expression.[32] It was clear to Magritte that these strategies for registering and generating unprocessed thought, if they had ever held the potential for effecting social change, had lost their utility. As he wrote in the summer of 1946, "The confusion and panic that Surrealism wanted to create in order to bring everything into question were achieved much better by the Nazi idiots than by us."[33] Black humor, irreverence, sexual innuendo, and scatological imagery seemed pathetically incommensurate to the devastation of World War II. As his work in the sunlit surrealist mode matured, Magritte sent increasingly mixed messages through paintings such as *Le lyrisme* (Lyricism) (1947, plate 3) and *L'intelligence* (Intelligence) (1946, plate 4), which distributed their ideas across two incongruous channels, as confectionary style veiled troubling imagery. It is no coincidence that viewing these artworks even today we may feel a mild physical and psychic discomfort. This was in line with their intention: upending any sense of comfort with pictorial convention.

Aesthetic merit aside, the virtue of sunlit surrealism lies in the fact that there is no escaping its highly artificial effect, never to be confused with a simulacrum of nature or a direct trace of emotion. As Magritte underscored: "*we must admit that we see the gap between the object and us*."[34] He achieved

this by sapping the brushstroke of its communicative force, breaking any connection it may have held, via the hand, to the mind of the subject who applied it.[35] The faulty appropriation of an impressionist style, purpose built to convey perception and sensation of, in Magritte's terms, the "mental universe," becomes concomitant with the limitations of subjectivity and all the prejudices and blind spots that term implies.

Like the paintings in the theme of *La condition humaine*, sunlit surrealism was the work of an absent author. It points back to no person and holds the promise of a world beyond the stable structures of painting in the humanist tradition. The next step for Magritte was to further expand the possibilities of this mode into a totalizing view.

Two and Two Makes Five

Time and again ailment and malady appear in Magritte's titles of the 1940s, as in the melancholic gouache *Le mal du pays* (Homesickness) (ca. 1948, plate 30) and the antic oil painting *Le mal de mer* (Seasickness) (1948, plate 10). Even when Magritte returned to working exclusively in his compact style, at the very end of the decade, he pursued this visceral dimension—not in the names of his pictures but in their effects on viewers. Among the most notable examples was Iolas's response to *Les valeurs personnelles* (Personal Values) (1952, plate 20), the earliest work in Magritte's so-called hypertrophy series, discussed in this publication by Clare Elliott. Here common objects of uncommon sizes are encased within cloud-covered bedroom walls, an alternative sky that approximates a full field of vision. The architectural solidity of this "clear field," alluded to in the canvas's first title, *Le champ libre*,[36] is strongly asserted, such that it can support a comb and register a shadow. Several elements in the precisely painted scene are askew,

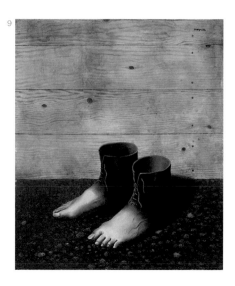

pointing to a series of questions: Who are we in this imagined world? Where, physically, do we as viewers stand? Are we large or small? We can say as little about ourselves in relation to the composition as we can about the rationale for the depiction itself. Whether due to its negation of transparency or its ambiguity and discordant scale, the picture left Iolas feeling "sick . . . depressed . . . helpless . . . confused."[37] While this was not Magritte's expressed intention, he took it as a positive sign: "Well, this is proof of the effectiveness of the picture. A picture which is really alive should make the spectator feel ill, and if the spectators aren't ill, it is because 1) they are too insensitive, 2) they have got used to this uneasy feeling, which they take to be pleasure—(my picture *The Red Model* [see figure 9] . . . is accepted now, but when it was new, it made quite a lot of people feel ill). Contact with reality . . . always produces this feeling."[38]

Les valeurs personnelles ushered in a new chapter for Magritte's painting, its use of disjunctive scale pointing to other strategies of two-channel communication that would be developed in his work of the 1950s and 1960s. They are seen in pictures that present iconographic superimpositions, such as two works titled *La place au soleil* (The Place in the Sun) (both 1956, plates 29 and 42), and perhaps most famously in *L'empire des lumières* (The Dominion of Light)

(1949–65, see plates 51–57), where, as Sandra Zalman describes in this publication, daytime skyscapes are joined with nighttime landscapes. In each of these pictorial types there is an unpredictable opening of the field as the collision of two knowns creates a wondrous unknown. For Magritte, these super-comprehensive views were at the heart of painting's potential for enchantment, harnessing the mind's capacity to understand synthetically experiences for which there are no natural precedents. Rather than paintings of "how we see the world" like *La condition humaine*, these later works might be thought to depict how we *make* the world, when we are no longer bound by the constraints of lived reality.

To open her introduction to the seminal essay collection *Surrealists on Art* (1970), art historian Lucy R. Lippard quoted Fyodor Dostoevsky's *Notes from Underground* (1864): "I admit that two-and-two-makes-four is an excellent thing, but if all things are to be praised, I should say that two-and-two-makes-five is also a delightful thing."[39] The statement is especially apt for Magritte. During his years as a member of the surrealist avant-gardes in Brussels and Paris, Magritte had been the painter most closely associated with both the adherence to and the transcendence of rational norms. Logical structures—be they the laws of

9 René Magritte, *Le modèle rouge* (The Red Model), 1935. Oil on canvas mounted on board, 22 ¹⁄₁₆ x 18 ⅛ in. (56 x 46 cm). Musée national d'art moderne/Centre de création industrielle, Centre Georges Pompidou, Paris

10
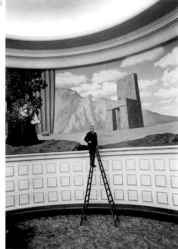

11
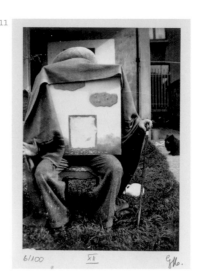

mathematics (scale, perspective), language (the equation of word and image), or nature (conventions of the seasons, cycles of night and day)—revealed for Magritte the means of their own undoing. The clearer a system's rationale, the more he strove to make evident the realities it obstructed and denied.

The possibility of reaching new realities through painting was something Magritte would have a chance to engage in a novel way in 1953, thanks to a commission from Gustave Nellens. This 360-degree panorama, measuring 233 feet in circumference and illuminated at its center by an enormous chandelier, took the name *Le domaine enchanté* (The Enchanted Domain) (see plate 44 and figure 10).

The tradition of panorama entertainments in late eighteenth- and early nineteenth-century Europe provides an instructive point of comparison for Magritte's postwar projects. Far from overtaking a viewer's sense of reality, the panorama entered visual culture as an amusement that balanced on the edge of ordinary perception and an illusory perception that spanned one's entire visual field, something akin to the wrap-around clouds in *Les valeurs personnelles*. Their rhetoric revolved around the trope of "far-fetching," in which "a remote cause, origin or phenomenon is evoked in

the immediate present or in nearby space, and all the intermediate steps connecting the two elements . . . are suppressed."[40] It is an effect that we might illustrate through *Le modèle rouge* (figure 9)—an unnerving image of feet becoming boots, or vice versa, whose mystery stems in part from its suppression of causality. Not surprisingly, the hyperbolic display of far-fetching in panoramas is documented as having had a jarring effect on early audiences, inducing feelings of vertigo and seasickness much like those Magritte attributed to contact with reality outside our norms. The inducement of visceral discomfort "comes when the visitor, entering the center of the panorama's visual field, feels their own field of vision being peeled off, as it were, and replaced by that of the panorama." Toggling between these two modes, "There is a momentary foundering of free-will on the rock of panorama's pre-determined vision."[41] In Magritte's language of problem solving, we might frame this as a problem of subjectivity—how do you as a viewer get yourself into and out of the picture at once?

Magritte considered the possibility of extra-subjective experience not only for the viewer but also for the artist. One of the places where he did this most clearly was in a photograph paralleled in the eighth and final panel of *Le domaine enchanté*. He called the image *Dieu, le huitième*

12

jour (God, the Eighth Day) (1937, figure 11). Situating himself both inside and outside the picture, Magritte hides his body behind a materially dense composition painted in the manner of an amateur artist. In *Le domaine enchanté*, as in *Le libérateur* (The Liberator) (1947, plate 46), he makes this body into a hollow birdcage—a setup that recalls Magritte's depictions of bowler men after 1964, when he began rendering them as apertures onto other scenes (see plates 34–38). In all these examples, if there is a sense of identity, it is achieved through the removal of the figure, its presence conveyed by absence.

Suppressing your view of the world, as maker or onlooker, means acknowledging that yours is not the only vantage point available. In a discussion of *Le chef-d'oeuvre ou les mystères de l'horizon* (The Masterpiece or The Mysteries of the Horizon) (1955, figure 12), Magritte described what he called a "prodigious paradox": "Each man has his moon. When he thinks, he thinks about his moon. . . . And yet there is only one moon. This is a philosophical problem: how to divide the unity."[42] The realization that there is no single, naturally authoritative position from which to assess the world around us could be terrifying. Or it could be liberating. We seem to have been given years with four seasons, weeks with seven days, and a planet with one moon. Magritte's

paintings show the insufficiency of even these most basic constructions. There is more space and time, more reality, available to us if we are willing to claim it. Could we ask for anything more?

12 René Magritte, *Le chef-d'oeuvre ou les mystères de l'horizon* (The Masterpiece or The Mysteries of the Horizon), 1955. Oil on canvas, 19 11/16 x 25 9/16 in. (50 x 65 cm). Private collection

1 The phrase appears in Anne Umland, Stephanie D'Alessandro, and Josef Helfenstein, "Introduction: Magritte's Essential Surrealist Years, 1926–1938," in *Magritte: The Mystery of the Ordinary, 1926–1938*, ed. Anne Umland (New York: The Museum of Modern Art, 2013), 16–23. For aid in research I thank Alex Zivkovic and Jessamine Batario. Gary Garrels and Lily Pearsall, San Francisco Museum of Modern Art, read and gave comments on earlier versions of this essay, for which I am grateful.

2 As Magritte explained, each painting created by this method would begin with three "givens" that would guide his research: "The object, the thing tied to it in the shadow of my consciousness and the light into which this thing had to emerge." René Magritte, "Life Line" (1938), in *René Magritte: Selected Writings*, ed. Kathleen Rooney and Eric Plattner, trans. Jo Levy (Minneapolis: University of Minnesota Press, 2016), 65.

3 On Magritte's solutions to the problems of the tree, *La géante* (The Giantess) (1935); the sea, *L'invention collective* (Collective Invention) (1934); fire, *L'échelle du feu* (The Ladder of Fire) (1934); and rain, *Le chant de l'orage* (The Song of the Storm) (1937), among others, see Magritte, "Life Line," 65–66. On *La corde sensible* as a solution to the problem of the cloud, see letter from René Magritte to André Bosmans, July 26, 1960, in David Sylvester, ed., *René Magritte: Catalogue Raisonné*, vol. 3, *Oil Paintings, Objects and Bronzes, 1949–1967*, by Sarah Whitfield and Michael Raeburn (Houston: The Menil Foundation and Philip Wilson Publishers, 1993), 330.

The term *problematology*, adapted from the philosophical writings of Michel Meyer, appears in Michel Draguet, "From the Image-Screen to the Art of the Problem," in *Magritte: The Treachery of Images*, ed. Didier Ottinger, trans. David Wharry (Paris: Éditions du Centre Pompidou, 2016), 183–87. See also the discussion of "the art of the problem" in Michel Draguet and Claude Goormans, "'Once the Image Is Isolated, What Happens to the Mind?' Brussels, 1930–1936," in Umland, *Magritte: The Mystery of the Ordinary*, 153–55.

4 On *La condition humaine* as a solution to the problem of the window, see René Magritte, "La ligne de vie I" (1938), in *René Magritte: Écrits complets*, ed. André Blavier (1979; repr., Paris: Flammarion, 2009), 121–22.

5 "C'est ainsi que nous voyons le monde, nous le voyons à l'extérieur de nous-mêmes et cependant nous n'en avons qu'une représentation en nous." Magritte, 121.

6 The lecture "La ligne de vie" was given November 20, 1938, at the Musée royal des Beaux-Arts, Antwerp, and first published in 1946. For a complete translation of the lecture in English, see Magritte, "Life Line," 58–67.

7 "The picture corresponds to a much older preoccupation: to find, in space, a phenomenon analogous to that of 'false recognition.'" Letter from René Magritte to André Breton, [July 1934], quoted in David Sylvester, ed., *René Magritte: Catalogue Raisonné*, vol. 2, *Oil Paintings and Objects: 1931–1948*, by David Sylvester and Sarah Whitfield (Houston: The Menil Foundation and Philip Wilson Publishers, 1993), 184.

8 Magritte himself acknowledged these qualities in a letter about *Les promenades d'Euclide* (Where Euclid Walked) (1955, plate 15): "The landscape of *The Human Condition* which was as anonymous as possible, is now 'interesting' in itself, since a wide road which reaches to the horizon has the same form and color as a tower visible in the foreground." Letter from René Magritte to Maurice Rapin, quoted in Sylvester, *René Magritte: Catalogue Raisonné*, vol. 3, 246.

9 Magritte to Breton, 184.

10 Relevant precedents can also be found in paintings with multiple compartments, with or without text, such as *La clef des songes* (The Interpretation of Dreams) (1927) and *Le musée d'une nuit* (One-Night Museum) (1927), as well as in the vertically split composition *L'espion* (The Spy) (1928).

11 Sylvester, *René Magritte: Catalogue Raisonné*, vol. 2, 176.

12 On this topic as it relates to Magritte, see Victor I. Stoichita, "Magritte and His Curtains," in Ottinger, *Magritte: The Treachery of Images*, 142–49.

13 "Surrealism does not like losing reason, it likes everything that reason makes us lose." Ferdinand Alquié, *The Philosophy of Surrealism*, trans. Bernard Waldrop (Ann Arbor: The University of Michigan Press, 1965), 111.

14 For a discussion of fake feeds, see "Julia Scher in Conversation with Rudolf Frieling," Predictive Engineering[3] Colloquium session, San Francisco Museum of Modern Art, September 16, 2016, video and transcript, https://www.sfmoma.org/watch /predictive-engineering3-colloquium/?videoId= 5528417184001#transcripts and https://s3-us -west-2.amazonaws.com/sfmomamedia/media /uploads/files/Transcript_Julia_Scher_Artist _Talk_09_15_2017.pdf. Describing *Security by Julia*, Scher explains, "It was the first of what I call fake feeds, where two [of] my friends . . . were inside the filmic space chasing each other. . . . That was the first fake feed to be mixed in with live surveillance."

15 Despite his vocal disinterest in the materiality of his compositions, Magritte was acutely attentive to the rhetoric of image making. For more on this topic, see Katrina Rush, "'The Act of Painting Is Hidden': The Materials and Technique of René Magritte," on pages 61–69 of this publication.

16 René Magritte, *Rhétorique*, no. 9, 1963, quoted in Harry Torczyner, *Magritte: Ideas and Images*, trans. Richard Miller (New York: Harry N. Abrams, 1977), 65.

17 On this topic, see Richard Shiff, *Cézanne and the End of Impressionism: A Study of the Theory, Technique, and Critical Evaluation of Modern Art* (Chicago and London: University of Chicago Press, 1984).

18 Letter from Alexander Iolas to René Magritte, November 21, 1948, quoted in Sylvester, *René Magritte: Catalogue Raisonné*, vol. 2, 155.

19 Clive Bell, *Since Cézanne* (1922; repr., New York: Harcourt, Brace and Company, 1923), 71.

20 For more on the soft "death of the author" in Magritte's late paintings, see my essay, "Self-Portrait as Anonymous Artist," on pages 55–59 of this publication.

21 David Sylvester, *Magritte: The Silence of the World* (New York: The Menil Foundation in association with Harry N. Abrams, 1992), 264.

22 Magritte and his fellow Surrealists introduced the journal, *L'invention collective*, as such: "By publishing this review, we intend to break the silence which has been imposed on our French and English friends by the war. In Belgium, we still have some possibility of making our voices heard. We intend to explore this possibility to the full. As long as it is within our power, we Surrealists will pursue a course which sets us in absolute and definitive opposition to the myths, ideas, feelings and behavior of this ambiguous world." René Magritte et al., *L'invention collective* prospectus, December 17, 1939, quoted in Sylvester, *René Magritte: Catalogue Raisonné*, vol. 2, 76.

23 Sylvester, 80 and 83.

24 For more on Magritte's patronage by James, see Stephanie D'Alessandro, "'Mirrors That Become Paintings': Magritte's Commissions for Edward James," in Umland, *Magritte: The Mystery of the Ordinary*, 194–209; and Sylvester, *René Magritte: Catalogue Raisonné*, vol. 2, 61.

25 Letter from Edward James to René Magritte, August 5, 1938, quoted in Sylvester, *René Magritte: Catalogue Raisonné*, vol. 2, 63.

26 For more on Magritte and anonymity, see "Self-Portrait as Anonymous Artist."

27 René Magritte, quoted in Sylvester, *Magritte: The Silence of the World*, 170.

28 René Magritte, "R. M. Has Changed . . ." (1943), in Rooney and Plattner, *René Magritte: Selected Writings*, 71. Tense adjusted for syntax.

29 Magritte, "Life Line," 58.

30 René Magritte, "Surrealism in the Sunshine: 4. Manifesto No. 2—November 1946," in Rooney and Plattner, *René Magritte: Selected Writings*, 98. He would elaborate: "1) EVERYTHING TAKES PLACE IN OUR MENTAL UNIVERSE. By mental universe we mean everything we can perceive, through the senses, feelings, reason, imagination, intuition, instincts or any other way. 2) IT IS IMPOSSIBLE FOR US TO HAVE ANYTHING EXCEPT THE MENTAL UNIVERSE. Example: It is impossible for you to have any sense of this writing that is penetrating word by word into your mental universe except from your mental universe. . . . 3) THE NOTION THAT THE AMENTAL EXISTS IS THE ONLY NOTION WE CAN HAVE CONCERNING THE AMENTAL. The mental world in which everything takes place leads to the existence of the amental, which we can say nothing about except that it exists. All the qualities we may attribute to it would be applicable, since these qualities would be from our mental universe: harshness, light, outer, inner, movement, etc. These qualities are only applicable to objects which are part of our mental world." René Magritte, "Surrealism in the Sunshine: 5. Manifesto of Amentalism," in Rooney and Plattner, 101.

31 René Magritte, "Surrealism in the Sunshine: 1. Quarrel of the Sun," in Rooney and Plattner, 92.

32 See René Magritte, "Le surréalisme en plein soleil, dossier" (1946–47), in Blavier, *René Magritte: Écrits complets*, 194–228. Of automatism Magritte wrote, "It is extremely useful in psychoanalysis, as is the use of the microscope in biology. But, as a poetic tool, it has become quite ineffectual." Magritte, "Surrealism in the Sunshine: 4. Manifesto No. 2," 98. Likewise, he wrote with regard to self-taught naïve artists whose expressions seemed equally to be without choice: "If they weren't so miserably limited by this wretched world, the Facteur Chevals, the Douanier Rousseaus, children and madmen who draw pictures, would be capable of creating a fairy land which would have meaning for us. We should bear these efforts in mind." René Magritte, "Surrealism in the Sunshine: 3. Manifesto No. 1—October 1946," in Rooney and Plattner, *René Magritte: Selected Writings*, 95.

33 Letter from René Magritte to André Breton, June 24, 1946, quoted in Sylvester, *René Magritte: Catalogue Raisonné*, vol. 2, 132.

34 Magritte, "Surrealism in the Sunshine: 1. Quarrel of the Sun," 91.

35 For more on this topic, see "Self-Portrait as Anonymous Artist."

36 Sylvester, *René Magritte: Catalogue Raisonné*, vol. 3, 191.

37 Letter from Alexander Iolas to René Magritte, October 15, 1952, quoted in Sylvester, 192.

38 Letter from René Magritte to Alexander Iolas, October 24, 1952, quoted in Sylvester, 192.

39 Lucy R. Lippard, ed., *Surrealists on Art* (Engelwood Cliffs, NJ: Prentice-Hall, 1970), 1.

40 Michael Charlesworth, *Landscape and Vision in Nineteenth-Century Britain and France* (Aldershot, UK: Ashgate, 2008), 14.

41 Charlesworth, 18.

42 René Magritte, "Interview pour *Life*" (1965), in Blavier, *René Magritte: Écrits complets*, 611.

Odalisques of Revolt

MICHEL DRAGUET

IN FEBRUARY 1943, AS THE GERMAN ARMY WAS OVERPOWERED AT STALINGRAD (NOW VOLGOGRAD, RUSSIA), THE GREATER NAZI DEFEAT WAS ALL BUT ASSURED. René Magritte construed the Soviet victory as a signal that the post–World War II era would by necessity be one of absolute liberation. He expected Surrealism, too, to transform radically, on both iconographic and stylistic fronts. In his work this rupture manifested in a richer use of color, which the artist had until then reserved for his advertising assignments (see figure 1). Color allowed Magritte to reconnect with a sensual aesthetic and break away from the conceptual deconstruction of language that he had pursued since the late 1920s. In the tradition of the Impressionist Pierre-Auguste Renoir—as well as the neoclassical painter Jean-Auguste-Dominique Ingres—Magritte's sunlit surrealist period would last until 1947. Meant to reflect a social and artistic revolution, the works created in this style number approximately seventy-five oil paintings and thirty gouaches (see plates 1–7 and 19).

Antimilitarist and libertarian, Magritte turned his back on the register of a reality dominated by war and used his art as a hopeful gesture. He linked the act of painting to pleasure, a concept born of his desire to re-enchant daily life. As early as December 1941 he mentioned to the surrealist poet Paul Éluard his wish to "bring fresh air into [his] painting" in such a way that a "fairly powerful charm" would replace the "disturbing poetry" of his prewar work. He embraced a form of hedonism in which one takes pleasure in the heart of reality while also being "sharply aware of all the imperfections of everyday life."[1] The image became a site where broken unity could regain its balance, despair could morph into hope, and Surrealism, until then

introspective and nocturnal, could step fully into the sunlight. "Since the beginning of this war," he wrote to his friend and colleague Pol Bury, "I have had a strong desire to achieve a new poetic effectiveness which would bring us both charm and pleasure. I leave to others the business of causing anxiety and terror and mixing everything up as before."[2]

Until spring 1943 Magritte's quest for a new style was embodied primarily in his iconography, which comprised "the whole traditional range of charming things, women, flowers, birds, trees, the atmosphere of happiness, etc."[3] One notes, at most, a lightening of his color scheme, ending the intentional confinement of his palette to grays and ochres that had symbolized the weight of the German occupation of Belgium. But he intended to push beyond his old technique as well, and soon claimed for himself a new, lyrical Impressionism that drew from the late work of Renoir, whose popularity had been revived in recent literature and reproductions. Magritte's *La moisson* (The Harvest) (1943, plate 7), for instance, borrows the principle deployed by Renoir in *Les baigneuses* (The Bathers) (ca. 1918–19, figure 2), with each section of the female body painted a different color. Fellow Surrealist Marcel Mariën commented: "Taking his stand on . . . freedom, which is the prerogative of the

Surrealists and which 'incites them to find the elements of creation as closely as possible to the object to be created,' Magritte, not content with transforming his bather, also appropriated Renoir's representational technique."[4] Without a trace of irony, the painter studied Impressionism until he perfected it. It was after the liberation of Brussels that this impressionist streak would evolve into a quest for "art for art's sake" and assume a dimension of total artificiality.

Magritte thus explored new paths marked by self-sacrifice, irony, and the explosive lyricism of the liberation. His work in this style, which he termed "sunlit surrealism," is simultaneously plastic and erotic, luminous and sensitive. It necessitated a complete overhaul of what Surrealism had come to stand for, as Magritte refused to fall back on prewar formulas. Similarly, revolutionary Surrealists, consumed with communist orthodoxy, called for an aesthetic transformation on ideological grounds. Magritte was growing closer to this fringe of young, politically committed artists and saw the dark excesses of psychoanalytic theory as symptoms of the rise of totalitarianism. To this he opposed an animist perspective as a form of affirmation rather than withdrawal: "In opposition to the general pessimism I set the search for joy, for pleasure," he wrote in a letter to the French poet and founder of Surrealism, André Breton.[5] With sunlit surrealism

Magritte decidedly embraced "humor-pleasure," a conception of humor deeply linked with sexuality that he developed in a November 1946 manifesto.[6]

First Arrows

Between January 8 and 22, 1944, Magritte displayed twenty-some paintings at the Galerie Dietrich, Brussels, in the first public exhibition of his sunlit surrealist work. The founder of the Belgian branch of the surrealist movement, Paul Nougé, authored a preface for the invitation titled "Grand air" (Fresh Air) under the pseudonym Paul Lecharentais. Magritte was taking a risk and was indeed violently attacked by the collaborationist press, which saw in his painting the apex of a modern art that had been deemed degenerate. He was similarly rejected by critics—both conservative and avant-garde—and by art dealers.[7] He found himself isolated, his only support a small and devoted group of friends and accomplices. Among them was Christian Dotremont, a young, flamboyant poet who entered the scene in February 1944, after the Galerie Dietrich exhibition. Stimulated by the critics' vicious onslaught, Dotremont resolved to write a study of Magritte's new work in collaboration with Mariën.[8] Magritte issued a warning: "This subject is close to my heart and I want you to know that, while very few of my

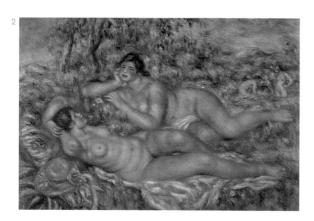

friends have been able to follow me on this path, it might be useful to point out to the rest that they have merged with the amorphous public mass deprived of the most basic freedom."[9]

By the end of 1944 the sunlit surrealist venture had gained another recruit. Jacques Wergifosse was a sixteen-year-old poet from Liège, France, who became a friend and disciple after a visit with Magritte. Wergifosse championed the artist's new style and even helped to further define it in 1946.[10] Other poets—among them Marcel Broodthaers—also appeared alongside Magritte for a time, though not all embraced sunlit surrealism.

The enchanted dimension at play in Magritte's sunlit surrealist works went hand in hand with his newfound literary enthusiasm, as he discovered in prose and poetry ideas that enriched the theories underpinning his art. Editorial projects led to his founding, with Mariën and Nougé, of the publishing imprint Le miroir infidèle in 1946, and illustration projects multiplied across the postwar years. Magritte created drawings for texts by Éluard, Georges Bataille, and the Marquis de Sade, and he published his own edition of the Comte de Lautréamont's *Les chants de Maldoror* (The Songs of Maldoror) (1869) in 1948.

Meanwhile, in the September 8–9, 1945, issue of the communist daily *Le drapeau rouge*, Dotremont announced that Magritte had joined the Belgian Communist Party. This commitment reflected the painter's gratitude for an organization that had lost many members to summary execution, as well as for the Union of Soviet Socialist Republics, which had paid the heaviest price in lives in the fight against the Nazis. It also, and perhaps most importantly, signaled Magritte's desire to confront the threat of a return to business as usual after liberation. He believed that fascism was not dead and that intellectuals could face it only from under the Red banner, writing, "We must manage to convince these people that it is impossible to think seriously about making profound changes in the present organization of life if they cling to habits of thought of a sickening banality. This task may well be hopeless because there is a difference between Marxism and bureaucrats who are naïvely convinced that they have got beyond it."[11] Magritte's allegiance to the party, however, was short-lived and limited to just a few articles and meetings, as he grew wary of the artistic diktat emanating from Moscow. Realizing his inability to influence the communist position from within, he chose to defect rather than wait for the ejection he knew was impending.[12]

Magritte remained eager to guide the reorientation of postwar Surrealism, and to this end he was the principal organizer of a large exhibition titled *Surrealism—An Exhibition of Pictures, Drawings, Collages, Objects, Photos and Texts* held at the Galerie des Éditions La Boétie in Brussels from December 14, 1945, to February 1, 1946. He appeared as a leader of the movement at a time when Nougé was retreating. Sales were few and the critics were unimpressed, but the exhibition was nonetheless well attended.[13]

Trash and Provocation

The denigration of sunlit surrealism, which was cast at best as a temporary misstep and at worst as a symptom of senility, rekindled in the artist the fundamental violence that had defined his youth, beginning with his mother's suicide in 1912. During the spring and summer of 1946 he worked on a series of pamphlets with Nougé and Mariën in the rebellious spirit of Dada. "L'imbécile" (Idiot), "L'emmerdeur" (Silly Bugger), and "L'enculeur" (Fucker) savagely defied moral and social conventions.[14] The pamphlets were anonymous, and the three friends filled them with inflammatory statements. Prewar pacifism and antimilitarism make a striking comeback in "L'imbécile": "Good patriots are idiots; good patriots muck up the country." Proud anarchists and atheists, Magritte and his accomplices then target the Church: "Priests are idiots; they don't know a thing about religion." Each text concludes with an address to the reader, the brutality and vulgarity of which delighted Magritte, who was settling accounts most notably with the world of advertising: "Fuckers make good publicity. Thus a fucker with a hobby in the perfume business has come up with the idea of displaying in his shop, amidst a rustic decor, a magnificent bunch of flowers sprouting out of a crapper."[15]

The pamphlets met with resistance from a portion of the surrealist world, but Magritte took full responsibility for the radicalization they reflected. He wanted to push beyond national unity, communism, and historical Surrealism—all flawed in his eyes—by expressing the kind of clear-cut positions Nougé saluted in René Descartes's *Discourse on the Method* (1637) and Breton's *Surrealist Manifesto* (1924). Beneath the insults that were hurled at him, Magritte saw "fundamental demands of mankind" that reeked of "ancient human fanaticism."[16] Many of the pamphlets were seized by postal authorities and did not reach their addressees. But the painter continued to delight in such practical jokes, risqué humor, and schoolboy pranks, around this time drafting a similarly provocative prospectus for a made-up lecture series at the Séminaire des Arts. It announces a conference on sexual practices led by "Professor Ijowescu"— a phonetic transcription of the Walloon sentence "he comes in his ass"—from the Academy of Advanced Sexological Studies in Sofia, Bulgaria, with demonstrations by young intellectuals of both sexes.[17] Amid the utter rejection of his sunlit surrealist work, Magritte was already switching gears to the type of forceful counterattack that would be embodied by his vache pictures two years later.

Paris Forever

Despite its negative reception, Magritte continued to pursue sunlit surrealism. In June 1946 he spent a week with Mariën in Paris, where he intended to reconnect with Breton, who had spent the war years in the United States. "Something will come of it," he wrote to the poet Gaston Puel.[18] To Breton he recounted the disapproval and sarcasm his texts promoting sunlit surrealism had provoked:

> The painting of my "sunlit period" is obviously in contradiction to many things we were convinced of before 1940. This, I think, is the main explanation of the resistance it

has met with. I believe however that we no longer exist to prophesy (our prophesies were always unpleasant, it must be admitted); at the International Surrealist Exhibition in Paris visitors had to find their way around with electric torches. We had this experience during the occupation and it wasn't funny. The confusion and panic that Surrealism wanted to create in order to bring everything into question were achieved much better by the Nazi idiots than by us, and there was no question of avoiding the consequences.[19]

The painter sought to break away from the spiritual climate in order to bring a truly revolutionary depth to the liberation, a sense of profound renewal. By claiming joy and pleasure, he hoped to grant fresh relevance to Surrealism while also charting its course: "I feel it lies within us, who have some notion of *how feelings are invented*, to make joy and pleasure, which are so ordinary and beyond our reach, accessible to us all. It is not a question of abandoning knowledge of objects and feelings that Surrealism has given birth to, but to use it for purposes different from the previous ones, otherwise people will be bored stiff in surrealist museums just as much as in any others."[20]

In a letter dated August 11, 1946, Magritte refused to see Surrealism as a mere bridge between the two World Wars. But his arguments fell on deaf ears. That the trial and darkness of war needed to be followed by a full exposure to sunlight was something Breton, from the perspective of his American exile, failed to comprehend. Magritte's critique of the past might have struck him as an attempt to do away with surrealist history in order to hijack the movement's future. Breton's response, fueled by his own growing sense of alienation from the surrealist world, was cold and aloof. He rejected Magritte's declaration of faith, his call for "a new feeling which can face the fiery light of the sun [and] makes it possible to achieve, within the space of our lifetime, that golden age which I refuse to relegate to some abstract future."[21] Magritte wanted revolution *here* and *now*,

and he wanted it tied both to sunlit surrealism and to communism, on which Breton had firmly turned his back. The poet replied derisively to Magritte's fierce discourse that he couldn't see any "sunlight" either in Magritte's work or in his ideas: "And how can it be, since you feel the need to look for the sun in Renoir? You go looking for it there but it doesn't follow you, and besides Magritte's sun would, by definition, be different. Let me assure you that none of your latest canvases gives me any impression of the sun (of Renoir, yes): really, not the slightest illusion. Is this my fault? . . . Contrary to what you think, I too love light, but only created light."[22]

Breton went on to note that he saw sunlit surrealism as a symptom of the kind of collapse that had struck the work of Giorgio de Chirico, an early influence on Magritte who found little success when he diverged from his "nocturnal— or oneiric—epoch, whichever you like to call it." The rift was final, as Magritte declared his determination to extricate himself from "crystallized Surrealism,"[23] and Breton refused to sign the sunlit surrealism pamphlet. Breton's verdict was scathing: he asserted that it was "anti-dialectical and . . . any fool can see that." Nougé and Magritte did not miss a beat, replying, "Well, *one* fool hasn't seen it. Many regrets."[24]

Magritte continued to exhibit in Brussels, putting on display the fruit of his pictorial revolution. Between May 31 and June 21, 1947, he showed his last works in the sunlit surrealist mode at the Galerie Lou Cosyn. Fifteen of the thirty gouaches on view were small-format variations on the theme of Sheherazade, the queen and storyteller in *One Thousand and One Nights*, which the artist had read enthusiastically over the summer of 1946. Oscillating between realism and Impressionism, Magritte's gesture loosens and sparkles, the new motif confirming his taste for the enchanted. In several examples, the female face is

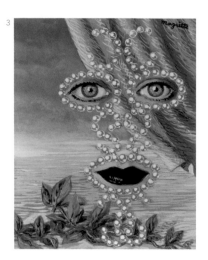

translucent; as in some later depictions of this theme, it is traced with a ribbon of pearls, becoming a kind of precious lace that achieves substance without coalescing into a full image (see plate 45 and figure 3). Magritte seemed to assign the status of object to these and other small gouaches, presenting them in box-like frames to be laid on a surface rather than hung on a wall. The fantastic entered the painter's iconography just as another new blaze overtook his palette; the Sheherazade works both evoked and further stimulated Magritte's desire to emphasize the "bright side of life."[25] But his old companions would have none of it: on July 7, 1947, when the international exhibition of Surrealism opened at Gallery Maeght in Paris, Breton demolished Magritte's approach, castigating it as clumsily submissive to the Stalinist dictate of "whole-hearted optimism."[26]

Magritte was hurt and insulted but nonetheless strengthened in his determination to carry on. He resolved that his work must continue to be seen, and seen in Paris. At the beginning of 1948 he asked the French Surrealist Léo Malet to help secure an exhibition space in the French capital. Plans were made with an undistinguished gallery, the financial and promotional terms of which were not to Magritte's advantage. The painter wanted this presentation to be primarily a manifestation of pleasure, and though he knew he could not

maintain high expectations for an exhibition held at the margins of the Parisian cultural establishment, he saw an opportunity worth the potential damage to his reputation.[27] The pleasure principle that had motivated his sunlit surrealist work was, in the new series of pictures he made for this show (see plates 8–13), redoubled: It resonates in the powerful sensuality that bursts forth in full color in these gouaches and canvases. It is palpable, too, in his correspondence, which reflects the thrill of settling accounts with Paris. Playfully misspelled in his letters to Louis Scutenaire as *parure* (finery) and *Piras* (a king in Greek mythology),[28] it was a city that had never embraced him, and Magritte was now fighting back against the French intelligentsia that had rejected him between the wars and then spurned his sunlit surrealist work. His pleasure was intense, apparent in both subject and technique, as well as in his use of the chance to confront the leaders of Surrealism with their inability to renew its mystery. Following sunlit surrealism, this "vache" phase was a slap in the face of good taste, a condemnation of avant-garde dogmatism, a return to pure Dada provocation.

3 René Magritte, *Shéhérazade* (Sheherazade) [Portrait of Rachel Baes], 1947. Gouache on paper, 6 11/16 x 5 1/8 in. (17 x 13 cm). Location unknown

1 Letter from René Magritte to Paul Éluard, December 4, 1941, quoted in David Sylvester, ed., *René Magritte: Catalogue Raisonné*, vol. 2, *Oil Paintings and Objects. 1931–1948*, by David Sylvester and Sarah Whitfield (Houston: The Menil Foundation and Philip Wilson Publishers, 1993), 290–91.

2 Letter from René Magritte to Pol Bury, February 24, 1945, quoted in Sylvester, 91.

3 Magritte to Éluard, 290.

4 Marcel Mariën, in René Magritte, *Manifestes et autres écrits*, ed. Marcel Mariën (Brussels: Les lèvres nues, 1972), 14, quoted in Sylvester, *René Magritte: Catalogue Raisonné*, vol. 2, 92.

5 Letter from René Magritte to André Breton, June 24, 1946, quoted in Sylvester, 132.

6 See René Magritte, "Le surréalisme en plein soleil: Manifeste no. 2—Novembre 1946," in *René Magritte: Écrits complets*, ed. André Blavier (1979; repr., Paris: Flammarion, 2009), 219.

7 Sylvester, *René Magritte: Catalogue Raisonné*, vol. 2, 102–4.

8 I discuss this in "Les développements de l'œil: 1. Dotremont face à l'image," in *Christian Dotremont: Les développements de l'œil* (Paris: Hazan, 2004), 35–43.

9 Letter from René Magritte to Marcel Mariën, February 1944, in René Magritte, *La destination: Lettres à Marcel Mariën (1937–1962)*, ed. Marcel Mariën (Brussels: Les lèvres nues, 1977), 73. Translation by Fabienne Adler.

10 Sylvester, *René Magritte: Catalogue Raisonné*, vol. 2, 108–9.

11 Letter from René Magritte to Achille Chavée, 1945, quoted in Sylvester, 114–15.

12 See René Magritte, "Magritte et le parti communiste, dossier" (1945–47), in Blavier, *René Magritte: Écrits complets*, 239. See also Magritte's words in Patrick Waldberg, *René Magritte* (Brussels: André De Rache, 1965), 208–10.

13 Sylvester, *René Magritte: Catalogue Raisonné*, vol. 2, 116–18.

14 Magritte also wrote a fourth pamphlet titled "La crapule" (The Crook), which would be discovered only after his death. Sylvester, 123.

15 René Magritte and Marcel Mariën, "Three Pamphlets" (1946), in *René Magritte: Selected Writings*, ed. Kathleen Rooney and Eric Plattner, trans. Jo Levy (Minneapolis: University of Minnesota Press, 2016), 76–78.

16 Letter from René Magritte and Marcel Mariën to Achille Chavée, quoted in Sylvester, *René Magritte: Catalogue Raisonné*, vol. 2, 121–22.

17 Sylvester, 123.

18 Letter from René Magritte to Gaston Puel, June 23, 1946, quoted in Sylvester, 128.

19 Magritte to Breton, 132.

20 Magritte to Breton, 132.

21 Letter from René Magritte to André Breton, August 11, 1946, quoted in Sylvester, *René Magritte: Catalogue Raisonné*, vol. 2, 133.

22 Letter from André Breton to René Magritte, August 14, 1946, quoted in Sylvester, 133.

23 Letter from René Magritte to André Breton, August 20, 1946, quoted in Sylvester, 133.

24 Letter from René Magritte to Marcel Mariën, October 8, 1946, quoted in Sylvester, 135. This letter recounts both sides of Magritte's exchange with Breton.

25 Sylvester, 144–45.

26 André Breton, "Devant le rideau," in André Breton and Marcel Duchamp, *Le surréalisme en 1947* (Paris: Pierre à Feu/Maeght, 1947), quoted in Sylvester, 147.

27 Sylvester, 159.

28 See my publication *Magritte tout en papier: Collages, dessins, gouaches* (Paris: Hazan, 2006), 168.

Mad or Bad? Magritte's Artistic Rebellion

ABIGAIL
SOLOMON-GODEAU

LONG CONSIDERED ABERRATIONS IN HIS ARTISTIC CAREER, RENÉ MAGRITTE'S SUNLIT SURREALIST AND VACHE PICTURES (see plates 1–13 and 19) have recently been reassessed by art historians and critics not only on their own terms but also in relation to the notion of "bad painting."[1] The two bodies of work have often been discussed separately, since they are stylistically dissimilar and the latter was produced specifically for Magritte's first solo exhibition in Paris, in 1948. Nevertheless, there is good reason to think of them as related. Both series are almost unrecognizable as "Magrittes," and one followed directly after the other, together spanning World War II and the immediate postwar period.[2] Far more than a neutral background, historical events may have helped shape, if not determine, the nature and terms of these works more than has until now been presumed.

The sunlit surrealist and vache paintings are deeply, thoroughly weird, not only in their iconography but also in their departure from Magritte's long-established style, palette, and facture. Whereas previously Magritte acknowledged only the artistic influence of the Italian Surrealist Giorgio de Chirico, the sunlit surrealist works refer—sometimes quite directly—to late paintings by Pierre-Auguste Renoir. But examples such as *La moisson* (The Harvest) (1943, plate 7), with its harlequinesque, multicolored limbs, torso, and head, are far closer to parody than pastiche. Certain vache works evoke other artists: the sinuous contours of several female nudes (see plate 8) recall those of Henri Matisse, and the intense hues and crude brushwork in other pictures have invited comparison to German Expressionism. With their penis-nosed grotesques, lurid colors, and bodily eruptions, the vache paintings have been described as "look[ing] like nothing so much as the missing link between James Ensor and Zap Comix."[3]

The subject matter of both series is as striking as the radically different styles in which they are rendered. A prime example of sunlit surrealism is *La bonne fortune* (A Stroke of Luck) (1945, figure 1). Rippled brushstrokes describe sky and ground, while an obelisk headstone dominates the background. The cemetery setting, the (arguably) phallic monument, and the floral wreath of the kind placed on soldiers' graves are perhaps not incidental to the postwar context of the work's creation. The principal subject, however, is a pig, its head and one tiny, beady eye turned toward the viewer. Unlike Magritte's more familiar depictions of figures or objects, this canvas makes no attempt to evoke the actual animal: it stands upright, it wears a dark and thickly painted jacket, and the shape of its head is more human than pig-like. Despite the impressionistic brushstrokes and colors—dominated by sugary pinks, corals, and oranges—whatever this is, like *La moisson*, it certainly is not Impressionism, a style grounded in ideas of visual and perceptual truth that Magritte's work systematically repudiated. Another strange element in several sunlit surrealist scenes is the substitution of objects for suns, radiating cursory beams. Perhaps the most delirious of these proxies appears in *Le lyrisme* (Lyricism) (1947, plate 3), where the sun has become the pear head invented by the satirists Honoré Daumier, Charles Philipon, and J. J. Grandville as stand-ins for Louis Philippe I,

the constitutional monarch installed after the French revolution of 1830 (see figure 2). But why would Magritte have reprised these caricatures? Was this choice determined by Louis Philippe's identification with and enrichment of the powerful bourgeoisie—nemesis of all Surrealists—and the belief that such images fostered the 1848 uprising that led to his overthrow?

Among the vache works, consider, for example, *La famine* (Famine) (1948, plate 12), which shows a loosely painted chain of heads, apparently eating one another. Their features are cursorily indicated, obscuring distinctions between mouths, tongues, and phallic noses or beaks. Is a literal interpretation of this picture—an acknowledgment that in famine, people may be reduced to cannibalism—possible or even appropriate?[4] The cartoonish style neutralizes any impulse to link the image to its title—as is the case with *Le stropiat* (The Cripple) (1948, plate 13). Here an equally crudely rendered man is frontally positioned against an undefined background. Sporting a Phrygian cap and spectacles, with eight pipes sprouting from his beard, mouth, eye, and forehead, is this figure to be understood as a self-reflexive reference to Magritte's famous pipe motif? Should *Le stropiat* or *La famine* be seen as comical, or vicious? Is the language of art criticism or art history

suitable or useful to make sense of such works, or should they be disregarded as aberrations or jokes?

That the vache paintings and gouaches, rapidly made over five or six weeks in 1948, were intended as provocations to the French art world is a necessary but insufficient explanation for their perversity and insistent "badness." Certainly there was more than a whiff of conspiratorial glee surrounding their production and exhibition.[5] Unsurprisingly, not a single picture in the show sold; Magritte's Brussels and London dealers, P.-G. Van Hecke and E. L. T. Mesens, were appalled, and for the most part, the French press found the compositions unfathomable and easily dismissed.[6] That is to say, bad. Still, there are reasons to reckon with them seriously—the form, facture, and subject matter are so defiantly non-Magrittian as to suggest calculation and raise questions of interpretation that exceed their deliberate provocation. The same can be said of the sunlit surrealist series: if any artist was temperamentally (and aesthetically) averse to apparent spontaneity or expressionist indulgence, it was Magritte. If these works *look* spontaneous, that was a no less strategic decision.

One way to consider both series might be in relation to "madness," not in the sense of mental disorder but in terms

1 René Magritte, *La bonne fortune* (A Stroke of Luck), 1945 (detail). Oil on canvas, 23 ⅝ x 31 ½ in. (60 x 80 cm). Musées royaux des Beaux-Arts de Belgique, Brussels

2 Honoré Daumier, after Charles Philipon, *Les poires* (The Pears), 1831. Lithograph, 13 ⅛ x 10 in. (33.3 x 25.4 cm). The Metropolitan Museum of Art, New York, gift of Arthur Sachs, 1923

of the range of emotions from rage and anger to irritation and frustration. This anger may have had wellsprings other than the Surrealists' principled loathing of capitalism, militarism, religion, and the bourgeoisie. One should at least entertain the possibility that the war and occupation contributed, even subliminally, to the outrageousness of both bodies of work.

Germany's invasion and occupation of Belgium began in May 1940.[7] Initially Magritte and several surrealist friends, including Louis Scutenaire, Irène Hamoir, and Raoul Ubac, fled to France, where Magritte stayed until August.[8] Once back in Brussels, judging from his correspondence, it is as though normal life was restored. Yet by December all Jews holding official positions were fired; in 1941 the word *Jew* was added to Belgian identifying documents, and Jewish children were expelled from the schools. By 1942 the occupation had become yet more oppressive, and food shortages were endemic—especially in cities, where all food was rationed. Even bread was sometimes unavailable. A thriving black market emerged, some of it run by Germans, some by enterprising Belgians. Citizens were taxed to pay for their own occupation and military operations elsewhere. Censorship was imposed on all news media. Almost two hundred thousand Belgians were conscripted and sent to Germany as forced labor. By the war's end, 40,690 Belgians, over half of them Jews, had been killed. Allied bombings were themselves responsible for many deaths.

But throughout the occupation, the art market continued to function. Paintings were bought and sold, galleries opened and closed, and exhibitions took place, if sometimes semi-clandestinely.[9] Most of the Belgian Surrealists retained their day jobs; continued to publish tracts, journals, pamphlets, and manifestos; and exchanged witty and apparently carefree letters.[10] Magritte and his friends met almost weekly and went to the coast on their holidays. Besides Paul Nougé, who was conscripted into the French army and demobilized after two months, only Marcel Mariën, the youngest of the Belgian group, was called up, subsequently spending three months in German camps.[11] Only the Jewish Fernand Demoustier—better known by his pseudonym, Fernand Dumont—lost his life; he died either en route to or in the Bergen-Belsen concentration camp.[12]

The photographs and short films Magritte produced in these years are antic and playful, and he rarely linked his art to external circumstances. In a 1944 letter to Mariën he wrote: "So I'm taking refuge in the ideal world of art. An idealist position, you'll tell me. Well—all right. But it's only a way of amusing myself, after all, and that's the main thing. And the noisier reality becomes, the less reluctant I am to escape from it as much as possible."[13] Another letter notes, "The German occupation marked the turning point in my art. Before the war, my paintings expressed anxiety, but the experiences of war have taught me that what matters in art is to express charm. I live in a very disagreeable world, and my work is meant as a counter-offensive."[14] These are uncharacteristically tepid remarks given the horrors of the period, but they have generally been taken at face value, possibly because the war barely features at all in Magritte's correspondence and other writings. Nevertheless, his statements need not mean that the war and occupation did not produce cultural or psychic symptoms in his oeuvre. His assertion that "what matters in art is to express charm" is, as we have seen, belied by the manifest charmlessness of the works themselves.

At least two vache canvases feature hams (see plate 10), perhaps alluding to wartime food shortages, but it is not subject matter *as such* in Magritte's paintings of this period that link them to their time and place. Far more suggestive

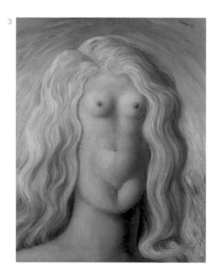

is their blatant cynicism: the parodic qualities of the sunlit surrealist compositions and the violence and disgust of the vache pictures, which are dense with fetishistic references and a manic deployment of fecal, phallic, and castration imagery. To be sure, these motifs can be identified throughout Magritte's career; despite his frequent denunciation of psychoanalytic readings of his work, no one was more adept at translating Freudian concepts into iconography. But a distinction can be drawn between his canny exploitation of psychologically charged themes—think here of the still-shocking *Le viol* (The Rape) (1945), reprised in a sunlit surrealist version (figure 3)—and what might be identified as a form of unarticulated or repressed rage at being subject to fascism, one of the threats that the Surrealists had sought to resist throughout the 1930s.

Magritte joined the Belgian Communist Party in 1945 and had contributed graphics and posters to it before the war.[15] But during the occupation, though he fully identified with the revolutionary aspirations of Surrealism, Magritte, like most of his cohort, had no known contact with the Belgian resistance. The weirdness of his sunlit surrealist style and the brutality of his vache works may be symptomatic of the contradictions of his position as a putatively subversive artist and the acquiescent circumstances of his daily

existence. At a time when the guise of the respectable bourgeois incarnated by Magritte's bowler-hatted man, often construed as a kind of alter ego, could not fully contain these inconsistencies, the series can perhaps be seen as means of rebellion, conscious or not: forms of protest against the status quo—be it the German occupation or merely business as usual.[16] The perversity of these bodies of work suggests that Magritte's statements about his intentions were either a kind of camouflage or part of a more general repression.

After the 1948 Paris exhibition closed, Magritte acknowledged that the vache paintings were a form of "slow suicide," referring specifically to their lack of buyers.[17] By 1949 he had returned to his signature style; his economic situation progressively improved, and the sunlit surrealist and vache works were effectively marginalized as short-term aberrations in an otherwise coherent oeuvre. They did not figure in his most important international exhibitions of the 1950s. Suggestively, his next extended series featured a wooden coffin as its central motif—a fitting coda for the war and occupation, whereby its horrors could be more safely and profitably sublimated into the language of art.

3 René Magritte, *Le viol* (The Rape), 1945. Oil on canvas, 25 11/16 x 19 13/16 in. (65.3 x 50.4 cm). Musée national d'art moderne/Centre de création industrielle, Centre Georges Pompidou, Paris

1 The term *sunlit surrealism* derives from Magritte's 1946 manifesto that states, "We have neither the time nor the taste to play at surrealist art, we have a huge task ahead of us, we must imagine charming objects which will awaken what is left within us of the instinct to pleasure." Cited in David Sylvester, ed., *René Magritte: Catalogue Raisonné*, vol. 2, *Oil Paintings and Objects: 1931–1948*, by David Sylvester and Sarah Whitfield (Houston: The Menil Foundation and Philip Wilson Publishers, 1993), 91. The complete dossier on sunlit surrealism, "Le surréalisme en plein soleil" (1946–47), can be found in *René Magritte: Écrits complets*, ed. André Blavier (1979; repr., Paris: Flammarion, 2009), 194–204. There are many more works in the sunlit surrealist category—approximately seventy-five oil paintings and thirty gouaches—than in the vache series, which numbers seventeen oils and twenty-two gouaches.

As to the concept of "bad painting," in 1978 Marcia Tucker curated an exhibition with an accompanying catalogue at the New Museum, New York, titled *"Bad" Painting*. Thirty years later the Museum Moderner Kunst Stiftung Ludwig in Vienna produced an exhibition and catalogue titled *Bad Painting—Good Art* that included Magritte's vache pictures. Each show represented different artists and had different agendas, raising the question of whether "bad painting" is the same thing as "bad" painting.

2 While producing the sunlit surrealist paintings, Magritte simultaneously churned out numerous works in all media that conformed to his established style, as well as commercial commissions.

3 Luc Sante, "Art: Magritte the Detective," *The Threepenny Review*, no. 56 (Winter 1994): 28.

4 Interestingly, a text by Magritte and his friend Marcel Mariën makes reference to famine: "Politicians have buggered up the world with their wars. Now they are preparing a famine. Never mind that, we'll soon be enjoying first-class meals and thinking about all those cretins who are dying of hunger." René Magritte and Marcel Mariën, "Silly Bugger" (1946), in *René Magritte: Selected Writings*, ed. Kathleen Rooney and Eric Plattner, trans. Jo Levy (Minneapolis: University of Minnesota Press, 2016), 77. "L'emmerdeur" (Silly Bugger) was one of three tracts—including "L'enculeur" (Fucker) and "L'imbécile" (Idiot)—printed to be mailed to friends and associates in 1946, but two of the three were seized by the Belgian Post Office. They were published later that year as a response to a questionnaire in the Belgian journal *L'art jeune*. For all three tracts and Magritte's related correspondence, see Blavier, *René Magritte: Écrits complets*, 158–61.

5 This is especially clear from Magritte's correspondence with his "co-conspirator" Louis Scutenaire and Scutenaire's wife, the novelist and poet Irène Hamoir. They contributed many titles, insofar as they, like many of Magritte's surrealist friends, routinely participated in the naming of individual works and invented subjects throughout his career.

6 "Alas, his [illegible word] is more and more like what de Chirico's was with its series of horses and gladiators, although the latest Magrittes are even much worse. To crown all, he flies into a rage at the slightest hint that this is the case. The poor crazy fellow believes that what he is doing now represents the 'high point' of his painting. Christ, what a catastrophe!" Letter from P.-G. Van Hecke to E. L. T. Mesens, April 1946, quoted in Sylvester, *René Magritte: Catalogue Raisonné*, vol. 2, 93.

7 For information about the war and occupation in Belgium, I have used the following sources: Jean-Michel Veranneman de Watervliet, *Belgium in the Second World War* (Barnsley, UK: Pen and Sword Books, 2014); Paul Aron and José Gotovitch, *Dictionnaire de la Seconde Guerre mondiale en Belgique* (Brussels: André Versaille, 2008); Dan Michman, ed., *Belgium and the Holocaust: Jews, Belgians, Germans* (Jerusalem: Yad Vashem, 1998); and Jacques de Launay and Jacques Offergeld, *La vie quotidienne des Belges sous l'occupation: 1940–1945* (Brussels: Paul Legrain, 1982).

8 Sylvester, *René Magritte: Catalogue Raisonné*, vol. 2, 80.

9 Magritte's 1943 exhibition of sunlit surrealist paintings at the Galerie Lou Cosyn in Brussels was not advertised and had limited hours. Ubac's 1941 exhibition at the same gallery was shut down by the authorities. Sylvester, 94 and 103. See also Xavier Canonne, *Le surréalisme en Belgique, 1924–2000* (Arles, France: Actes Sud, 2007).

10 Scutenaire and Hamoir continued to work as civil servants, Paul Nougé as a biochemist, Paul Colinet and Mariën (after his demobilization) as editors and freelance writers, and Marcel Lecomte as a teacher. See *René Magritte et le Surréalisme en Belgique* (Brussels: Musées royaux des Beaux-Arts de Belgique, 1982) and Canonne, *Le surréalisme en Belgique*.

11 After his release Mariën worked closely with Magritte, writing the introduction to the artist's first monograph in 1943. In a memoir published in 1983, Mariën claimed that during the war Magritte produced forgeries of paintings, including works by Old Masters, as well as counterfeit currency. Much of Mariën's book *Apologies de Magritte, 1938–1993* (Brussels: Didier Devillez, 1994) is devoted to the various lawsuits brought by Magritte's widow, Georgette, in response to his allegations.

12 Sylvester, *René Magritte: Catalogue Raisonné*, vol. 2, 76–77 and 80; and Keith Aspley, *Historical Dictionary of Surrealism* (Plymouth, UK: Scarecrow Press, 2010), 177.

13 Letter from René Magritte to Marcel Mariën, June 1944, quoted in Sarah Whitfield, *Magritte* (London: The South Bank Centre, 1992), cat. no. 86.

14 Letter from René Magritte to Paul Éluard, date unknown, quoted in Suzi Gablik, *Magritte* (New York: Thames and Hudson, 1985), 146.

15 Mariën claims that Magritte joined the party three times, but his membership was brief in each instance. Other sources say he joined only once, in 1945. Sylvester, *René Magritte: Catalogue Raisonné*, vol. 2, 33.

16 For an in-depth reading of Magritte's use of the bowler-hatted man as alter ego, see Caitlin Haskell, "Self-Portrait as Anonymous Artist," on pages 55–59 of this publication.

17 Letter from René Magritte to Louis Scutenaire and Irène Hamoir, June 7, 1948, quoted in Sylvester, *René Magritte: Catalogue Raisonné*, vol. 2, 167. Scutenaire and Hamoir ended up purchasing many of the vache works.

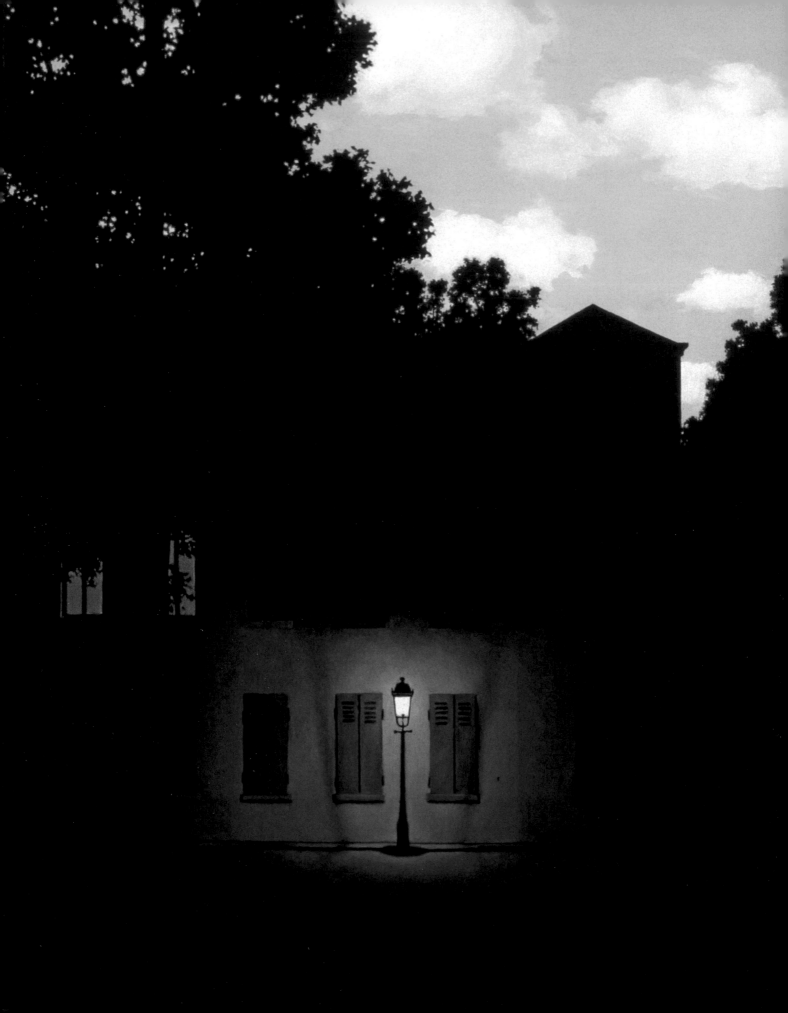

Otherworldly: Magritte's *L'empire des lumières*

SANDRA
ZALMAN

SEVENTEEN OF RENÉ MAGRITTE'S OIL PAINTINGS—
AND TEN GOUACHES—SHARE THE NAME *L'EMPIRE
DES LUMIÈRES* (THE DOMINION OF LIGHT), making
the motif his most recurrent and among the most successful
of the problems he posed in his work. He completed the
first of the canvases in 1949 (plate 51); sustained by its
allure to collectors, he marshaled demand for the painting
into an opportunity to revise and re-envision it for more
than a decade, as the theme continued to occupy him until
the mid-1960s.[1] While Magritte often revisited ideas, his
consistent titling of each iteration of *L'empire des lumières*
demonstrates that he considered these works a united corpus,
if not an outright series. When seen together—a circumstance
Magritte almost certainly would never have anticipated—
the pictures' slight and overt variations create a cumulative
eeriness, as the viewer becomes completely immersed in
the artist's repeated incursions on the tranquility of the
landscape. With each retelling, Magritte emphasizes his
point: that paintings are never simply views *onto* the world,
but rather views *into* the world.

Unlike many of Magritte's scenarios, *L'empire des lumières*
is incredibly subtle. The consistent characteristic is the
contrast of a darkened, well-maintained bourgeois neighbor-
hood with a sunlit, cloud-filled sky. Almost always, a single
streetlamp at the center illuminates the lower portion's
after-dusk, shedding light on a road or pond and sometimes
plunging into deeper shadow a boulder (see plates 54–55)
or other foreground element that reveals itself only upon
close looking. Each painting's first impression is that of a
snapshot of the world at sundown, the last gasp of natural
light before darkness settles in. But then the viewer might
notice that the darkness is too dark, even prematurely dark,

and that instead of depicting the fleeting transition from
day to night, the image refuses to resolve around familiar
circadian rhythms. This might be the most brilliant aspect
of the *L'empire des lumières* conceit. The disjunction is
not—as is often the case in Magritte's oeuvre—a spatial
one, but a temporal one. Thus the artist casts doubt on a
parallel dimension of painting previously unchallenged
in his work.

As Magritte made his way through variants of the theme,
he continually revised its central elements. Politician and
businessman Nelson Rockefeller bought the first iteration
from Magritte's New York dealer, Alexander Iolas, as a
present for his secretary; Iolas urged the artist to paint
another likely because of its quick sale.[2] The second version
(1950, plate 52 and figure 1)—a close copy, but with the
addition of more trees and a strange, blocky building—
was given to The Museum of Modern Art, New York, by
Dominique and Jean de Menil, early supporters of Magritte
who would eventually acquire the largest collection of his
oil paintings outside Belgium.[3] Here an oversize chimney
creeps up into the sky, its rectangular geometry countering
the freer forms of the clouds—though the clouds are
curiously regular in shape, their distribution almost
suggesting a pattern.

René Magritte, *L'empire des lumières* (The Dominion of Light), 1954 (detail, plate 56)

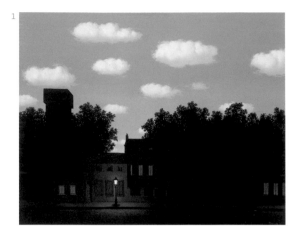

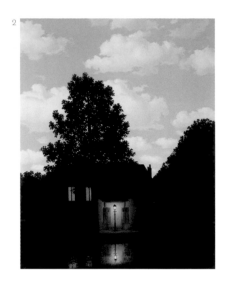

Though we might conventionally categorize the works titled *L'empire des lumières* as landscapes, Magritte considered them landscapes with opposing skyscapes: "The landscape suggests night and the skyscape day."[4] For him the paintings are antagonistic, but at the same time they unite their opposing forces—not only night and day but also nature and artifice, sunlight and electric light, the specific and the universal. Missing here, it would seem, is human presence, though its influence on the land is foregrounded. Magritte appeared to enjoy that *L'empire des lumières* is not—at least not mainly—about the human experience, writing in a letter, "My latest picture, a variant of *The Dominion of Light* has made a great impression on [Paul] Colinet, and that is good. But his attempt to explain it . . . is depressing: it appears I am a great mystic, providing consolation (because of the luminous sky) for our miseries (the landscape of houses and black trees). The intention is no doubt good, but all this keeps us on the level of pathetic humanity."[5] Magritte disliked this uplifting metaphorical reading, but perhaps most of all he was disappointed that even in the absence of a figure, his close friend Colinet saw the painting as a comment on humankind.

Magritte further renounced the primacy of humanity in these paintings with their title. It was supplied by poet Paul

Nougé, "who commented that it was often misunderstood (as in the usual English translation *The Empire of Lights*): . . . 'English, Flemish and German translators take it in the sense of *territory*, whereas the fundamental meaning is obviously *power, dominance.*'"[6] The distinction is revealing—while an empire exists in relation to a ruler, a dominion does not necessarily require this. Dominion, the more accurate but ambiguous interpretation of the title, can reflect nature's dominance over humanity, humanity's dominance over nature, or the interplay of these forces as expressed by our power of perception. Magritte alluded to this when he invoked "the spectator's vision" in an early discussion of the painting.[7] The act of seeing, the artist seemed to say, is a way of attempting to establish our dominion; it becomes especially vital when the laws of nature are undermined and our knowledge of the world is pitted against the visual information at hand. Only through our power of perception can we synthesize these antagonisms, even as we recognize them as such.

Thus, while these works do not privilege humanity, neither do they dismiss it. Though the first two *L'empire des lumières* paintings are horizontally oriented, like traditional landscapes, Magritte adopted the vertical format associated with portraiture in 1951 for the third. And in the absence

1 René Magritte, *L'empire des lumières* (The Dominion of Light), 1950. Oil on canvas, 31 ½ x 39 ⅜ in. (80 x 100 cm). The Museum of Modern Art, New York, gift of D. and J. de Menil, 1951

2 René Magritte, *L'empire des lumières* (The Dominion of Light), 1954. Oil on canvas, 57 ½ x 44 ⅞ in. (146 x 114 cm). Private collection

of a human figure, the streetlamp at the center of each canvas becomes the protagonist. Its vertical thrust, its demonstration of our mastery of nature (our ability to light the night), and its deliberately bowler-hatted shape make it a mechanical stand-in for the viewer.[8] In at least one version of *L'empire des lumières* Magritte modified the lamp to arrive at an even more human form, rounding its geometric angles to better resemble the curves of his characteristic bowler hat.[9] Several iterations include a pair of unusual linear shadows that frame the streetlamp and repeat the slanted angle of its glass panes (see plates 53–56). These dark forms meet with an amorphous shadow above to cast a larger version of the streetlamp's globe and canopy onto the building behind. The visual echo of the light source is composed, paradoxically, from the very absence of illumination. But more suggestively, these shadows trace another outline of the man in the bowler hat, further asserting our place, psychically if not physically, in the "dominion of light."

The eighth and largest of the *L'empire des lumières* canvases (1954, plate 56) was shown in the Belgian pavilion at the Venice Biennale the year it was made. Here the artist again used the streetlamp's shadows to evoke a hazy reference to the man in the bowler hat. If Magritte's muted allusion to the missing figure goes unnoticed, it is perhaps because he included the more striking silhouette of a tall tree looming against the bright sky, enhancing the drama of the painting by bringing the whiteness of the clouds and the blackness of the foliage into direct contact. The tree also emphasizes the verticality of the composition, making the lone streetlamp appear diminutive beneath its towering form.

Magritte's boldness in enlarging the dimensions and increasing the pictorial tension through the dominating tree was rewarded when multiple buyers wanted to purchase the painting from the well-attended Biennale.[10] It caused a fair amount of confusion: Magritte inadvertently promised the canvas to three collectors, though it went to a fourth.[11] The theme of the Biennale had been Surrealism, in honor of the thirtieth anniversary of the movement's founding. The exhibition represented an international acknowledgment of Surrealism's importance, as well as a chance to become reacquainted with the artists who practiced surrealist strategies.[12] It was therefore fitting that the *L'empire des lumières* painting ultimately went to Peggy Guggenheim, a prominent collector of avant-garde art who sought to fill a gap in her impressive surrealist holdings.[13] She had moved these works to Venice after World War II and had begun to show publicly there in 1951, likely in anticipation of opening a museum.[14]

After Magritte decided to sell the painting to Guggenheim, he set to work on three more versions—one of which was bought by the Musées royaux des Beaux-Arts de Belgique, Brussels (1954, plate 55). In these canvases, which followed the Biennale in quick succession, Magritte experimented with adding water to the scene (see figure 2). The water activates the foreground with a mise-en-abyme effect, its reflective surface doubling the lamppost, houses, and tree trunks. While their abbreviated forms become refracted and diffuse, light itself seems to become more material, the staccato brushstrokes of the illumination from the streetlamp rebuffing the blended finish of the rest of the painting.

The idea of adding water may have come to Magritte following his move to a new apartment in Brussels, which occurred while he was filling the demand for *L'empire des lumières* in 1954. The apartment was across the street from Parc Josaphat, which contained several ponds and was lined with regularly planted trees and streetlamps. Later the artist would describe the neighborhood: "In the evenings,

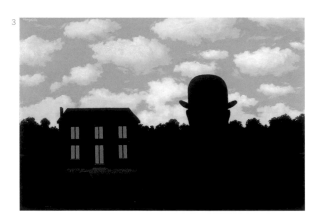

it's like being in the picture—*The Dominion of Light*. The villa where I live is surrounded by gardens and the houses looking directly onto the boulevard Lambermont stand out against a wide sky."[15] The 1954 iteration of the painting owned by the Menil Collection, Houston (plate 54), testifies further to this reading—its defining feature is a row of four nearly identical trees repeated at even intervals, a version of nature made by and for humankind.

In the last oil variant of *L'empire des lumières* (1964 or 1965, figure 3), a human figure finally makes an appearance, though he does not emerge from the shadows. Silhouetted, he turns away from the viewer and perhaps becomes our surrogate. The lamppost, rendered unnecessary as a substitute for this figure, has been removed. Instead the bowler-hatted man stands in the darkened foreground, gazing at a single building in the middle ground and a forest beyond. The collision here seems to be less about day and night and more overtly about humanity and nature.

Depicting the landscape can be a way to assert control over nature by insisting on our ability to remake it according to our own proclivities. At the same time, rendering the world around us is an inherently subordinate act, for it admits that painting is a representation, secondary to nature itself.

Magritte was surely aware of the prominent place landscape painting held in the Northern European tradition. But unlike seventeenth-century Netherlandish scenes, which often maintain an elevated or God's-eye perspective to map the ways in which the Dutch industriously worked their land or quietly marveled at its magnitude, the *L'empire des lumières* compositions eschew the possibility of claiming dominance over—or even knowledge of—our surroundings. For Magritte the landscape is contested territory. The cloud-filled sky and bourgeois buildings exist in uneasy juxtaposition, alongside day and night. These distinctions of space and time seem to be articulated through variations of light and its contingent effects. In Magritte's work, however, the world is never properly illuminated by the properties of light, and certainly never by one light source alone. The full force of Magritte's idea appears when we can see the paintings together, asserting their dominion in specificity and continuity.

3 René Magritte, *L'empire des lumières* (The Dominion of Light), 1964 or 1965. Oil on canvas, 19 ¾ x 28 ¾ in. (50 x 73 cm). Private collection

1 David Sylvester, ed., *René Magritte: Catalogue Raisonné*, vol. 3, *Oil Paintings, Objects and Bronzes, 1949–1967*, by Sarah Whitfield and Michael Raeburn (Houston: The Menil Foundation and Philip Wilson Publishers, 1993), 145. No more than three works from the series were exhibited together during Magritte's lifetime, and no more than two since his death, until their presentation in *René Magritte: The Fifth Season*.

2 Sylvester, 145 and 157.

3 The Menils eventually bought three *L'empire des lumières* oil paintings—one for The Museum of Modern Art (MoMA), New York; one for their son; and one for their own collection. Sylvester, 157, 200, and 236.

4 René Magritte, television broadcast, June 13, 1956, quoted in Sylvester, 145.

5 Letter from René Magritte to Marcel Mariën, July 27, 1952, quoted in Sylvester, 200.

6 Sylvester, 145. This inconsistency continues: the Menil Collection, Houston, translates the title as "Domain of Light," but the Solomon R. Guggenheim Foundation and MoMA both call their paintings on this theme "Empire of Light." When Magritte quoted from *L'empire des lumières* in *Le domaine enchanté* (The Enchanted Domain) (1953, see plate 44), the mural he installed in the ballroom of the Grande Casino Knokke, Belgium, Colinet described the scene as simultaneously depicting "two different moments of a day in human life." Souvenir booklet, "Le domaine enchanté de René Magritte" (1953), quoted in Sylvester, 210. It seems doubtful that Magritte would have appreciated the direct connection to human life that Colinet refers to. For more on *Le domaine enchanté*, see pages 24–25 of Caitlin Haskell, "The Fifth Season," in this publication.

7 René Magritte, response to MoMA questionnaire, January 1951, quoted in Sylvester, *René Magritte: Catalogue Raisonné*, vol. 3, 157. Magritte wrote that the second version of *L'empire des lumières* offers "a possibility of giving more strength to the spectator's vision . . . particularly because of the ideas of night and day which are present in this picture."

8 When two versions of *L'empire des lumières* were shown in Magritte's first U.S. retrospective, held at the Dallas Museum for Contemporary Arts (now Dallas Museum of Art) in 1960–61, this connection was made explicit: the galleries were sprinkled with black poles adorned with Styrofoam heads topped with bowler hats.

9 This has been demonstrated by Katrina Rush and Brad Epley, conservators at the Menil Collection. For more on this subject, see pages 66–67 of Katrina Rush, "'The Act of Painting Is Hidden': The Materials and Technique of René Magritte," in this publication.

10 Widely publicized, the Biennale was seen by 176,796 visitors. "La Biennale di Venezia," October 17, 1954, Alfred H. Barr, Jr. Papers [AAA 2198;1290], MoMA Archives, NY. This document goes on to state: "More than 300 foreign and Italian newspapers have dedicated articles to the Biennale, without counting those published or in print in reviews and magazines." It also notes that among the four thousand works on display, Magritte's painting was one of 422 works sold and one of 133 works sold by a non-Italian artist. The Biennale took a 15 percent commission on all works sold. "XXVII Esposizione Biennale Internazionale D'Arte 1954 Regulations," 1954, AHB [AAA 2198;1340], MoMA Archives, NY.

11 Sylvester, *René Magritte: Catalogue Raisonné*, vol. 3, 55 and 228. The artist originally promised the painting to the Museés royaux des Beaux-Arts de Belgique, Brussels; Belgian collector Willy Van Hove; and Magritte's longtime dealer Alexander Iolas, with whom he was frustrated because of unpaid debts.

12 The top painting prize was awarded to Max Ernst. Despite advance notice of the theme, the U.S. pavilion, which was purchased by MoMA, did not exhibit work by surrealist artists and instead focused on pieces by Ben Shahn and Willem de Kooning. Rodolfo Palluchini, in his role as general secretary of the Biennale, had suggested Yves Tanguy, Eugene Berman, and Max Weber as possible artists whose work would exemplify the surrealist motif. Letter from Rodolfo Palluchini to René d'Harnoncourt, February 11, 1954, AHB [AAA 2198;1347], MoMA Archives, NY.

13 Magritte's friend E. L. T. Mesens had recommended that the painting go to Guggenheim in part, it seems, because it was he who had encouraged her interest in it. Following up on the outcome of the "Iolas-Biennale-Peggy Guggenheim affair," Mesens wrote Magritte that he had told Guggenheim the artist's work was "inadequately represented in her very considerable collection" and that she then swiftly took action to rectify the situation. Letter from E. L. T. Mesens to René Magritte, December 7, 1954, quoted in Sylvester, *René Magritte: Catalogue Raisonné*, vol. 3, 55–56.

14 Peggy Guggenheim Collection, "Peggy Guggenheim," accessed July 19, 2017, http://www.guggenheim -venice.it/inglese/museum/peggy.html. In 1953 Guggenheim "renewed her offer" to purchase the U.S. pavilion for her own use. Memo from Porter McCray to René d'Harnoncourt, September 29, 1953, AHB [AAA 2198;1348], MoMA Archives, NY. Instead MoMA bought the pavilion a few months later, continuing the anomaly of the United States' participation with the only privately run pavilion (of more than twenty) in the exhibition. MoMA press release, March 29, 1954, MoMA Archives, NY. Eventually, in 1986, the Peggy Guggenheim Collection

Advisory Board supplied funds for the Solomon R. Guggenheim Foundation to purchase the pavilion: "Since 1986 the Peggy Guggenheim Collection has worked with the United States Information Agency (USIA), the US Department of State and the Fund for Artists at International Festivals and Exhibitions in the organization of the visual arts exhibitions at the US Pavilion, while the Solomon R. Guggenheim Foundation has organized the comparable shows at the Architecture Biennales." Peggy Guggenheim Collection, "US Pavilion," accessed April 20, 2017, http://www.guggenheim-venice.it/inglese/pavilion /index.php.

15 Letter from René Magritte to Alexander Iolas, January 9, 1956, quoted in Sylvester, *René Magritte: Catalogue Raisonné*, vol. 3, 63. *L'empire des lumières* (1948/1962), according to its owners, was begun in 1948 (though it was not finished until much later) and depicted Magritte's apartment at rue Esseghem, Jette-Brussels, where he lived prior to moving to boulevard Lambermont. Sylvester, 368.

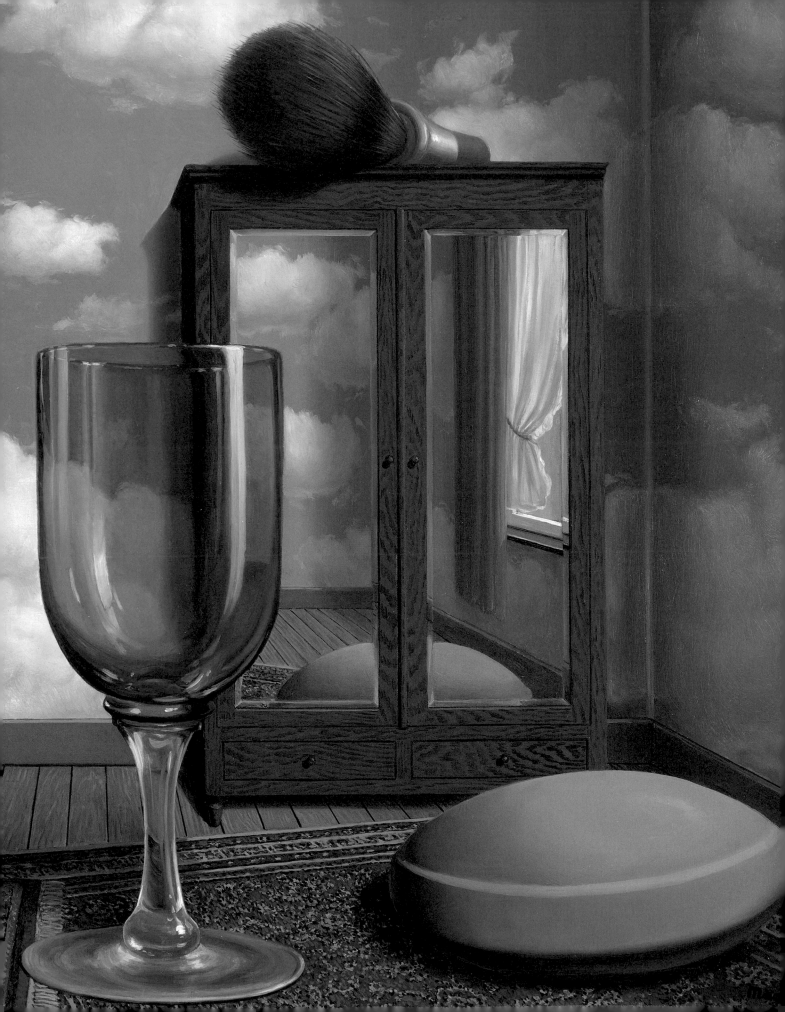

The Hypertrophy of Objects

CLARE
ELLIOTT

AS MUCH AS A PAINTER, RENÉ MAGRITTE MAY BE
CONSIDERED A KIND OF PHILOSOPHER—one who
cultivated and communicated complex ideas through images
rather than words. By presenting recognizable objects, or,
more accurately, representations of objects, in irrational
circumstances, he asks viewers to reconsider the familiar,
unveiling the latent strangeness in "everyday experience,
hampered as it is by religious, secular, or military morality."[1]
In this pursuit, after a concentrated period of experimentation
with impressionist and expressionist styles, Magritte
returned to a quasi-academic painting technique. Carefully
chosen to deflect attention from itself, it allowed him to
present his attacks on received wisdom in a reassuringly
unoriginal manner. Thus his return did not signal retreat,
as he continued his rigorous interrogation of the visible.
A series of seven paintings produced between 1952 and
1960, as well as a group of drawings (see figure 1), featuring
hypertrophied (overgrown) objects exemplifies this persistent
examination.[2] These works reveal an artist dedicated to the
ongoing viability of image making in a period dominated
by abstraction.

In 1952 Magritte completed *Les valeurs personnelles*
(Personal Values) (plate 20), a scene unlike any of his many
previous interiors. A group of banal but greatly magnified
objects—a comb, a match, a stemmed glass, a shaving
brush, and a round bar of soap—are arranged in a bourgeois
bedroom alongside typical furnishings—a bed, a wardrobe,
and rugs—rendered in proportion to the room itself.
The floor and the ceiling conform to viewers' expectations:
the baseboards and crown molding are described with
extreme precision, as are the cracks in the roof's plaster.
The walls, by contrast, defy reality, as they resemble not
drywall and paint or wallpaper, but an azure sky resplendent

with billowing white clouds. Mirrors reflect the rest of
the room, including a window and the continuation of the
cloudy sky on the remaining walls.

With the exception of the glass, *Les valeurs personnelles*
strays from Magritte's familiar iconography—his bilboquets,
tubas, sleigh bells, and, famously, pipes. The canvas's
enlarged, mass-produced items are rare among the artist's
imagery or even unique to the scene. They are used to
perform the unremarkable domestic rituals of a bourgeois
society: the comb to straighten one's hair, the brush and
soap with which to shave, the glass from which to drink,
and the match to light one's pipe. All serve the purpose of
either grooming to prepare oneself for the day's labor or
relaxing to renew oneself for tomorrow's. Originally called
Le champ libre (The Clear Field), the work was renamed
Les valeurs personnelles by Magritte's close friend, the poet
Paul Nougé. This title highlights the normally overlooked
essence of the objects—in the sense that they are employed
upon one's person, they are *personal*; in the sense that
they are useful to the worker and thus to capitalism, they
have *value*. As Magritte explained to Alexander Iolas, his
dealer in New York, "The individual in society needs a set
of ideas thanks to which a comb, for instance, becomes
a *symbol* allowing a certain combination of events, in

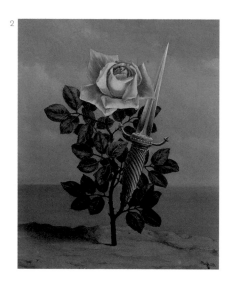

which he, the individual, manages to act within society by behaving in a manner comprehensible to society: a comb is for combing hair, it is manufactured, sold, etc. . . . In my picture, the comb (and the other objects as well) has specifically lost its 'social character,' it has become an object of useless luxury."[3]

Was Magritte creating a sly capitalist critique as Europe recovered from the turmoil of two World Wars, the Great Depression, and the Holocaust, and as consumer culture swelled, buoyed by pent-up demand and a newly weaponized advertising industry?[4] A 1950 note to the Communist Party amplifies this reading of the work, revealing more of Magritte's preoccupation with utility and luxury: "The communist painter justifies his artistic activity by creating pictures that are an intellectual luxury, a luxury for a communist society, differing—it goes without saying—from the useless, ostentatious and bad-taste luxury of the present exploitative classes."[5] Characteristically enigmatic, Magritte communicated his position not with a sentimental idealiza-tion of the proletariat but with a discreet representation of the absurdity of the bourgeoisie. What's more, he did so with a highly refined and carefully detailed realistic image at a time when abstraction had been all but declared the ultimate style of meaningful painting.

Magritte's subtle rebuke of bourgeois values and art returned in *Le tombeau des lutteurs* (The Tomb of the Wrestlers) (1960, plate 24).[6] This and the rest of the hypertrophy works—*L'anniversaire* (The Anniversary) (1959, plate 23) and several titled *La chambre d'écoute* (The Listening Room) (see plates 21–22)[7]—differ from *Les valeurs personnelles* in marked ways. Their subjects—a rose, a rock, and an apple—come from nature rather than the manufactured world and consistently occupied Magritte's postwar production (see figure 2 and plate 31, plates 64–69, and plate 33). More importantly, they simplify the composition to single objects, enlarged to even more extreme sizes. The final hypertrophy picture, *Le tombeau des lutteurs* was inspired by Harry Torczyner, a Belgian-born, New York–based attorney and one of Magritte's most important collectors. Following a trip to the Union of Soviet Socialist Republics, Torczyner visited the artist, who asked if he had seen works of Russian Suprematism or Constructivism, two of the century's pioneering abstract movements.[8] Torczyner recalled, "Magritte . . . went on with a lively critique of the [abstract painters]: 'They paint white on white, and they believe that this is an achievement.' [See figure 3.] I remarked that one could perfectly well paint white on white, and achieve a result, figurative, surrealist and Magrittian and said 'from time to time you have filled a room with a green

1 René Magritte, *Les valeurs personnelles* (Personal Values), 1962. Crayon and graphite on paper, 8 ½ x 11 in. (20.6 x 27.9 cm). Lena and Gilbert Kaplan Collection

2 René Magritte, *Le coup au coeur* (The Blow to the Heart), 1952. Oil on canvas, 18 ⁵⁄₁₆ x 15 ¼ in. (46.5 x 38.7 cm). Private collection

apple, which puts one's teeth on edge. Why don't you paint for me a white rose in a white room, and a window with a view of a snow landscape?"[9]

Notably, Magritte altered Torczyner's suggestion, turning the rose and walls from white to red. He related the color to the hallmark of Soviet communism and described the picture as "very 'left wing,'"[10] but he was also amusingly convinced that the dominance of the color could mislead some viewers into appreciating the work as they might an abstract or color field painting: "It seems to me that given the spirit (or lack of same) prevailing in the 'responsible' circles, that picture might have some chance of being appreciated, albeit for the wrong reasons. In effect, with the requisite lack of vision it could be taken for a painting in the 'abstract,' 'tachist' or whatever mode. The importance of the red color will obviously inspire interest, like the thud of a bass drum, in the minds of those who admire the kind of painting that is presently fashionable."[11]

Indeed, as abstraction swept the art market and the critics' attention, Magritte deliberately remained removed from the unrestrained action painting on display in popular and fine arts magazines.[12] His practice was in many ways narrowly contained: Geographically, he lived nearly his entire life

in Brussels—thoroughly detached from New York, the birthplace of Abstract Expressionism and an undisputed center of cultural production by the 1950s. Physically, he famously kept no studio and confined himself to painting in his apartment. This reverberates through the hypertrophy works that followed *Les valeurs personnelles*, which evoke not only the unease of trying to reconcile two competing systems of proportion and scale, but also the uncanniness of the unseen and intense claustrophobia. However implausible it may seem, viewers can imagine entering the bedroom in *Les valeurs personnelles*. The comb and brush are pushed to the back of the scene; although radically out of proportion, the match is too slender to obstruct much of the room; and if anything were behind the soap, we would be able to see it in the mirror. Finally, we can see through the drinking glass, the most central object. The uselessly huge items are thus arranged so as not to obscure the room's detail. In contrast, if a door, fireplace, or second window exists in any of the later canvases, we cannot know. Any means of escape or relief from the pressure of the overbearing object is hidden from our view. Especially in those titled *La chambre d'écoute*, the only motif among the hypertrophy series that Magritte chose to repeat, the sheer volume of the apple pushing against the walls and ceiling and into our space completely prevents any such possibility, resulting in a

3 Kazimir Malevich, *Suprematist Composition: White on White*, 1918. Oil on canvas, 31 ¼ x 31 ¼ in. (79.4 x 79.4 cm). The Museum of Modern Art, New York

suffocating sense of confinement. We may respond to
these compositions the way Iolas responded to *Les valeurs
personnelles*: "It is a picture . . . the colors of which (the
bedroom, the walls, the shaving gear and the glass) make
me feel sick, I am so depressed that I cannot yet get used to
it. It may be a masterpiece, but every time I look at it I feel
ill. . . . It leaves me helpless, it puzzles me, it makes me
feel confused and I don't know if I like it."[13]

For Magritte, the artist-philosopher, this visceral reaction
proves that the painting succeeds. He replied to Iolas,
"A picture which is really alive should make the spectator
feel ill, and if the spectators aren't ill, it is because 1) they
are too insensitive, 2) they have got used to this uneasy
feeling, which they take to be pleasure. . . . Contact with
reality (not the symbolic reality which allows social
exchanges and social violence) always produces this
feeling."[14] In the hypertrophy series Magritte continued
to challenge the notion that seeing is believing, presenting
seemingly plausible images of inconceivable scenarios.
While a younger generation of artists sought freedom
from bourgeois values through formal innovation—which
was quickly embraced by powerful art critics and the
popular press—Magritte redoubled his efforts to use the
appearance of reality to call into question "all the absurd
intellectual habits" that we typically take for granted.[15]
If the standard systems for measuring objects are insistently
violated, any number of the structures by which we make
sense of our world fall apart.

1 René Magritte, "Life Line" (1938), in *René Magritte: Selected Writings*, ed. Kathleen Rooney and Eric Plattner, trans. Jo Levy (Minneapolis: University of Minnesota Press, 2016), 59. See also Didier Ottinger, "Ut pictora philosophia: Portrait of Magritte as a Philosopher," in *Magritte: The Treachery of Images*, ed. Didier Ottinger, trans. David Wharry (Paris: Éditions du Centre Pompidou, 2016), 15–27.

2 While much of the literature on Magritte refers to the objects in these works as "magnified" or "inflated," the word *hypertrophied* is frequently used by Belgian scholars and carries a sense of both size and malignancy. As a medical term, it gains particular traction with organic subjects like the apple or rose, which threaten the room as they swell, just as hypertrophied organs or limbs threaten the body. Magritte, of course, used disjunctions in scale throughout his career to produce surreal effects.

3 Letter from René Magritte to Alexander Iolas, October 24, 1952, quoted in David Sylvester, ed., *René Magritte: Catalogue Raisonné*, vol. 3, *Oil Paintings, Objects and Bronzes, 1949–1967*, by Sarah Whitfield and Michael Raeburn (Houston: The Menil Foundation and Philip Wilson Publishers, 1993), 192.

4 See also Sandra Zalman, "Secret Agency: Magritte at MoMA in the 1960s," *Art Journal* 71, no. 2 (Summer 2012): 100–113.

5 René Magritte, "Note to the Communist Party" (1950), in Rooney and Plattner, *René Magritte: Selected Writings*, 133.

6 Magritte took the title from the novel *Ompdrailles, le tombeau-des-lutteurs* (Ompdrailles, the Tomb of the Wrestlers) (1879) by Léon Cladel, which he claimed to have read and forgotten. Magritte's reference to this novel suggests both the common association of red roses with romance and love and another, separate narrative replete with powerful allusions to death and drama, yet there is no logical connection between the image and its title. See Ben Stoltzfus, "Cladel, and *The Tomb of the Wrestlers*: Roses, Daggers, and Love in Interarts Discourse," in *Magritte and Literature: Elective Affinities* (Leuven, Belgium: Leuven University Press, 2013), 133–49.

7 Magritte completed four versions of *La chambre d'écoute*, all with variations among the details. The first (plate 21) was finished in 1952 and sold to John and Dominique de Menil. A larger version was completed the following year, at Iolas's request, and sold to artist and collector William Copley. Copley and his wife, Noma, commissioned another version of the painting for Noma's parents in 1958 (plate 22); the fourth version is thought to have been completed around the same time. Sylvester, *René Magritte: Catalogue Raisonné*, vol. 3, 198–99, 224, and 291; and *La chambre d'écoute* invoice, Object File 91-53, Menil Archives, Houston.

8 In Torczyner's account, Magritte asked if he had seen any "tachist" works, which Torczyner recalled as being Magritte's catchall designation for abstract art. That Magritte was referring to an earlier generation of abstract artists is clear from his specific reference to Malevich's 1918 suprematist canvas.

9 Harry Torczyner, unpublished manuscript, September 26, 1985, quoted in Sylvester, *René Magritte: Catalogue Raisonné*, vol. 3, 326.

10 Letter from René Magritte to Harry Torczyner, June 30, 1960, quoted in Sylvester, 326.

11 Letter from René Magritte to Harry Torczyner, August 25, 1963, in *Magritte/Torczyner: Letters Between Friends*, trans. Richard Miller (New York: Harry N. Abrams, 1994), 87.

12 For example, [Dorothy Sieberling], "Jackson Pollock: Is he the greatest living painter in the United States?" *Life*, August 8, 1949, 42–45, includes photographs by Martha Holmes and Arnold Newman of Jackson Pollock, his abstract expressionist paintings, and the artist at work in his studio. Photographs by Hans Namuth of Pollock working also appear in Robert Goodnough, "Pollock Paints a Picture," *Art News* 50, no. 3 (May 1951): 38–39.

13 Letter from Alexander Iolas to René Magritte, October 15, 1952, quoted in Sylvester, *René Magritte: Catalogue Raisonné*, vol. 3, 192. Contrary to Iolas's assertion that *Les valeurs personnelles* was painted hastily, Katrina Rush's essay in this publication addresses the laborious rendering of its elements. See pages 64–65 of Rush, "'The Act of Painting Is Hidden': The Materials and Technique of René Magritte."

14 Magritte to Iolas, 192.

15 Magritte, "Life Line," 64.

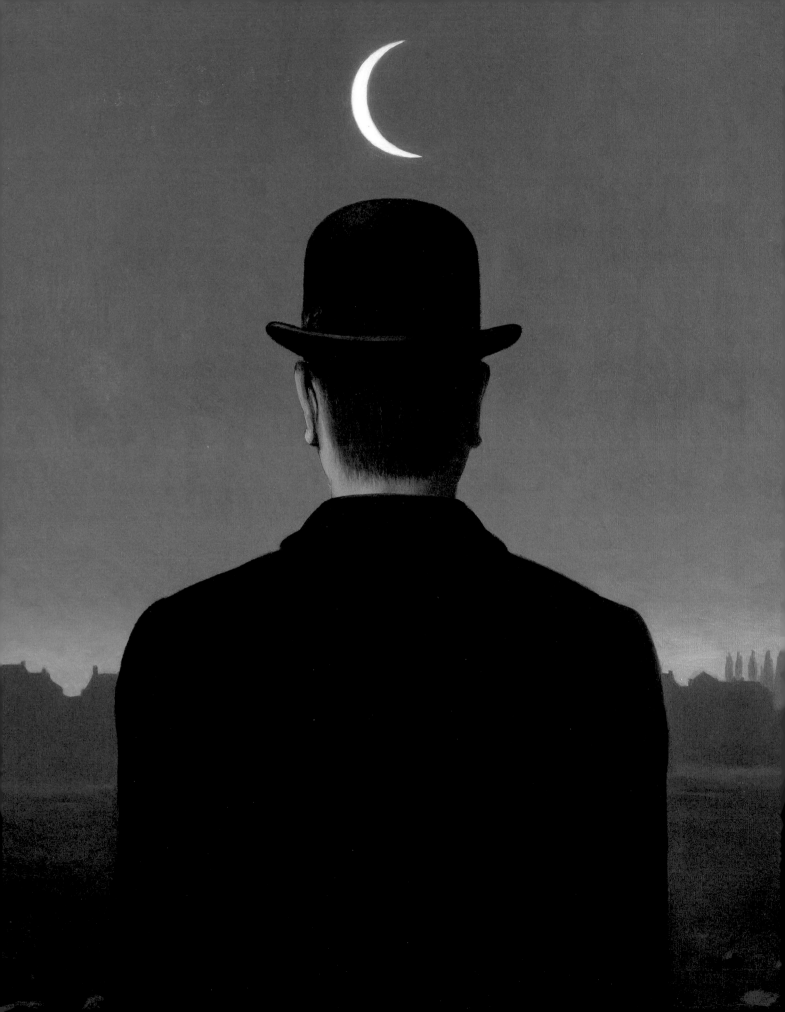

Self-Portrait as Anonymous Artist

CAITLIN
HASKELL

THE BOWLER HAT, KNOWN IN FRENCH AS *CHAPEAU MELON*, IS SO CLOSELY ASSOCIATED WITH RENÉ MAGRITTE that it may come as a surprise to note that the bowler-hatted man did not always appear as an identifiable, regularly recurring motif in his oeuvre. He painted the theme in its classic forms—a single or doubled figure facing forward or backward—no fewer than thirty-six times in oil and seventeen times in gouache between 1926 and 1966 (see plates 31–39). If we include variations such as those seen in *Golconde* (Golconda) (1955, plate 40), the tally increases by an additional dozen pictures.[1] Yet even though the character originated in Magritte's early career, all but a few of the paintings with this imagery were made in the 1950s and 1960s. It was only in these final years of the artist's life that the bowler figure came to be understood as an alter ego and even, at times, a self-portrait.[2]

The process by which the bowler man passed from anonymous, generic male figure to stand-in for a painter with a distinctly anonymous style is worthy of attention. It deserves consideration not only because Magritte was an artist consumed by the mechanisms and capriciousness of signification, but especially because it helps to reveal how he affected the interpretation of his works after they were done, shifting their public understanding long after the paint was dry and the easel and brushes had been put away.

When Magritte first painted a man in a bowler, in *Les rêveries du promeneur solitaire* (The Musings of a Solitary Wanderer) (1926, figure 1), there was no suggestion that the back-turned figure in the black topcoat was in any sense a proxy for the artist.[3] Likewise, when two similar types appeared the following year in *L'assassin menacé* (The Murderer Threatened), this time facing the viewer, there

was no reason to think that they might represent Magritte himself. As numerous scholars and critics have pointed out, the ready association for audiences would have been with actors and characters in contemporary films, such as Charlie Chaplin and Fantômas.[4] It is equally unexpected that the bowler man would come to be understood as Magritte's surrogate when considered in light of his confirmed self-portraits. While these are relatively few, in the best-known examples from his surrealist years, *Tentative de l'impossible* (Attempting the Impossible) (1928, figure 2) and *La clairvoyance* (Clairvoyance) (1936, figure 3), Magritte resembles the bowler man very little.[5] In neither of these pictures does he wear a hat, and in both he holds a palette and brush. Notably, they are constructed around the dramatic moment of applying a stroke of paint, demonstrating that the image of the working artist, however fantastically construed, was key to his self-presentation. By contrast, the most "painterly" action by a bowler man appears in *La cinquième saison* (The Fifth Season) (1943, plate 19), where two such figures hold framed pictures under their arms. Despite the potential for a meta-artistic reading of the scene, Magritte's first published description of it downplays this suggestion by failing to identify the men in any specificity. According to this early discussion of the work, they might be collectors, dealers, or simply porters.[6]

René Magritte, *Le maître d'école* (The Schoolmaster), 1955 (detail, plate 32)

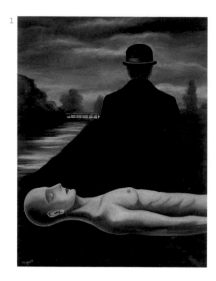

Magritte's long-time dealer Alexander Iolas was likely the first to associate the artist with his bowler men. More than once Iolas described the figure in *La boîte de Pandore* (Pandora's Box) (1951, plate 31) as "your portrait in a Brussels street."[7] He also referred to *Le chant des sirènes* (The Sirens' Song) (1952), which includes another backward-facing bowler man, as "your portrait."[8] Prior to these identifications, the type seemed to bear no more than a passing resemblance to Magritte. As many have noted, both the painter and these figures were of "average height and build . . . conservatively dressed in dark clothes, neatly collared and tied," and, above all, were likely to go "unnoticed in a crowd."[9] While there is no question that Iolas was in regular communication with Magritte and was in a position to know his thoughts about these works, the dealer's comments stress a specific reading of the pictures that, to this point, the artist had left open-ended. But Magritte would soon make anonymity a defining feature both of his painted bowler men and of his own public presentation. Moving forward, these "blank" figures—nondescript in precisely a way that would allow for the projection of anyone's selfhood—would unmistakably become emblems of Magritte.

The connection between and near assimilation of Magritte and the bowler-hatted man were not merely the result of the

figure's frequent appearance in the artist's late paintings. Indeed, he worked energetically during the 1960s to ensure this equivalence, particularly when he found himself before the camera (see figure 4).[10] In examining how this motif became tied to Magritte's public persona, it is helpful to consider his shifting thoughts about his professionalism and what it meant to be an artist in the postwar era.

Those who spent time with Magritte have said that he had a "desire to live without history (even his own) and without style . . . to render himself invisible."[11] As the bowler-hat type evolved, the artist developed new ways for it, too, to skirt detection. After becoming regularized in the 1950s, when the broad landscape of *La boîte de Pandore* was cropped closely to the figure, variations on the theme could be placed along a spectrum of presence and absence. In some instances the form has a robust corporeality and volume; in others, such as *La belle société* (High Society) (1965–66, plate 37), it feels entirely flat. Around this time Magritte also explored a hollow silhouette that makes the motif's propensity for invisibility fully manifest. First in *L'ami de l'ordre* (The Upholder of the Law) (1964, plate 34) and later in *L'heureux donateur* (The Happy Donor) (1966, plate 38), a bowler man–shaped aperture allows the familiar contours of the figure to assume the dimensions of the

1 René Magritte, *Les rêveries du promeneur solitaire* (The Musings of a Solitary Wanderer), 1926. Oil on canvas, 54 ¾ x 41 ⁵⁄₁₆ in. (139 x 105 cm). Private collection

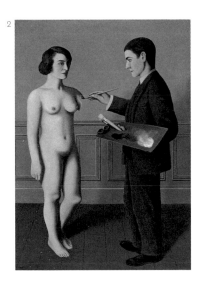

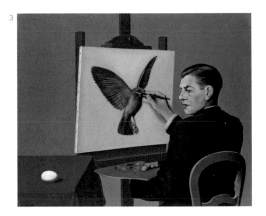

canvas, framing a view onto a different scene like a variation of his paintings of pictures within pictures. Among their other traits, these examples literalize the bowler man's tendency to disappear within a crowd.

Magritte has aptly been described as "The Master of the Bowler Hat."[12] This phrase is an especially happy one because, more than just pointing out a preoccupation of the painter's late career, it uses the nomenclature of art historical anonymity. If the names of many medieval and Renaissance masters are lost to us due to a lack of archival documentation, Magritte made himself anonymous by playing the bookkeeper, the bourgeois cipher. Here is Magritte himself in 1966: "The bowler . . . poses no surprise. It is a headdress that is not original. The man with the bowler is just middle-class man in his anonymity. And I wear it. I am not eager to singularize myself."[13]

Why was anonymity a useful tool for Magritte in his work of the 1950s and 1960s? It offered, I would suggest, an effective means of destabilizing his audience by challenging the typical patterns of engagement for artist and viewer. No one would dispute that originality and subjectivity were central to the tradition of modern painting that Magritte entered into. But by the end of his career, artists one or two

generations younger, from Jasper Johns to Vija Celmins, were in search of alternatives to modernism's most prevalent creative tropes.[14] Magritte's particular refusal to conform to type was productive not only because it offered an affectless model of painting but also because it placed a different set of demands on audiences. By shedding any claim to individuality and thus subjectivity, Magritte declined to present himself as a motivating force behind his images. In the face of this soft "death of the author," a viewer cannot alleviate the mystery of a confounding picture by tracing it back to a unique maker who supplied its origin. Try to use me as an interpretive key, Magritte seems to say, and you will be led to an empty place, a hollow source.

The curious possibility that a painting of a generic figure might become a portrait after the fact defies any logic of meaning-making in which artistic intention is primary. But it was hardly foreign to Magritte. As early as 1943 he was quoted by his friend and fellow Surrealist Louis Scutenaire: "It can happen that a portrait tries to resemble its model. However, one can hope that this model will try to resemble its portrait."[15] By the 1960s Magritte had facilitated just this sort of reversal—and he achieved something else as well. In the same way the poet Paul Colinet could refer to the imagery of *La clairvoyance* as "two different forms of

2 René Magritte, *Tentative de l'impossible* (Attempting the Impossible), 1928. Oil on canvas, 45 11/16 x 31 7/8 in. (116 x 81 cm). Private collection

3 René Magritte, *La clairvoyance* (Clairvoyance), 1936. Oil on canvas, 21 1/4 x 25 9/16 in. (54 x 65 cm). Private collection

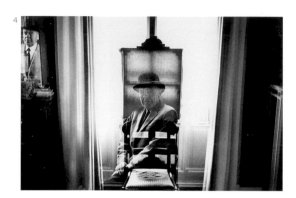

the same bird," Magritte's self-portraits of the 1920s and
bowler-hat figures of the postwar period show two different
sides of the same artist.[16] Whether posing for the camera or
serving as the eponymous patron in *L'heureux donateur*,
Magritte was acutely attuned to what happened with his
pictures after the painting was done. He fashioned himself
an anonymous artist in the studio, and then, reversing the
mirror, he made himself a model of anonymity.

4 Duane Michals, *René Magritte*, 1965. Gelatin silver print, 4 ¾ x 7 ⅛ in. (12 x 18.1 cm).
San Francisco Museum of Modern Art, gift of Van Deren Coke

1 For essential aid in research I thank Alex Zivkovic. A complete census of the bowler figures would also include their appearances on painted bottles and in collage, as well as the use of the hat as a sculptural object.

2 For more on the bowler-hatted man as Magritte's alter ego, see Sandra Zalman, "Secret Agency: Magritte at MoMA in the 1960s," *Art Journal* 71, no. 2 (Summer 2012): 100–113; Sandra Zalman, "Pipe Dreams: In Search of an Allegorical Magritte," in *Gravity in Art: Essays on Weight and Weightlessness in Painting, Sculpture and Photography*, ed. Mary D. Edwards and Elizabeth Bailey (Jefferson, NC: Mcfarland and Company, 2012), 243–52; and Suzi Gablik, "The Bowler-Hatted Man," in *Magritte* (New York: Thames and Hudson, 1985), 154–72. Magritte's 1964 painting *Le fils de l'homme* (The Son of Man) (plate 33) features a bowler man intended as a self-portrait, while the figure in the 1966 canvas *L'heureux donateur* (The Happy Donor) (plate 38) reads as such when one learns that Magritte himself donated the work to the Musée d'Ixelles, Brussels.

3 While few dispute the anonymity of the figure, art critic and curator David Sylvester suggests that the setting may be a "conscious or unconscious" reference to the landscape near Magritte's childhood home. David Sylvester, ed., *René Magritte: Catalogue Raisonné*, vol. 1, *Oil Paintings, 1916–1930*, by David Sylvester and Sarah Whitfield (Houston: The Menil Foundation and Philip Wilson Publishers, 1992), 198.

4 On cinematic references latent in the bowler image, see, for example, Anne Umland, "'This Is How Marvels Begin': Brussels, 1926–1927," in *Magritte: The Mystery of the Ordinary, 1926–1938*, ed. Anne Umland (New York: The Museum of Modern Art, 2013), 32–35; and Peter Wollen, "Magritte and the Bowler Hat," in *Paris Manhattan: Writings on Art* (London and New York: Verso, 2004), 133–35.

5 Five self-portraits have been identified in oil and two in gouache. The oil paintings are *Tentative de l'impossible, La clairvoyance, La lampe philosophique* (The Philosopher's Lamp) (1936), *Le sorcier* (The Magician) (1951), and *Le fils de l'homme*. The gouaches are *La lampe philosophique* (The Philosopher's Lamp) (1936) and *La maison de verre* (The Glass House) (1939).

6 "In a street, a man who carries a picture of the sky under his arm meets a man who carries a picture of the forest under his arm." René Magritte, *Dix tableaux de Magritte, précédés de descriptions* (Brussels: Le miroir infidèle, 1946), n.p. My translation.

7 Alexander Iolas, quoted in David Sylvester, ed., *René Magritte: Catalogue Raisonné*, vol. 3, *Oil Paintings, Objects and Bronzes, 1949–1967*, by Sarah Whitfield and Michael Raeburn (Houston: The Menil Foundation and Philip Wilson Publishers, 1993), 190.

8 Alexander Iolas, quoted in Sylvester, 198. It has been noted that the phrase "your portrait" does not necessarily indicate that Iolas viewed these as self-portraits. Yet, since both figures are turned with their faces out of view, any inclination to describe them as portraits, rather than simply as pictures of men, points to an understanding that each was, in some sense, a painting of a particular individual, and most intuitively Magritte. On *La boîte de Pandore*: "There is no indication that Magritte regarded it as a self-portrait." Sylvester, 190.

9 Patrick Waldberg, *Magritte: Peintures* (Paris: L'autre musée/La différence, 1983), 17, quoted in Stephanie Barron, "Enigma: The Problem(s) of René Magritte," in *Magritte and Contemporary Art: The Treachery of Images*, ed. Stephanie Barron and Michel Draguet (Los Angeles: Los Angeles County Museum of Art, 2006), 25.

10 The work of Duane Michals, who published pictures of the artist including *René Magritte* (1965, figure 4) in "This Is Not Magritte," *Esquire* (February 1966): 100–103, and Steve Shapiro, who published photographs of Magritte wearing a bowler in "The Enigmatic Visions of René Magritte," *Life*, April 22, 1966, 113–19, is especially relevant in this regard. Magritte did not typically wear a bowler but developed a "habit of putting on a bowler hat to pose for the camera." David Sylvester, *Magritte*, 2nd ed. (Brussels: Mercatorfonds in association with the Menil Foundation, 2009), 15.

11 Gablik, "The Bowler-Hatted Man," 154. Consider as well Magritte's remark to Gablik: "I don't want to belong to my own time, or, for that matter, to any other." René Magritte, "Interview Suzi Gablik" (1967), in *René Magritte: Écrits complets*, ed. André Blavier (1979; repr., Paris: Flammarion, 2009), 645–46.

12 Wollen, "Magritte and the Bowler Hat," 128.

13 René Magritte, quoted in "The Enigmatic Visions of René Magritte," 117.

14 For a discussion of Magritte's influence on these generations of artists, see Barron and Draguet, *Magritte and Contemporary Art*.

15 René Magritte, quoted by Louis Scutenaire in *Magritte* (1943), in Harry Torczyner, *Magritte: Ideas and Images*, trans. Richard Miller (New York: Harry N. Abrams, 1977), 194.

16 Colinet wrote this to describe the second panel of Magritte's surrealist panorama *Le domaine enchanté* (The Enchanted Domain) (1953, see plate 44.II), which incorporates the egg and bird imagery of *La clairvoyance*. See pages 114–15 in this publication. Note that Magritte did not include a bowler figure in any panel of *Le domaine enchanté*.

"The Act of Painting Is Hidden": The Materials and Technique of René Magritte

KATRINA
RUSH

RENÉ MAGRITTE OFTEN ASSERTED THAT THE CONCEPT OF HIS WORK WAS PARAMOUNT—OR, MORE SIMPLY, THAT ONLY THE IMAGE COUNTED. He dismissed the notion that style or formal qualities were significant to his oeuvre, attesting publicly to how he would "always try to make sure that the actual painting isn't noticed, that it is as little visible as possible."[1] Scholars and art historians have typically followed suit, as most have restricted their discussions of his later pictures, in particular, to his iconography.

But just as Magritte's paintings of canvases in front of windows such as *La condition humaine* (The Human Condition) (1933, plate 14) and *Les promenades d'Euclide* (Where Euclid Walked) (1955, plate 15) might cause us to question what lies behind a picture, so too must we question what lies behind the material construction of Magritte's images.[2] Conservation treatments and analysis have shown that despite the artist's claims to the contrary, his works exhibit a distinct interest in the physicality of paint and the process of painting.[3] In fact, Magritte explored technique and media to a much greater extent and to greater effect than is currently reflected in the scholarly record. In-depth study confirms that his later pictures, although less materially experimental than those of the 1920s and 1930s, are markedly varied in style and execution.[4] Numerous examples demonstrate Magritte's keen attention not only to artistic process, the application of paint, and other tools of the trade but also to the unique impact of these formal qualities on the viewer's experience of his work.

Composition and Media

In 1927 Magritte painted *Le sens de la nuit* (The Meaning of Night) (figure 1), one of the first depictions of his bowler-hatted man.[5] This work exemplifies a number of the artist's recurrent methods and material interests. As tended to be his practice, he began with a commercially pre-primed canvas.[6] He sketched the composition in pencil and then completed the sky and sea with a mixture that included ultramarine blue and indigo, leaving unpainted reserves for the figures.[7] Details in the water and overall landscape were added next, followed by the weighted clouds and, finally, the dark-suited men. The latter deviated from the initial drawing, as Magritte reworked the pants, coats, and bowler hats as he went.[8] In both earlier and later pictures it was not uncommon for the artist to diverge from a plan like this, modifying or, at times, entirely repainting canvases. Two of his more radical departures from preliminary compositions include *Le chant de l'orage* (The Song of the Storm) (1937), which he painted over another complete work,[9] and *Le grand style* (The Great Style) (1951, figure 2a), where examination with infrared reflectography has uncovered an initial drawing that Magritte abandoned altogether (figure 2b). Such changes show that his painting wasn't formulaic—he was considering and reconsidering his

compositions as they were executed, not merely putting predetermined images on canvas.

Le sens de la nuit also exemplifies Magritte's use of multiple media within a single work, a practice that he pursued more frequently than was previously thought.[10] While only five pictures, all made before 1927, are cataloged as containing the commercially manufactured house paint Ripolin along with traditional oils, new analysis has revealed additional canvases with more than one type of paint.[11] In *Le sens de la nuit*, the glossy black lines that enhance the figures' hats and shoulders and the silky, fast-drying white that comprises the lace petticoat of the fur form's skirt are materially unlike other parts of the artwork, demonstrating Magritte's use of different media to achieve variations in sheen or intensity.[12] His interest in the appearance or handling of paint and his exploitation of material differences are also keenly apparent in several other early works, including *L'assassin menacé* (The Murderer Threatened) (1927), in which Magritte selectively varnished the shadows on three of the faces and traced the main figures' suits in glossy black;[13] *L'alphabet des révélations* (The Alphabet of Revelations) (1929), where he used multiple white paints and included exposed white ground as a central component of the image;[14] and *Le sens propre* (The Literal Meaning)

(1929), where the script was executed in a different black than that used throughout the rest of the artwork.[15]

These examples suggest that paint was not just paint for Magritte: he appears to have taken a careful, critical approach to selecting media with specific material properties or optical differences. Despite his own dissenting accounts,[16] Magritte was a painter of elemental substances (fire, water, stone, and sky), attentive to what he put down on canvas and how it was applied. He was also experimental, using widely available products to novel ends—especially nontraditional paints and varnish.

Juxtapositions of Style

Following a prolific early career, Magritte mostly turned away from experiments in media and focused on other methods of emphasis. Incited by the German occupation of Belgium during World War II, he began painting his impressionist-style "sunlit surrealist" canvases in 1943.[17] These light-filled pictures, such as *La préméditation* (Forethought) (1943, plate 1), are characterized by vibrant colors and enthusiastic brushwork. The luscious paint handling, though more subdued than that in most actual impressionist canvases, attests to an interest not just in

1 René Magritte, *Le sens de la nuit* (The Meaning of Night), 1927. Oil on canvas, 54 ½ x 41 ½ in. (138.4 x 105.4 cm). The Menil Collection, Houston

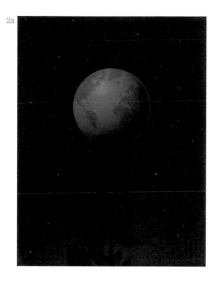

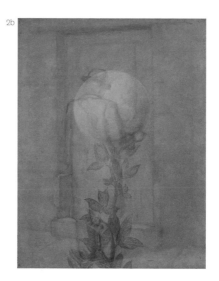

imagery but also in the physicality of painting. To the dismay of many, including his dealer Alexander Iolas; his wife, Georgette; and numerous friends, Magritte produced around seventy-five oils and thirty gouaches in this typically less lucrative manner over the next four years (see plates 1–7 and 19).[18] As cathartic as the expressive technique appears to have been for the artist, however, by 1945 he was shifting major passages of his compositions to a more refined style, combining, for example, impressionistic birds with his signature clouds in pictures such as *L'île au trésor* (Treasure Island) (1945).[19]

Such juxtapositions of style became common in Magritte's later work, where disparate painting techniques often emphasize and define distinct elements in a given canvas. In *Le monde invisible* (The Invisible World) (1954, plate 69), for instance, this approach serves to accentuate the presence and materiality of the large boulder against the darkened sky. The rock face consists of numerous short strokes in a seemingly random pattern, evoking a mottled and unevenly cut stone.[20] Magritte started with a middle gray tone and then added, wet into wet, other partially mixed paints: gray mixed with black, gray mixed with white, and gray mixed with blue, all applied before each combination was fully integrated on the palette, leaving streaks of pure color

visible within individual brushstrokes (see figure 3). Also intermingled are areas mixed with tan, brown, and even tiny amounts of green. As the rock was nearing completion, pure white, black, and green were incorporated to add highlights, form, and dimension.

The rest of the canvas is different. The shadow on the proper left of the boulder was painted with less variation: hurried applications of dark gray and black laid over black give the impression of a loss of detail, as one might expect when looking at something in shadow. The sky, like the rock, contains a labor of thousands of strokes mixed wet into wet with a relatively small brush; here, however, the vigorous mixing that occurred on the canvas yielded a more uniform color.[21] After that, the architectural forms were rendered flat, with little detail, lending them the feel of almost mass-produced illustration. The unembellished railing was sketched and then painted before the waves of the sea, which were incorporated between the rails in simple, horizontal blue lines. Finally, Magritte used elongated strokes of smooth brown for floorboards that have no wood grain.[22]

This use of multiple styles produces a visual balance and contrast between the architecture and the rock, accentuating the tangible materiality and reality of the textured stone

2a René Magritte, *Le grand style* (The Great Style), 1951. Oil on canvas, 31 ½ x 23 ⅝ in. (80 x 60 cm). The Menil Collection, Houston

2b Reflected infrared image of *Le grand style* showing an abandoned drawing of a bowler-hatted man at a door

face. Magritte achieved a similar but inverse effect in the 1952 canvas *La chambre d'écoute* (The Listening Room) (plate 21). There the detailed construction of the room—with its accurate perspective and the finely delineated wood grain in the floorboards, composed with successively applied, individual shades of brown—opposes the more generalized painting of the oversize central subject. This disparity in style serves to emphasize the scale of the apple, rather than allowing the viewer to get lost in a specific, well-rendered fruit. *La chambre d'écoute* and *Le monde invisible*, both depictions of natural objects in man-made settings, exemplify how Magritte used not only imagery but also paint handling to create a sense of disjuncture in his work.

Perspective, Scale, and Color

In addition to variations in media and style, Magritte relied on other formal qualities to achieve his desired effects. His mastery of the brush is particularly evident in the small series of oil paintings to which *La chambre d'écoute* belongs, where larger-than-life objects such as an apple (see also plate 22), a rock (plate 23), and a rose (plate 24) fill the spaces of rooms. These canvases, sometimes known as the hypertrophy works, elucidate a period in Magritte's oeuvre when close attention to perspective, scale, and color was not just important but essential to the success of his pictures.[23]

Several hypertrophy canvases benefited from a meticulous consideration of perspective. Infrared reflectography and transmitted infrared of *La chambre d'écoute*, for example, reveal a great degree of completion of the room prior to the painting of the apple (see figure 4): the crown molding extended horizontally across the composition, and a line of small notches mapped the placement of the floorboards beneath the fruit. This extrapolation of linear elements demonstrates that Magritte used one-point perspective while planning the artwork.[24] In *Les valeurs personnelles* (Personal Values) (1952, plate 20), Magritte labored to an even greater extent over the smallest perspectival details.[25] He began by drawing the room in pencil on a commercially pre-primed canvas, designating the positions of the walls, baseboard, crown molding, and armoire (see figure 5).[26] He also made a sketch of the bed, which was reduced in size during the painting process. Such careful attention to perspective propels the disruption of scale into stark relief; by contributing to the believability of the world of each hypertrophy work, these formal techniques enhance the absurdity of the imagery.

3 Detail of paint strokes on the boulder in René Magritte, *Le monde invisible* (The Invisible World), 1954 (plate 69)

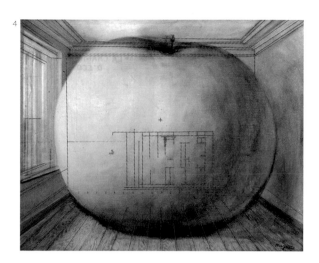

4

Magritte's attention to color is also not to be overlooked. In *Les valeurs personnelles* he used pure color to execute minute details—such as the bright yellow tip of the matchstick—or to support the varying styles employed for each object in the room. This is exemplified by the contrast of the short, pointillist strokes used for the tactile carpets and the long, smooth strokes used for the expertly painted glass. He layered hues to embellish elements such as the comb, applying a salmon color, brown overall, and finally a light brown and black for the tortoiseshell pattern. The last layer was painted while the previous layers were wet enough to yield soft edges at the interface, but not so wet as to cause the colors to become overly mixed. The drinking glass was composed by mixing shades of striking teal with others drawn from the surrounding room, and the image was perfected with carefully placed white highlights and black shadows.[27]

The palette of *Les valeurs personnelles* also has an impact in and of itself. Throughout the work Magritte applied his distinct colors with fine brushes to produce a polished finish. However, the juxtaposition of clouds and bright objects—perhaps inspired by his sunlit surrealist period—produces a startling, disjointed effect. Iolas told Magritte that the colors made him sick, to which the artist replied, "A picture which is really alive should make the spectator feel ill."[28] The visceral response provoked by his manipulation of color further illustrates Magritte's masterly exploitation of formal qualities and techniques.

A Path to Refined Painting

Throughout his career Magritte developed his techniques and ideas by repeating and elaborating on his more successful themes across multiple media, including oil and gouache. Works with these repeated themes are known as "variants."[29]

Gouache handles very differently than oil. Where oils can take weeks or months to fully dry, it can take mere moments for enough moisture from a stroke of gouache to wick into a paper support, allowing for successive applications of intense colors not dulled by mixing. This is why some artists use it as a preparatory material for oil paintings: it offers a means for developing ideas quickly. Magritte made gouaches consistently, including *Le survivant* (The Survivor) (1950, plate 27) and *Golconde* (Golconda) (1955, plate 40), which are variants of well-known works in oil. Many theorize that he took advantage of this more rapid approach to stave off boredom, while others speculate that his use of the medium could have been financially motivated: as gouaches are less expensive to produce than oil paintings, they are

4 Reflected infrared image of René Magritte, *La chambre d'écoute* (The Listening Room), 1952 (plate 21), annotated in red to emphasize underdrawing

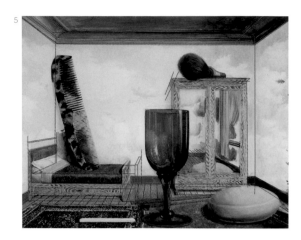

easier to create and sell in multiples.[30] Either way, scrutiny of these works gives additional insight into Magritte's practice. The artist often began a gouache by laying in a background of solid color, likely on wetted paper. He then built on top of this layer, usually sequentially—the quick drying time allowed individual strokes to remain visible, lending a more detailed, tangible appearance to various elements, such as individual blades of grass (see plate 5). This was a technique Magritte replicated in oil, employing it, for example, to render the intricate wood grain in works such as *La chambre d'écoute*.

Magritte's variants in oil are even more informative. For instance, there are seventeen known oil paintings titled *L'empire des lumières* (The Dominion of Light) (see plates 51–57). While they share the same title and much of the same imagery, they are not copies of one another, nor do they seem mechanical, as one might anticipate of copies. Each is different and, in most cases, contributes to the overall evolution of the theme. Together they exemplify many of the compositional processes and material concerns that spanned Magritte's career.[31]

In one *L'empire des lumières* variant made in 1954 (plate 54), the eleventh in the series, Magritte drew major components

of the composition in a dry medium such as pencil or charcoal before painting.[32] The preliminary sketch was modified in the final artwork; underdrawing visible in a detail of a reflected infrared image (figure 6) reveals that he ultimately shortened the lamppost and altered the shape of the globe. Transmitted infrared indicates two other notable changes. The first is that three stacked windows originally adorned the house in the background left. The topmost window is retained in the final image, though it is in deep shadow and barely observable. The lighted window below it also remains, but the bottom window has been completely obscured, with a fence post incorporated in its stead. The second change is in the shape of the third tall tree. Here Magritte used several daubs of thick white paint on the perimeter to cover a portion of the leaves, making the foliage symmetrical. These changes, while minor, indicate that the artist was considering the unique details of this composition during each step of the process. Had the general iconography been the only important element of the variants, such nuanced revisions would likely have been unnecessary.

This version of *L'empire des lumières* also speaks to Magritte's continued interest in the appearance of paint as such. On close inspection, it becomes apparent that the four tall trees were rendered with a black that is more matte than the rest

5 Reflected infrared image of René Magritte, *Les valeurs personnelles* (Personal Values), 1952 (plate 20), annotated in red to emphasize select underdrawing

of the much glossier foliage. This material difference was confirmed by examination of the canvas with ultraviolet radiation that revealed that the glossier layer contains a fluorescing component, such as varnish, while the four tall trees do not.[33] Of course, it is impossible to ascertain whether this subtle difference was for aesthetic purposes, to disrupt the homogeneity of the scene, or practical purposes, perhaps to saturate this portion of the work between stages of painting.[34] If the former is true, it would speak to Magritte's recurrent interest in the variation and use of black paint.[35] In either case, in an oeuvre where images are considered paramount, it is interesting to note that this discrepancy does not translate in a normal reproduction and can only truly be experienced by encountering the artwork in person.

A final aspect to consider when looking at Magritte's later pictures is the artist's ability to paint "just enough." His canvases, despite his great skill, are only selectively realistic. Close examination of his work teaches that Magritte has often given the viewer enough detail to convincingly convey an image but not always enough to create a scene that is true to life. Examples include the

landscapes in *La condition humaine* and *La clef de verre* (The Glass Key) (1959, plate 66). While seemingly exacting, they are not rendered with all the layers and nuances that would be present in a realist canvas or an actual landscape. These depictions are more atmospheric than precise, emphasizing the extent to which the artist's techniques subtly reinforce the connections between his images and ideas. As a result of this deliberate inconsistency and our own tendency to unconsciously fill in the gaps, sustained examination can cause our belief in his pictures to fall apart. Those who take the time to scrutinize may be surprised to see how little information Magritte has provided—his material renderings are supplemented by details *we* provide, which naturalize them by calling upon prior experience or habit. Perhaps this is part of what fostered the belief in Magritte's contemporaries that viewing reproductions was sufficient for appreciating his work.[36] Such a stance, while common, acknowledges only some of the genius of Magritte's vision. It denies important elements of his artistry, including his skillful manipulation of materials and technique, quiet but essential to the impact of his images.

6 Detail of a reflected infrared image of René Magritte, *L'empire des lumières* (The Dominion of Light), 1954 (plate 54)

1 René Magritte, quoted in Sarah Whitfield, *Magritte* (London: The South Bank Centre, 1992), 28. He continued: "So the act of painting is hidden [in my work]."

2 See pages 15–18 of Caitlin Haskell, "The Fifth Season," in this publication for consideration of *La condition humaine* as a work about concealment. X-radiography conducted at the National Gallery of Art, Washington, D.C., and infrared imaging described in a treatment record dated November 4, 1988, revealed a small house in the landscape that was later abandoned by the artist, suggesting what literally transpires behind the painting within the painting and beyond our view. I am grateful to the conservation department at the National Gallery of Art, and particularly Jay Krueger and Douglas Lachance, for providing the treatment records and x-radiography of the painting.

3 I am grateful to participants in the study day held at the Menil Collection, Houston, on April 21, 2017, for discussion of the concept that Magritte was engaged in painting in a way that he denied.

4 See Josef Helfenstein with Clare Elliott, "'A Lightning Flash Is Smoldering beneath the Bowler Hats': Paris, 1927–1930," in *Magritte: The Mystery of the Ordinary, 1926–1938*, ed. Anne Umland (New York: The Museum of Modern Art, 2013), 71–72. I am indebted to painting conservators Brad Epley, the Menil Collection; Michael Duffy, The Museum of Modern Art (MoMA), New York; and Allison Langley, the Art Institute of Chicago, for their observations and collaboration during our 2013–15 research, examination, and study of Magritte's early work.

5 For a more thorough reading of the imagery in this painting, see Anne Umland, "'This Is How Marvels Begin': Brussels, 1926–1927," in Umland, *Magritte: The Mystery of the Ordinary*, 30–31.

6 This was determined by objective observation of the ground layer and was supported by analysis results obtained from the Thread Count Automation Project. I am grateful to Don H. Johnson, Rice University, Houston, for examining the thread counts and other characteristics of Magritte's canvas supports by analysis of X-rays of the paintings. This study has allowed for the development of a small but growing database of thread maps for more than forty works by Magritte. For more information about thread counting, see D. H. Johnson, C. R. Johnson Jr., and E. Hendriks, "Automated Thread Counting," in *Van Gogh's Studio Practice*, ed. Marije Vellekoop, Muriel Geldof, Ella Hendriks, et al. (Amsterdam: Van Gogh Museum, 2013), 142–55. See also Don Johnson, C. Richard Johnson Jr., Andrew Klein, et al., "A Thread Counting Algorithm for Art Forensics," in *2009 IEEE 13th Digital Signal Processing Workshop and 5th IEEE Signal Processing Workshop Proceedings, Marco Island, Florida, January 4–7, 2009*, 679–84.

7 Examination of this painting and numerous others with infrared reflectography revealed Magritte's use of pencil underdrawing. The pigments were identified by analysis of paint samples with Raman spectroscopy; I am grateful to Maria Kokkori, the Art Institute of Chicago, for conducting this analysis. X-radiography and microscopic examination of the artwork revealed that the background colors do not continue fully beneath the figures.

8 Underdrawing detected through infrared reflectography reveals that the background figure's bowler hat became shorter and more rounded, while the brim was given greater curvature and was raised higher on his head. His coat collar was also altered, from square to round. The foremost figure's coat and pants became narrower in some places and wider in others; in several areas, the figures' clothes were expanded to cover portions of the landscape and clouds that had already been painted. Parts of clouds are visible beneath them with x-radiography and in strong raking light.

9 Elemental mapping completed in 2013 by Ana Martins, MoMA, using the Bruker M6 Jetstream XRF scanner (developed by Joris Dik, Delft University of Technology, The Netherlands, and Koen Janssens, University of Antwerp, and on loan to MoMA) revealed finished wood grain in the table, a fully colored necktie, and other details that point to a completed painting or one with a greater degree of completion than had previously been surmised. I am indebted to Martins for this analysis. For a contrasting view see David Sylvester, ed., *René Magritte: Catalogue Raisonné*, vol. 2, *Oil Paintings and Objects, 1931–1948*, by David Sylvester and Sarah Whitfield (Houston: The Menil Foundation and Philip Wilson Publishers, 1993), 249–50 and 254. Based on x-radiography of the painting and letters from Magritte, Sylvester and Whitfield argue that the work beneath *Le chant de l'orage* was unfinished.

10 See David Sylvester, ed., *René Magritte: Catalogue Raisonné*, vol. 1, *Oil Paintings, 1916–1930*, by David Sylvester and Sarah Whitfield (Houston: The Menil Foundation and Philip Wilson Publishers, 1992), 139, 143, 151, 163, 164, 165, 166, 168, 191, 200, 234, 245, and 346. Several paintings are listed as tempera and oil on canvas or board; others as Ripolin and oil on canvas, pencil and oil on canvas, or Ripolin, pencil, and oil on canvas. One oil painting is noted as containing metal snaps, one as containing corrugated cardboard and card, and one as containing collaged canvas.

11 Ripolin is a fast-drying brand of enamel house paint that often has a glossier appearance than traditional oil paints. For more information on artists' uses of Ripolin, see "Part One of *Special Issue: From Can to Canvas*," *Journal of the American Institute for Conservation* 52, no. 3 (2013); and "Part Two of *Special Issue: From Can to Canvas*," *Journal of the American Institute for Conservation* 52, no. 4 (2013). For Magritte paintings cataloged as containing Ripolin, see Sylvester, *René Magritte: Catalogue Raisonné*, vol. 1, 163, 164, 165, 168, and 191. Limitations of prior material analyses are addressed in Sylvester, xiii, and in an e-mail from Sarah Whitfield to Brad Epley, November 7, 2012. No reference to Ripolin was found in David Sylvester's René Magritte Catalogue Raisonné Research Papers, the Menil Collection.

12 Designation of the black paint was supported by examination beneath a microscope. The elemental compositions of the two different white paints were determined by analysis with X-ray fluorescence spectroscopy (XRF) using a Bruker/Keymaster TRACeR III-VTM energy dispersive X-ray fluorescence analyzer. The white paint in the fur form's skirt is composed of a zinc-containing pigment, while the rest of the white paint in the artwork is composed of a lead-based pigment. The sizes of the analyzed spots varied, but they were each approximately six to eight millimeters in diameter. I am grateful to Kokkori for her assistance with this analysis. The small cavities visible in the zinc-containing white paint under high magnification are typically caused by air bubbles that escape as the paint dries and can be indicative of a faster drying time.

13 I am indebted to Duffy for sharing these observations, which were made during his 2012 treatment of and research on this artwork. See also Michael Duffy, "Magritte's *The Menaced Assassin*, 1927—Treatment and Research," *Inside/Out: A MoMA/MoMA PS1 Blog*, November 21, 2013, https://www.moma.org/explore/inside_out/2013/11/21/magrittes-the-menaced-assassin-1927-treatment-and-research-2/.

14 A material difference in the paints was discovered by microscopic examination and confirmed by analysis with XRF. I am again grateful to Kokkori for her assistance with this analysis.

15 These findings are based on analysis with XRF. I am grateful to Kokkori for her assistance with this analysis.

16 "When it came it was sudden. I knew how simple it was. The question was not to look for a new way—a *manière* of painting, but to know what you must show. When you have an idea you must choose an eagle, a rock and some eggs, and you must paint them in a correct, precise way, but not in a *manière*, in any special technique." René Magritte, "Interview pour *Life*" (1965), in *René Magritte: Écrits complets*, ed. André Blavier (1979; repr., Paris: Flammarion, 2009), 611.

17 Sylvester, *René Magritte: Catalogue Raisonné*, vol. 2, 91 and 309.

18 For more about Iolas's considerable pressure to reproduce commercially successful images, see Sylvester, 144 and 153. Regarding Georgette's

feelings, Magritte once wrote that she "prefers the carefully finished paintings as 'of yore,' so *above all to please Georgette in future I shall exhibit the old kind of painting.*" Letter from René Magritte to Louis Scutenaire, June 7, 1948, quoted in Sylvester, 167. For information about Magritte's contemporaries' feelings, see Whitfield, *Magritte*, 35.

19 Sylvester, *René Magritte: Catalogue Raisonné*, vol. 2, 356.

20 This is unlike Magritte's "petrifaction" paintings, in which his approach to rendering stone was much more structured and formulaic.

21 Examination with transmitted infrared revealed an intensity of brushwork that is not immediately visible to the naked eye.

22 Contemporaneous works such as *La chambre d'écoute* (The Listening Room) (1952, plate 21) show that Magritte was quite adept at painting wood grain; here the lack of detail speaks directly to artistic choice.

23 For a more thorough reading of this series, see Clare Elliott, "The Hypertrophy of Objects," on pages 49–53 of this publication. Magritte's attention to perspective, detail, and color in the hypertrophy canvases and contemporaneous works contrasts with other periods in his oeuvre where such exacting nuances of painting were much less critical. It is just such variation in technique that points to the artist's greater interest in manners and methods of painting than he explicitly made known.

24 It is commonly acknowledged that linear perspective, in which guidelines or receding planes converge at a single vanishing point, was developed by the early Renaissance architect Filippo Brunelleschi (1377–1446) and adapted to painting by Masaccio (1401–1428). Otto G. Ocvirk, Robert E. Stinson, Philip R. Wigg, et al., *Art Fundamentals: Theory and Practice*, 9th ed. (New York: McGraw-Hill, 2002), 190–92. In works such as *La chambre d'écoute*, the vanishing point is at the center of the image. The center of *La chambre d'écoute* also displays traces of yet another drawing— possibly the facade of a building from a discarded composition or a fireplace abandoned prior to the final picture.

25 Magritte testified to having worked on this painting "*for at least two months*, and every detail was reconsidered and revised until a *certain state of grace* was achieved." Letter from René Magritte to Alexander Iolas, October 24, 1952, quoted in David Sylvester, ed., *René Magritte: Catalogue Raisonné*, vol. 3, *Oil Paintings, Objects and Bronzes, 1949–1967*, by Sarah Whitfield and Michael Raeburn (Houston: The Menil Foundation and Philip Wilson Publishers, 1993), 192. I am grateful to Paula De Cristofaro, San Francisco Museum of Modern Art, for sharing conservation folders and making this painting available for study and analysis.

26 Examination of this painting with infrared reflectography and transmitted infrared revealed the pencil underdrawing. The use of a commercially pre-primed canvas was determined by analysis results obtained from the Thread Count Automation Project. I am again grateful to Johnson for examining the thread count and other characteristics of Magritte's canvas. After 1939 Magritte acquired his canvases and paints from his sister-in-law's shop, Maison Berger, Brussels, which specialized in artists' materials. Sylvester, *René Magritte: Catalogue Raisonné*, vol. 2, 74.

27 Such attention to detail is also evident in other works from this period. In *Le chant des sirènes* (The Sirens' Song) (1952), for example, Magritte methodically embellished all the objects with highlights, shadows, and pure color. The candlestick was constructed by first painting in gold and then mixing shades of yellow, brown, black, and white directly on the canvas. An almost unnoticeable stroke of pure white on the handle creates a highlight. Though *Le chant des sirènes* is not part of the hypertrophy series, thread count analysis revealed that the canvas was cut from the same bolt or roll of primed canvas as that used for *La chambre d'écoute* and *Les valeurs personnelles*. There is also evidence of a discarded hypertrophy painting beneath the final image. I am grateful to Johnson for examining the thread counts of these canvases.

28 Letter from Alexander Iolas to René Magritte, October 15, 1952, and Magritte to Iolas, quoted in Sylvester, *René Magritte: Catalogue Raisonné*, vol. 3, 192.

29 See Sylvester, *René Magritte: Catalogue Raisonné*, vol. 1, xvii. See also Sylvester, *René Magritte: Catalogue Raisonné*, vol. 2, 167–68, regarding how Magritte's "variants could bring out exciting new possibilities in a theme" and how a variant was "by no means always weaker than the original."

30 I am grateful to participants in the Menil Collection study day for discussion of the possibility that painting in gouache was a way for Magritte to combat boredom and painting fatigue. Attesting, on the other hand, to the financial advantages of the medium, one collector commissioned fifty-three gouaches from Magritte. Sylvester, *René Magritte: Catalogue Raisonné*, vol. 3, 68.

31 For more on the considerable history of the *L'empire des lumières* variants, see Sandra Zalman, "Otherworldly: Magritte's *L'empire des lumières*," on pages 43–47 of this publication.

32 Sylvester, *René Magritte: Catalogue Raisonné*, vol. 2, 236. Examination of this painting with infrared reflectography and transmitted infrared revealed the underdrawing.

33 A 1983 note in the treatment records for the second *L'empire des lumières* variant (1950, plate 52) describes a "milkiness" in the black paint, "particularly in the treetops." This may indicate that those trees were originally similarly glossy; conservation treatment to remove and replace the varnish in 1966 may have obscured the effect to some degree. I am grateful to Duffy for providing the treatment records for this work.

34 I am grateful to Epley for his suggestion of the possibility of a working varnish.

35 Magritte's use of black paint is a topic that warrants further investigation.

36 According to Magritte scholar Sarah Whitfield, Georgette Magritte was surprised that Whitfield wanted to view a work in person that she had already seen. Whitfield stated, "[Georgette] was not alone in finding the close attention we paid to the works themselves and how they were painted quite ridiculous. Louis Scutenaire and Irène Hamoir were similarly amused by our desire to revisit works whenever we could. For them, a reproduction was every bit as useful." E-mail from Sarah Whitfield to Brad Epley, November 7, 2012. See also Whitfield, *Magritte*, 15. Magritte's artistry is a subject that merits further consideration. I am once again grateful to Epley for ongoing discussions regarding elements of Magritte's work that can be fully experienced only with direct and sustained viewing—when the material and conceptual aspects are given the opportunity to subconsciously reinforce one another.

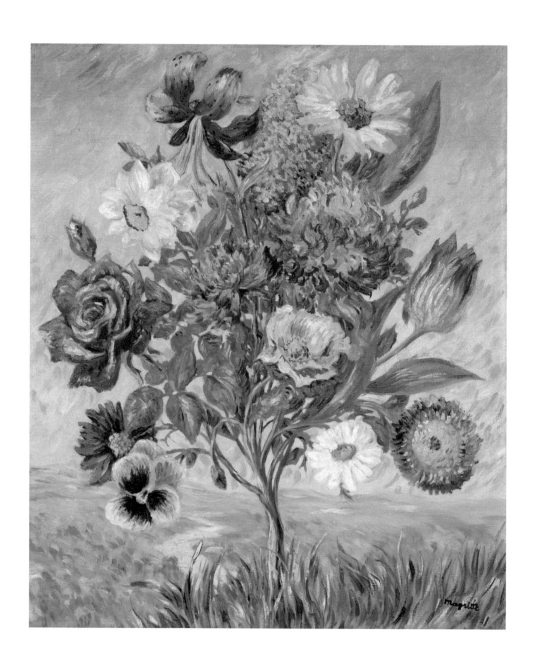

PLATE 1 *La préméditation* (Forethought), 1943
Oil on canvas
21 ⅝ x 18 ⅛ in. (55 x 46 cm)
Koons Collection

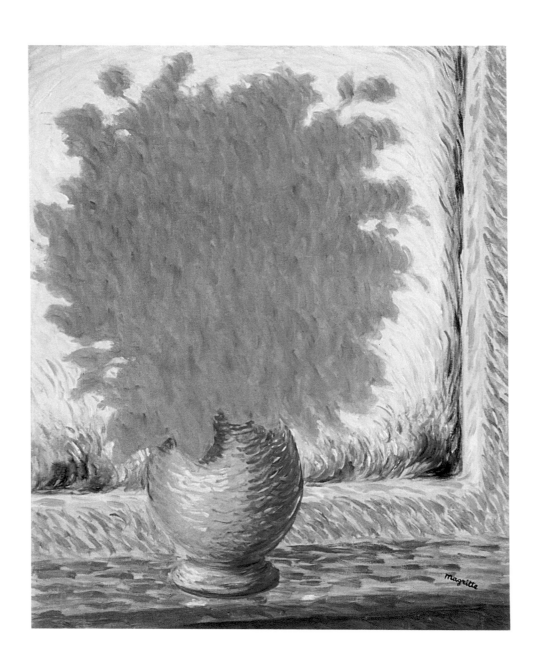

PLATE 2 *L'éclair* (Lightning), 1944
Oil on canvas
21 ¼ x 17 ¹³⁄₁₆ in. (54 x 45.3 cm)
Musée des Beaux-Arts de Charleroi, Belgium

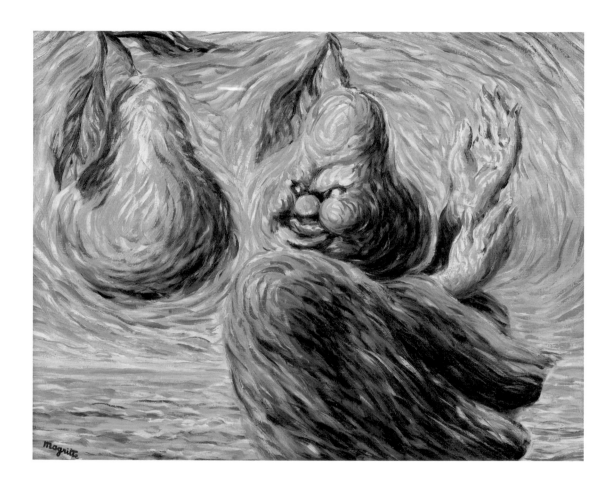

PLATE 3 *Le lyrisme* (Lyricism), 1947
Oil on canvas
19 ¹¹⁄₁₆ x 25 ⁹⁄₁₆ in. (50 x 65 cm)
Musées royaux des Beaux-Arts de Belgique, Brussels

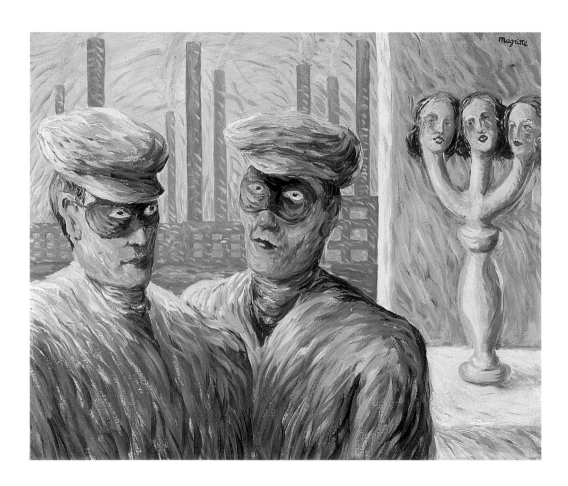

PLATE 4 *L'intelligence* (Intelligence), 1946
Oil on board
21 ¼ x 25 ⁹⁄₁₆ in. (54 x 65 cm)
Musées royaux des Beaux-Arts de Belgique, Brussels

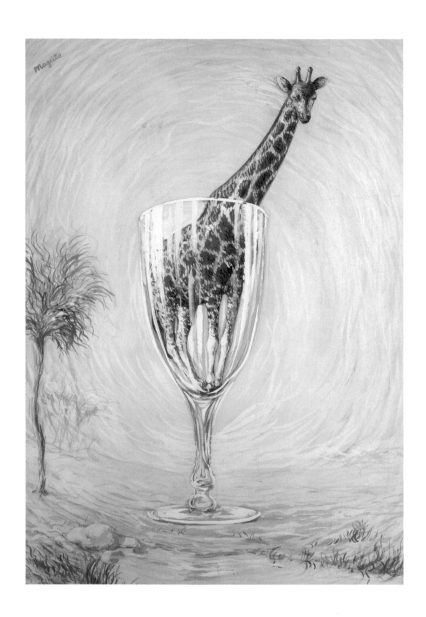

PLATE 5 *Le bain de cristal* (The Cut-Glass Bath), 1946
Gouache on paper
19 ⅛ x 13 ⅜ in. (48.5 x 34 cm)
Private collection

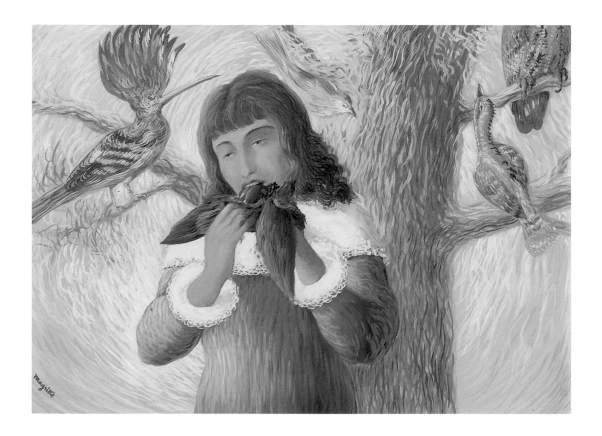

PLATE 6 *Le plaisir* (Pleasure), 1946
Gouache on paper
14 ³/₁₆ x 19 ½ in. (36 x 49.5 cm)
Collection Lucien Bilinelli, Brussels and Milan

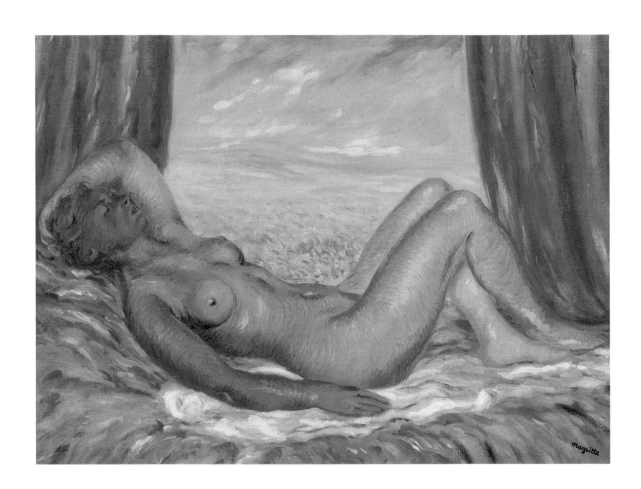

PLATE 7 *La moisson* (The Harvest), 1943
Oil on canvas
23 ⅝ x 31 ½ in. (60 x 80 cm)
Musées royaux des Beaux-Arts de Belgique, Brussels

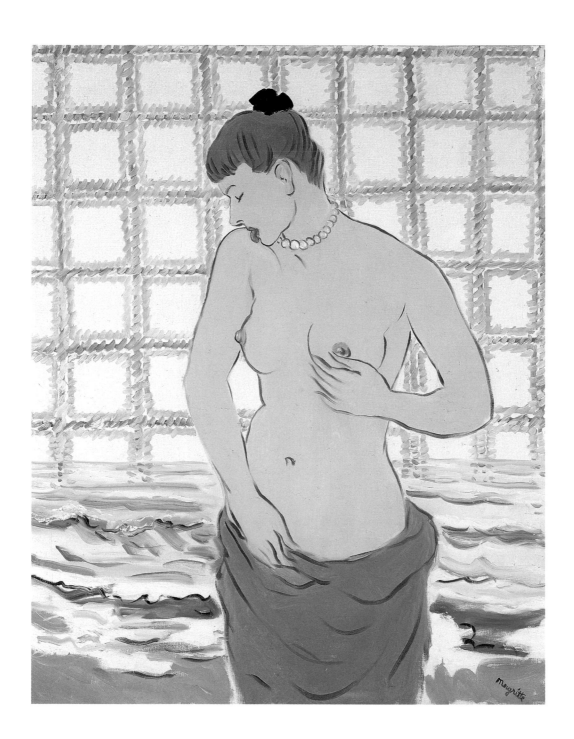

PLATE 8 *Le galet* (The Pebble), 1948
Oil on canvas
39 ⅜ x 31 ⅞ in. (100 x 81 cm)
Musées royaux des Beaux-Arts de Belgique, Brussels, gift of Georgette Magritte

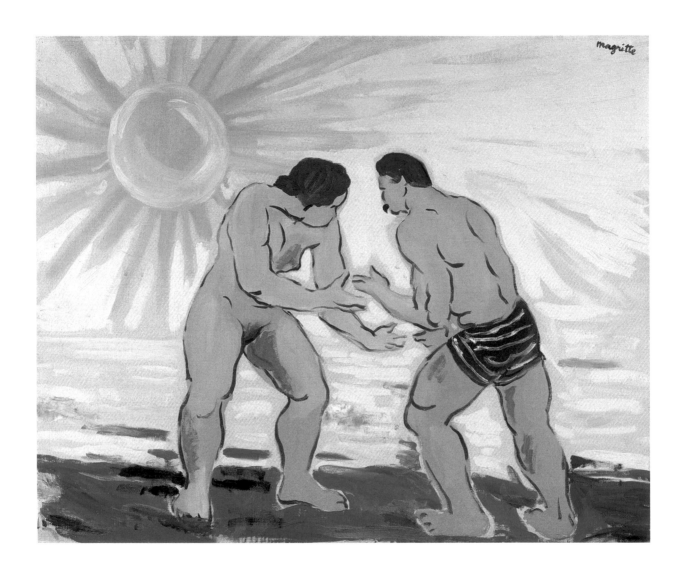

PLATE 9 *La vie des insectes* (The Life of Insects), 1947/1948
Oil on canvas
31 ⅞ x 39 ⅜ in. (81 x 100 cm)
Musées royaux des Beaux-Arts de Belgique, Brussels

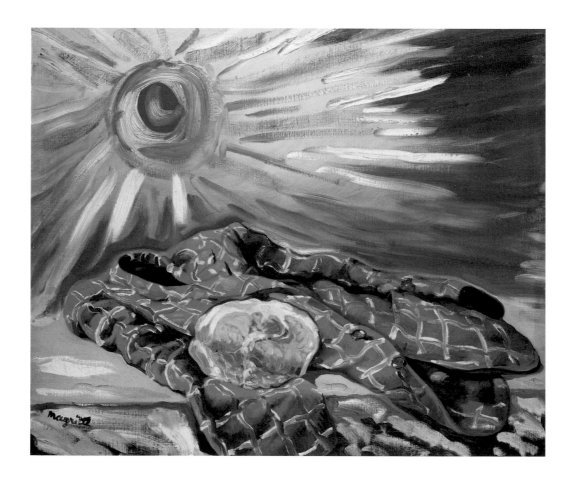

PLATE 10 *Le mal de mer* (Seasickness), 1948
Oil on canvas
21 ¼ x 25 ⁹⁄₁₆ in. (54 x 65 cm)
Private collection

PLATE 11 *L'arc-en-ciel* (The Rainbow), 1948
Watercolor, gouache, and gold paint on paper
17 ¾ x 12 ¹¹⁄₁₆ in. (45.1 x 32.3 cm)
Private collection, Switzerland, courtesy Simon Studer Art, Geneva

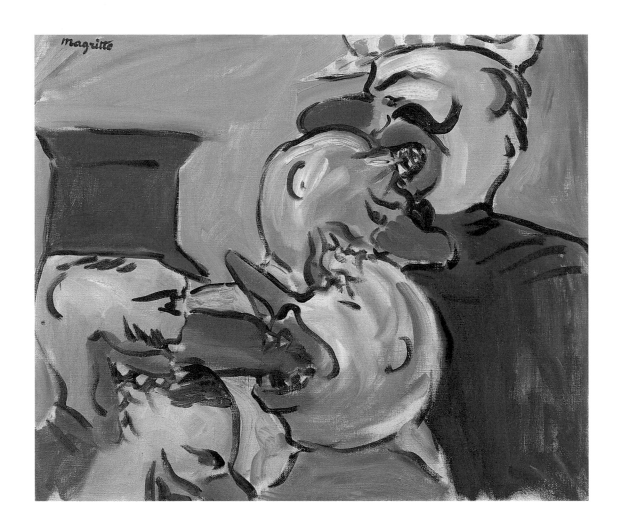

PLATE 12 *La famine* (Famine), 1948
Oil on canvas
18 ⅛ x 21 ⅝ in. (46 x 55 cm)
Musées royaux des Beaux-Arts de Belgique, Brussels

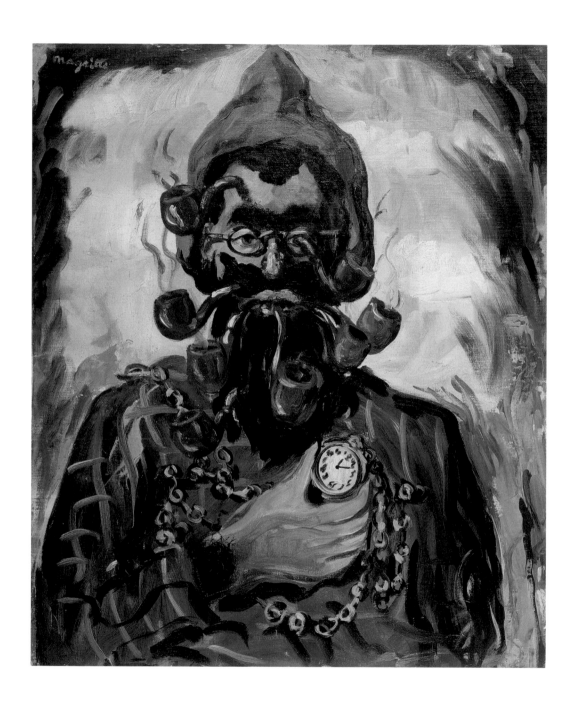

PLATE 13 *Le stropiat* (The Cripple), 1948
Oil on canvas mounted on panel
23 ⁷⁄₁₆ x 19 ⁷⁄₁₆ in. (59.5 x 49.5 cm)
Musée national d'art moderne/Centre de création industrielle,
Centre Georges Pompidou, Paris

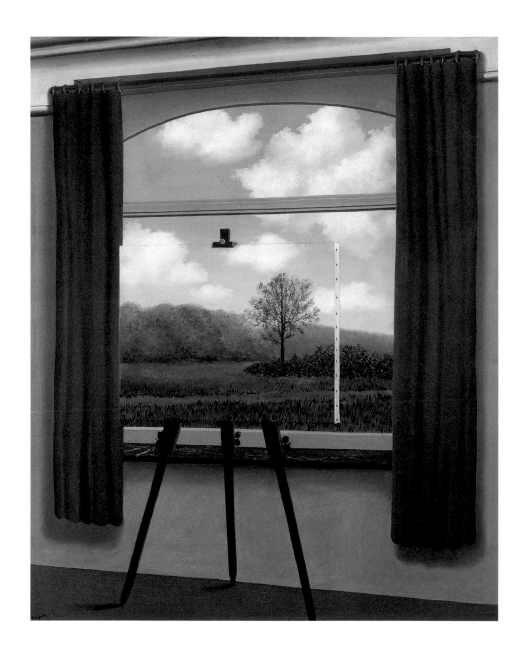

PLATE 14 *La condition humaine* (The Human Condition), 1933
Oil on canvas
39 ⅜ x 31 ⅞ in. (100 x 81 cm)
National Gallery of Art, Washington, D.C., gift of the Collectors' Committee

PLATE 15 *Les promenades d'Euclide* (Where Euclid Walked), 1955
Oil on canvas
63 ¾ x 51 ³⁄₁₆ in. (162 x 130 cm)
Minneapolis Institute of Art, The William Hood Dunwoody Fund

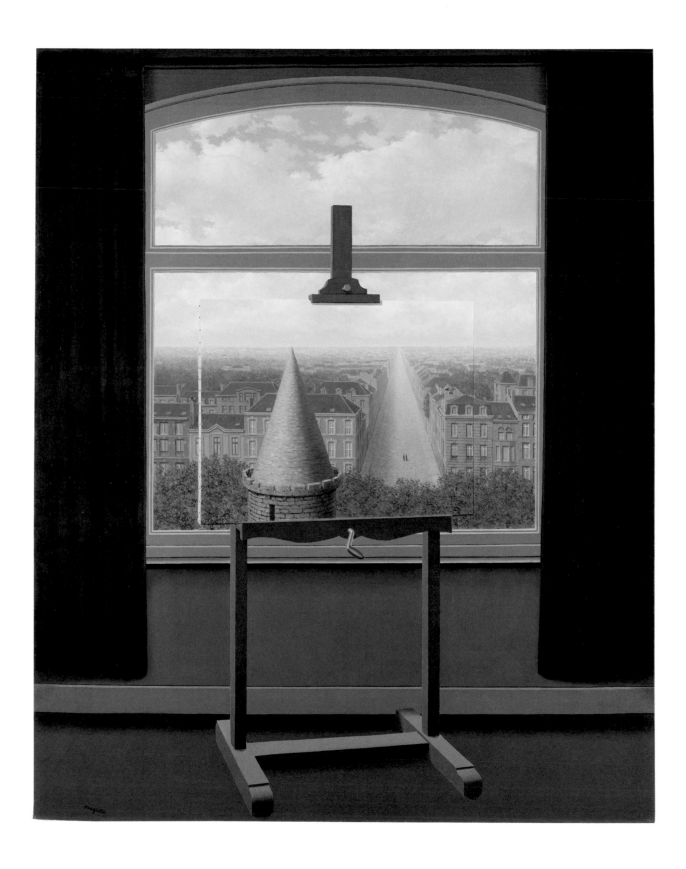

PLATE 16 *Le monde des images* (The World of Images), 1950/ca. 1961
Oil on canvas
39 ⅜ x 31 ⅞ in. (100 x 81 cm)
Private collection

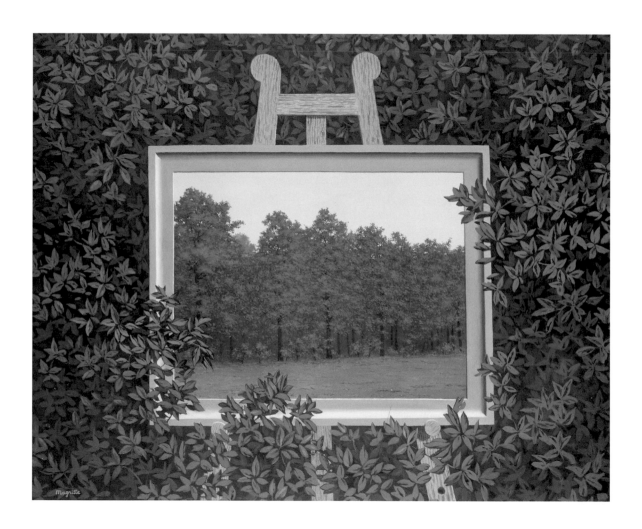

PLATE 17 *La cascade* (The Waterfall), 1961
Oil on canvas
31 ⅞ x 39 ⅜ in. (81 x 100 cm)
Esther Grether Family Collection

PLATE 18 *La belle captive* (The Fair Captive), ca. 1950
Oil on canvas
11 ¹³⁄₁₆ x 15 ¾ in. (30 x 40 cm)
Private collection

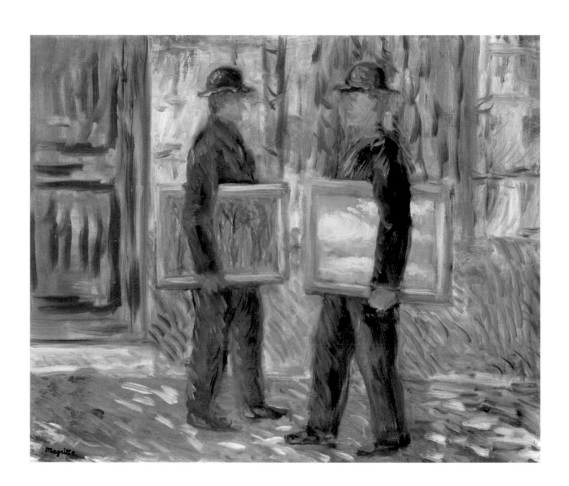

PLATE 19 *La cinquième saison* (The Fifth Season), 1943
Oil on canvas
19 ¹¹⁄₁₆ x 23 ⅝ in. (50 x 60 cm)
Musées royaux des Beaux-Arts de Belgique, Brussels

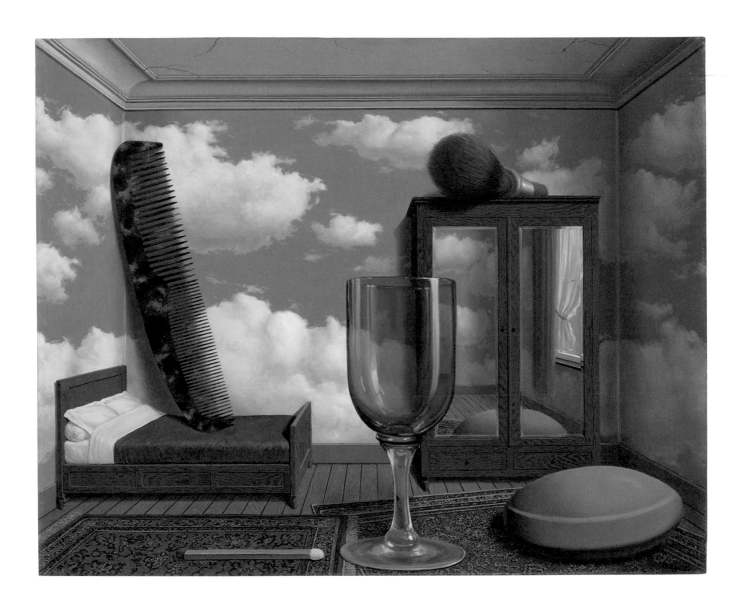

PLATE 20 *Les valeurs personnelles* (Personal Values), 1952
Oil on canvas
31 ½ x 39 ⅜ in. (80 x 100 cm)
San Francisco Museum of Modern Art, purchase through a gift of Phyllis C. Wattis

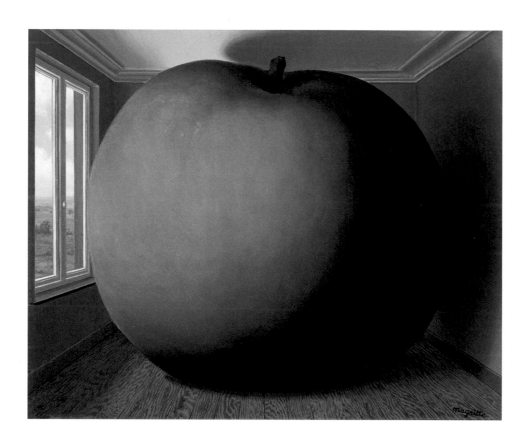

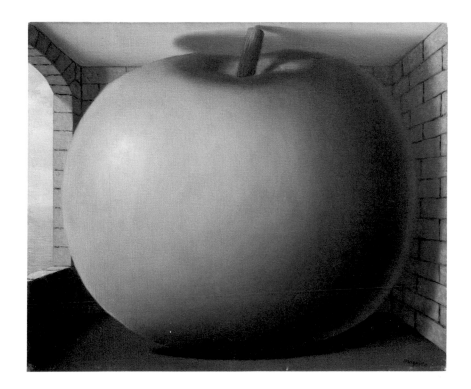

PLATE 22 *La chambre d'écoute* (The Listening Room), 1958
Oil on canvas
14 ¹⁵⁄₁₆ x 18 ⅛ in. (38 x 46 cm)
Private collection, courtesy Brachot Gallery, Brussels

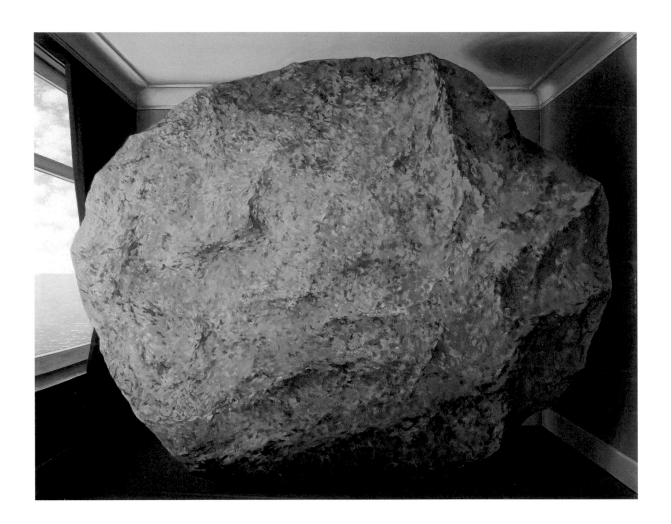

PLATE 23 *L'anniversaire* (The Anniversary), 1959
Oil on canvas
35 1/16 x 45 3/4 in. (89.1 x 116.2 cm)
Art Gallery of Ontario, Toronto, purchase, Corporations' Subscription Endowment, 1971

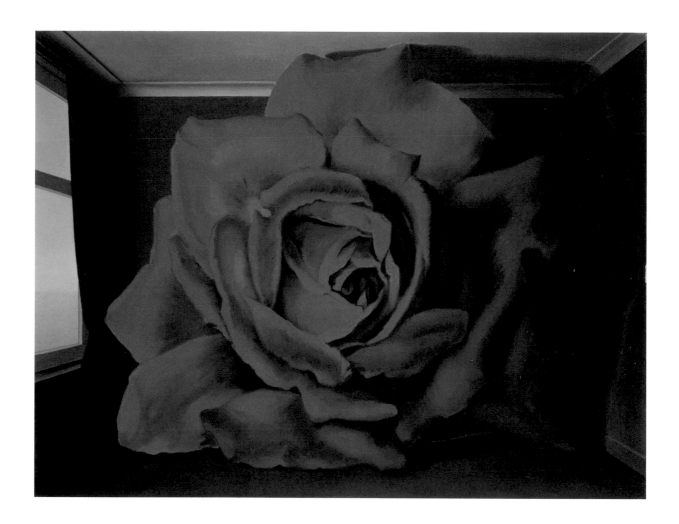

PLATE 24 *Le tombeau des lutteurs* (The Tomb of the Wrestlers), 1960
Oil on canvas
35 $\frac{1}{16}$ x 45 $\frac{11}{16}$ in. (89 x 116 cm)
Private collection

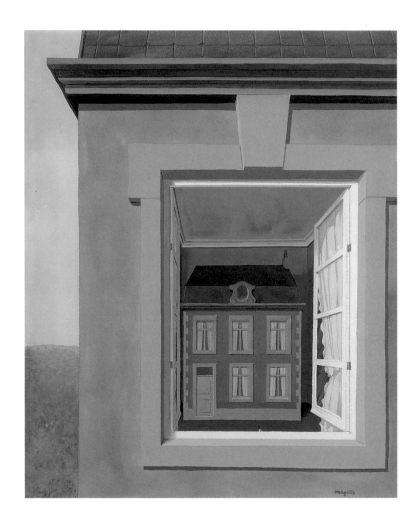

PLATE 25 *Eloge de la dialectique* (In Praise of the Dialectic), 1936
Gouache on paper
14 ¹⁵⁄₁₆ x 12 ⅝ in. (38 x 32 cm)
Musée d'Ixelles, Brussels

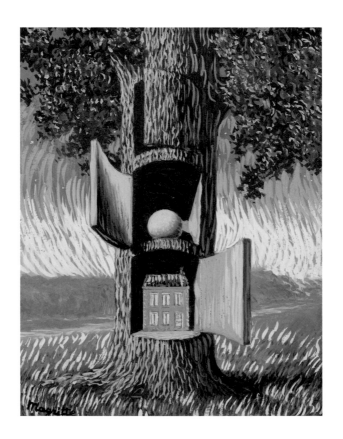

PLATE 26 *La voix du sang* (Blood Will Tell), 1947
Gouache on paper
9 ½ x 7 ½ in. (24.1 x 19 cm)
Private collection, courtesy Guggenheim, Asher Associates

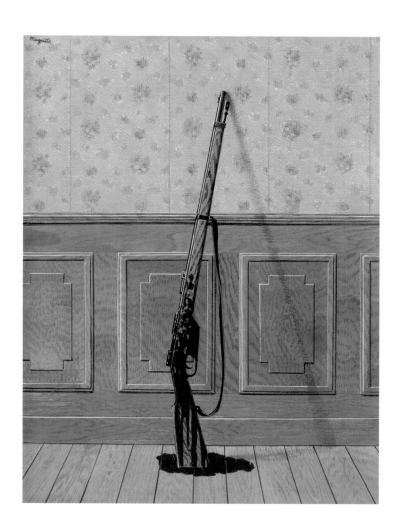

PLATE 27 *Le survivant* (The Survivor), 1950
Gouache on paper
18 ⅛ x 14 ½ in. (46 x 36.8 cm)
Private collection

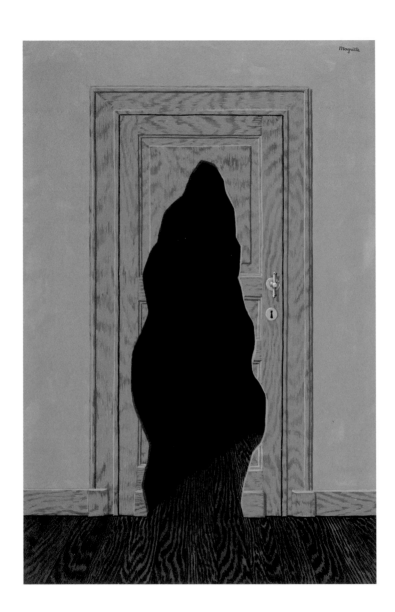

PLATE 28 *La réponse imprévue* (The Unexpected Answer), 1963–64
Gouache on paper
21 ⅝ x 14 in. (55 x 35.6 cm)
Collection of an anonymous charitable foundation

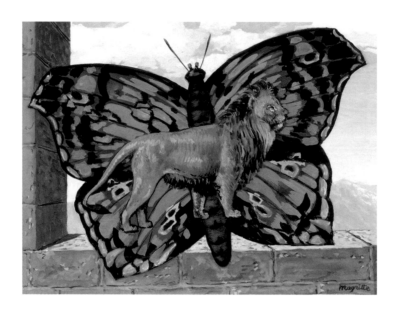

PLATE 29 *La place au soleil* (The Place in the Sun), 1956
Gouache on paper
5 ⁷⁄₈ x 7 ¹¹⁄₁₆ in. (15 x 19.6 cm)
Private collection

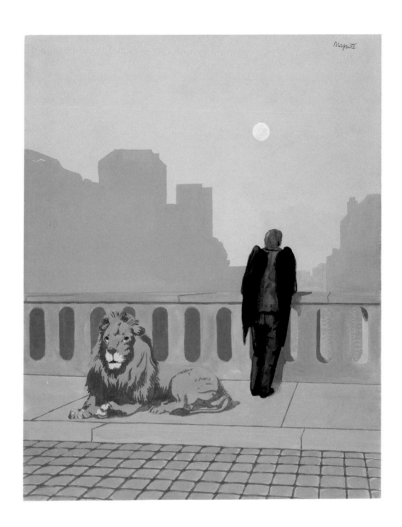

PLATE 30 *Le mal du pays* (Homesickness), ca. 1948
Watercolor and gouache on paper
17 15/16 x 13 3/4 in. (45.5 x 35 cm)
The Art Institute of Chicago, gift of Mary and Leigh Block

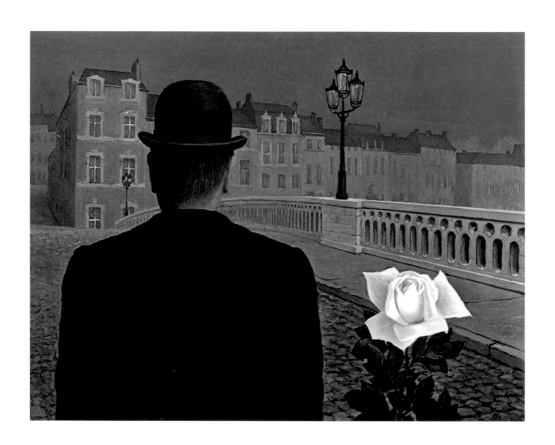

PLATE 31 *La boîte de Pandore* (Pandora's Box), 1951
Oil on canvas
17 11/16 x 21 5/8 in. (45 x 55 cm)
Yale University Art Gallery, New Haven, Connecticut,
gift of Dr. and Mrs. John A. Cook, B.A. 1932

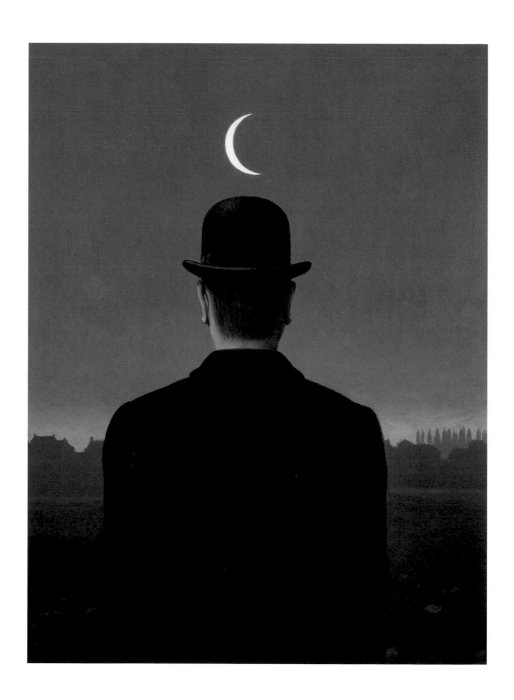

PLATE 32 *Le maître d'école* (The Schoolmaster), 1955
Oil on canvas
31 ½ x 23 ⅝ in. (80 x 60 cm)
Private collection

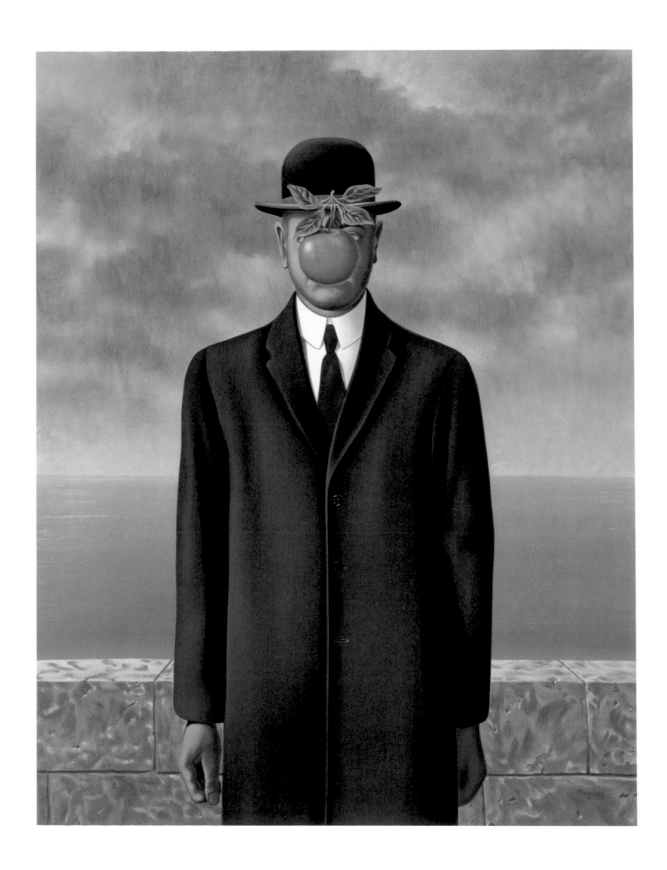

PLATE 33 *Le fils de l'homme* (The Son of Man), 1964
Oil on canvas
45 ½ x 35 in. (115.6 x 89 cm)
Private collection, U.S.A.

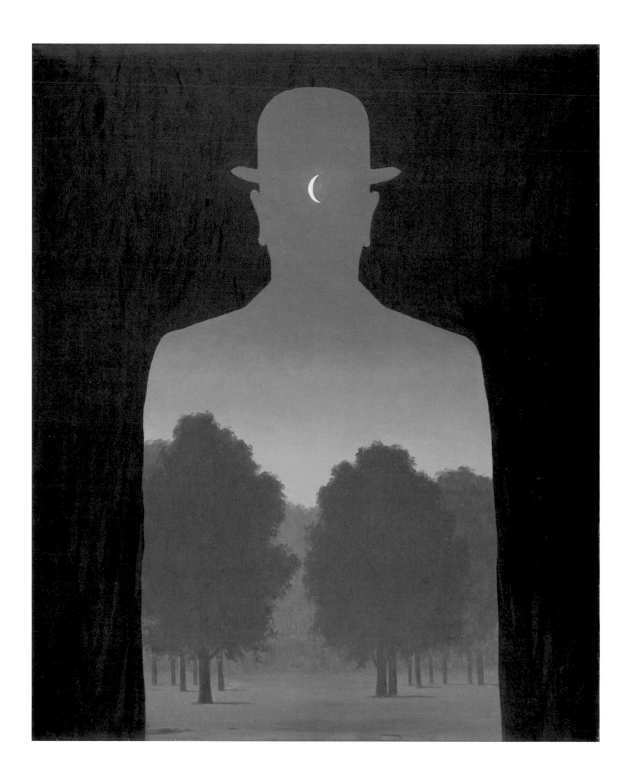

PLATE 34 *L'ami de l'ordre* (The Upholder of the Law), 1964
Oil on canvas
39 ⅜ x 31 ⅞ in. (100 x 81 cm)
Private collection

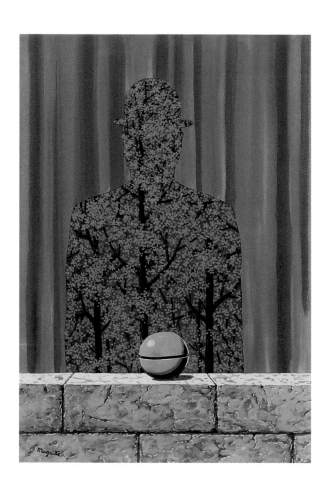

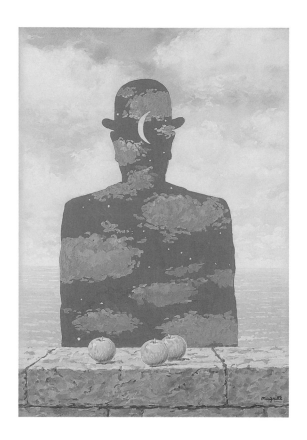

PLATE 35 *L'homme et la forêt* (Man and the Forest), 1965
Gouache on card
19 ⁵⁄₁₆ x 11 ⁷⁄₁₆ in. (49 x 29 cm)
Private collection, courtesy Keitelman Gallery, Brussels

PLATE 36 *La carrière de granit* (The Granite Quarry), 1964
Gouache on paper
16 ½ x 11 ⅝ in. (41.9 x 29.5 cm)
Private collection, courtesy Guggenheim, Asher Associates

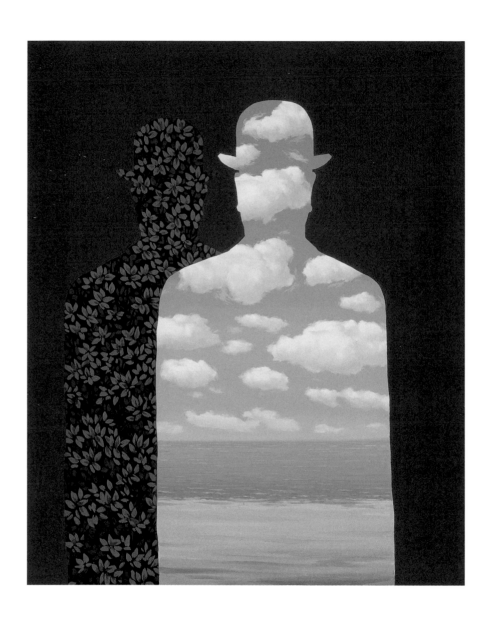

PLATE 37 *La belle société* (High Society), 1965–66
Oil on canvas
31 ⅞ x 25 ⁹⁄₁₆ in. (81 x 65 cm)
Colección Telefónica, Madrid

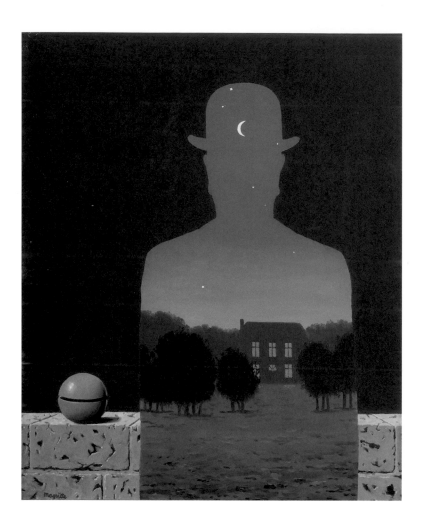

PLATE 38 *L'heureux donateur* (The Happy Donor), 1966
Oil on canvas
21 ⅝ x 17 ¹¹⁄₁₆ in. (55 x 45 cm)
Musée d'Ixelles, Brussels

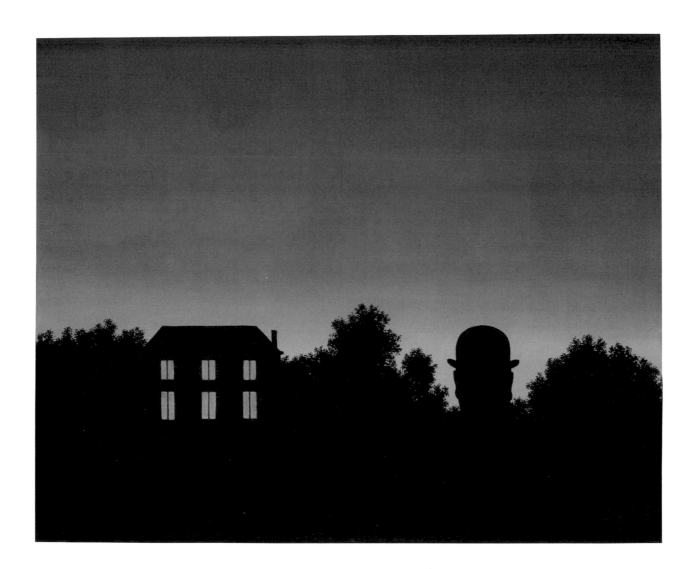

PLATE 39 *La fin du monde* (The End of the World), 1963
Oil on canvas
32 ⅛ x 39 ½ in. (81.6 x 100.3 cm)
Private collection

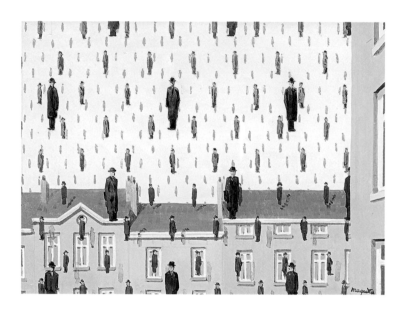

PLATE 40 *Golconde* (Golconda), 1955
Gouache on paper
6 ¼ x 8 ¼ in. (15.9 x 21 cm)
Private collection, courtesy Guggenheim, Asher Associates

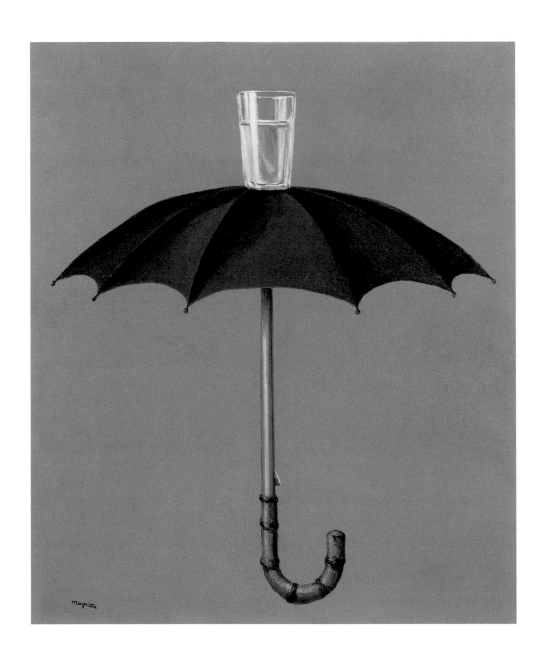

PLATE 41 *Les vacances de Hegel* (Hegel's Vacation), 1958
Oil on canvas
23 5/8 x 19 11/16 in. (60 x 50 cm)
Private collection

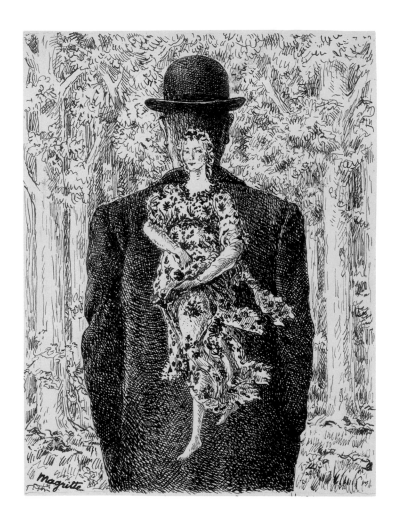

La place au soleil (The Place in the Sun), 1956
Ink on paper
10 ⅛ x 7 ⅝ in. (25.7 x 19.4 cm)
Private collection, courtesy Guggenheim, Asher Associates

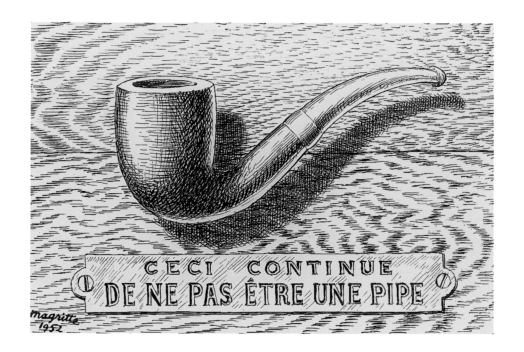

CECI CONTINUE
DE NE PAS ÊTRE UNE PIPE

PLATE 43 *La trahison des images* (The Treachery of Images), 1952
India ink on paper
7 ½ x 10 ⅝ in. (19 x 27 cm)
Private collection

III. Oil on canvas
 26 ¾ x 53 ⅝ in. (68 x 136.2 cm)
 Private collection

IV. Oil on canvas
 26 ¾ x 36 ¹³⁄₁₆ in. (68 x 93.5 cm)
 Private collection

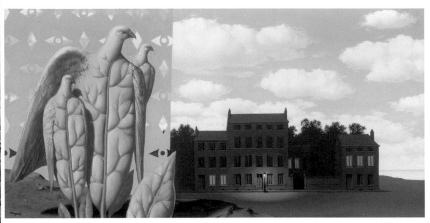

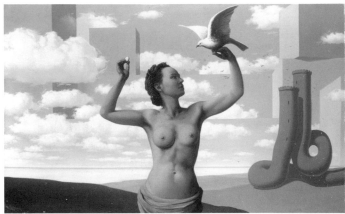

I. Oil on canvas
 26 ¾ x 53 ⅝ in. (68 x 136.2 cm)
 Museum Würth, Künzelsau, Germany

II. Oil on canvas
 26 ¾ x 53 in. (68 x 134.6 cm)
 Private collection

"Ici commence le domaine enchanté" (Here Begins the Enchanted Domain)
By Paul Colinet, translated by Austryn Wainhouse
First published in Patrick Waldberg, *René Magritte* (Brussels: André De Rache, 1965)

I.

Les grands oiseaux sont ceux de l'île au trésor, où les arbres n'ont d'autre feuillage que leurs chants.

Le papier découpé des premières recherches est un papier masqué et très attentif.

La lumière rayonne. On voit en même temps deux moments espacés d'une journée de la vie humaine.

The great birds are those of the Island of Treasure where the trees have only their songs for foliage.

The paper cut out of the earliest researches is of a masked and very attentive kind.

Light shines. At the same time one sees two moments separated by a day of human life.

II.

Dans l'espace appelé ciel s'élèvent des constructions d'azur.

Une jeune femme présente avec grâce deux formes différentes d'un même oiseau.

Deux tours se promènent comme des amies, devant la mer.

In the space called sky rise constructions of azure.

A young woman gracefully presents two different forms of the same bird.

A couple of towers, best of friends, stroll by the seashore.

III.

Une porte s'ouvre sur la nuit veloutée, où une lune précise signe ses dentelles.

Des feuilles violentes retiennent leurs grelots et bouleversent leurs oiseaux.

A door opens upon a night of velvet whose lace is wrought of an unerring moon.

Violent leaves hold their bells in check and overwhelm their birds.

IV.

Abrité du large par un grand rideau, un séduisant navire d'eau de mer raconte ses voyages à une sirène renversée.

Sheltered from the offing by a broad curtain, a seductive seawater frigate tells tales of its travels while an inverted mermaid listens.

V.

Les claires voies d'un jeune regard embaument la fête d'un vieil arbre.
Une chaise légendaire se complaît à s'inventer.
La montagne à demi cachée est en travail de ses ailes.

The piercing gaze of young knowing wreathes the springtime of an ancient tree.
A legendary chair delights in its invention.
The half-hidden mountain brings its wings to bear.

VI.

Un bombardon libère son bouquet de flammes.
Sur l'épaule d'une magicienne nourrie de ciel, une colombe immobilise du silence.
Une tour penchée, délicatement soutenue par une plume, adoucit ses miroitements.
Les édifices aériens bleuissent leurs échos.

A tuba lets loose its bouquet of flowers.
Upon the shoulder of a sorceress rich from heaven's feeding alights a dove
immobilizing silence.
A leaning tower, delicately propped up by a feather, takes on a more sober tone.
Aerial edifices blue their echoes.

VII.

Il y a, sur le rivage de la mer, deux pommes visiteuses, venues de très loin.
Elles sourient en sourdine, étrangères à ce qu'elles regardent.
Une souche d'arbre se crispe sur son désastre. Un arbre resté debout révèle ses secrets.

There, a little off the land, are two cruising apples, come upon inspection from over
the seas. They smile under their breath, foreign to what they behold.
A tree-stump huddles over its disaster. A tree left standing discloses its secrets.

VIII.

Deux tourterelles, dans la chaude pénombre de leur maison, veillent à la santé d'un
thérapeute de grands chemins. Les perles d'un visage fleurissent sa main droite.
Une guirlande de roses apaise son lion.
Un papier troué collectionne des morceaux de ciel.

In the warm darkness of their home a pair of turtledoves watch over the health
of a wayward healer. The pearls of a face bedeck his right hand. A garland of roses
appeases its lion.
A perforated wallpaper collects bits of sky.

PLATE 44 *Le domaine enchanté* (The Enchanted Domain), 1953

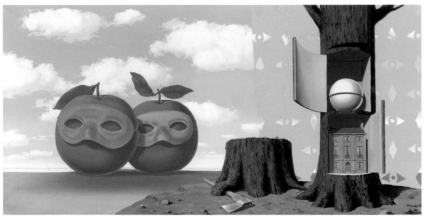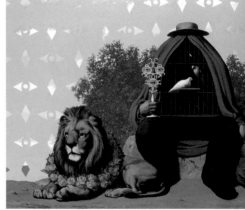

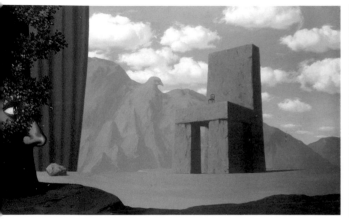

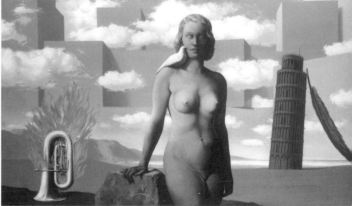

V. Oil on canvas
 26 ¾ x 53 ⅝ in. (68 x 136.2 cm)
 Private collection

VI. Oil on canvas
 26 ¾ x 53 ¹⁄₁₆ in. (68 x 134.8 cm)
 Private collection

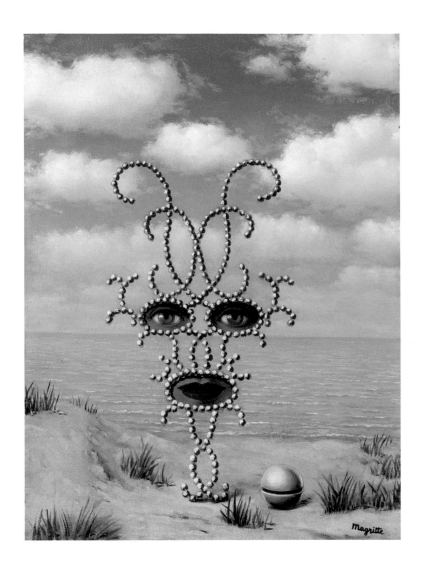

PLATE 45 *Shéhérazade* (Sheherazade), 1950
Oil on canvas
15 ¾ x 11 ¹³⁄₁₆ in. (40 x 30 cm)
Private collection

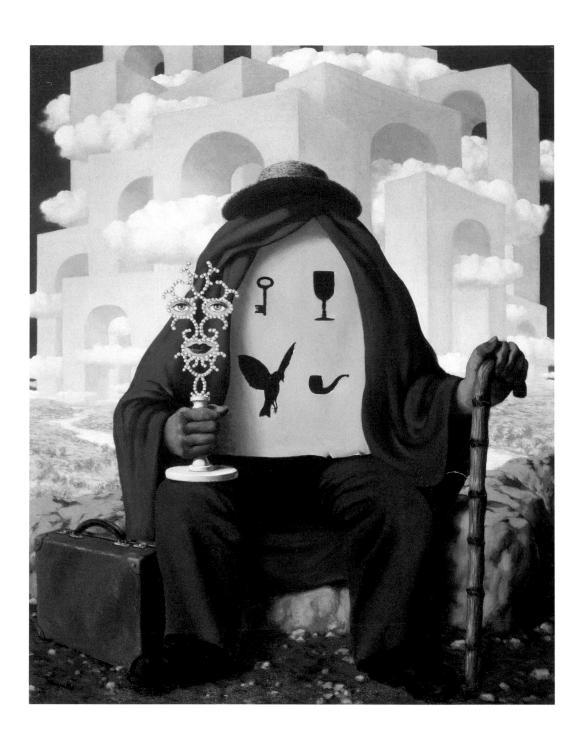

PLATE 46 *Le libérateur* (The Liberator), 1947
Oil on canvas
39 ⅜ x 31 ½ in. (100 x 80 cm)
Los Angeles County Museum of Art, gift of William Copley

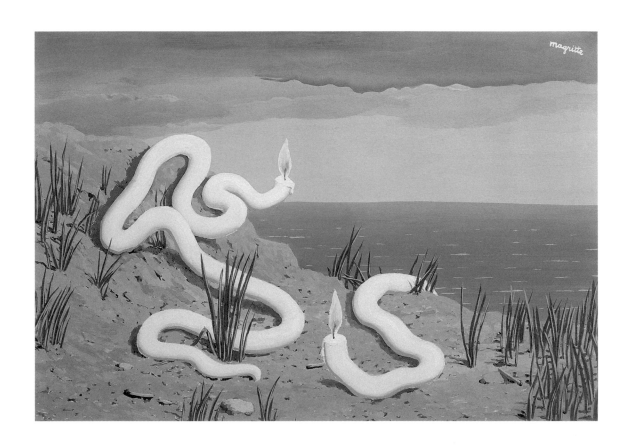

PLATE 47 *Le retour à la nature* (The Return to Nature), 1938–39
Gouache on paper
10 ¹³⁄₁₆ x 15 ⁹⁄₁₆ in. (27.5 x 39.5 cm)
Private collection

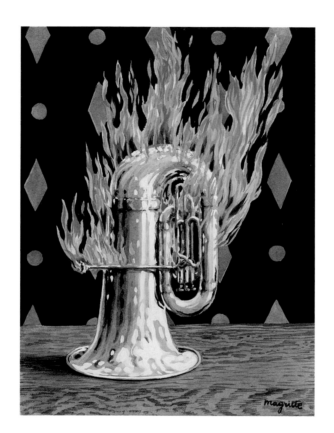

PLATE 48 *La découverte du feu* (The Discovery of Fire), 1959
Gouache on paper
9 ⁷⁄₁₆ x 7 ³⁄₈ in. (24 x 18.7 cm)
The George Economou Collection, Athens

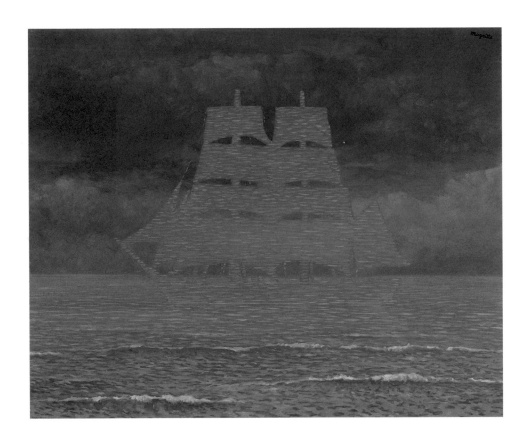

PLATE 49 *Le séducteur* (The Seducer), 1950
Oil on canvas
19 ¹¹⁄₁₆ x 23 ⅝ in. (50 x 60 cm)
Virginia Museum of Fine Arts, Richmond, collection of Mr. and Mrs. Paul Mellon

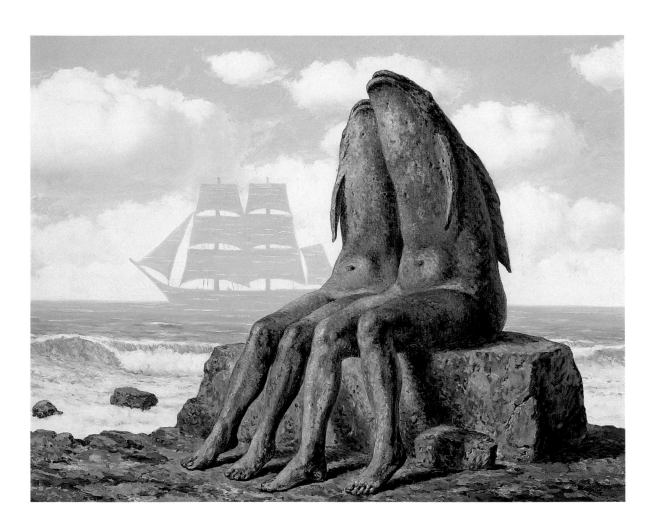

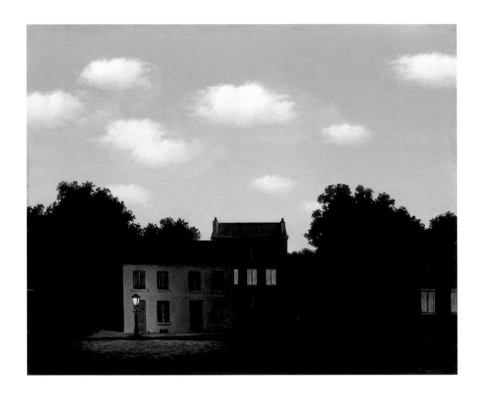

PLATE 51 *L'empire des lumières* (The Dominion of Light), 1949
Oil on canvas
19 ¹¹/₁₆ x 23 ⅝ in. (50 x 60 cm)
Private collection

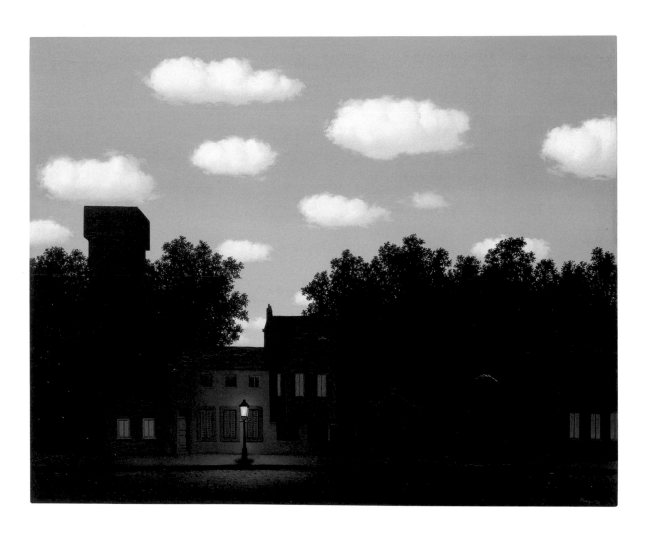

PLATE 52 *L'empire des lumières* (The Dominion of Light), 1950
Oil on canvas
31 ½ x 39 ⅜ in. (80 x 100 cm)
The Museum of Modern Art, New York, gift of D. and J. de Menil, 1951

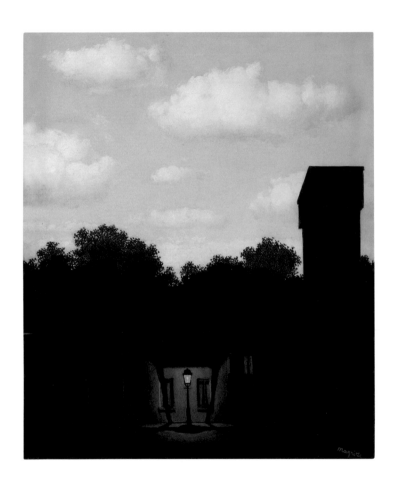

PLATE 53 *L'empire des lumières* (The Dominion of Light), 1953
Oil on canvas
18 ⅛ x 14 ¹⁵⁄₁₆ in. (46 x 38 cm)
Private collection, courtesy Guggenheim, Asher Associates

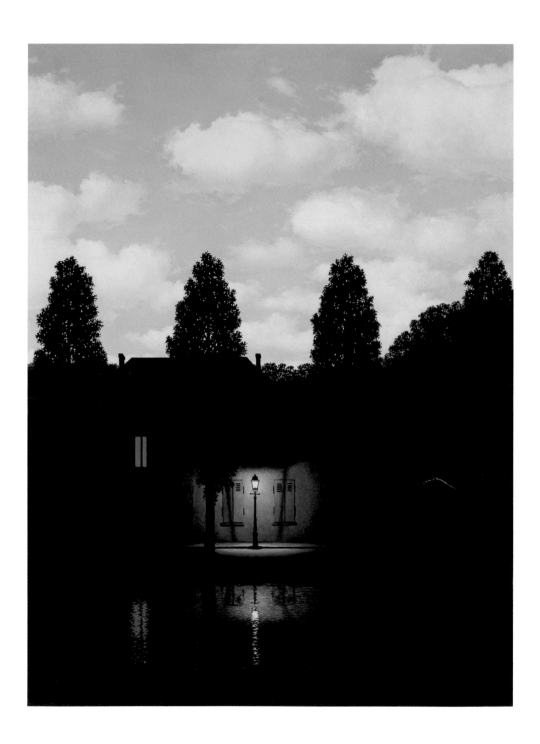

PLATE 54 *L'empire des lumières* (The Dominion of Light), 1954
Oil on canvas
51 ⅛ x 37 ¼ in. (129.9 x 94.6 cm)
The Menil Collection, Houston

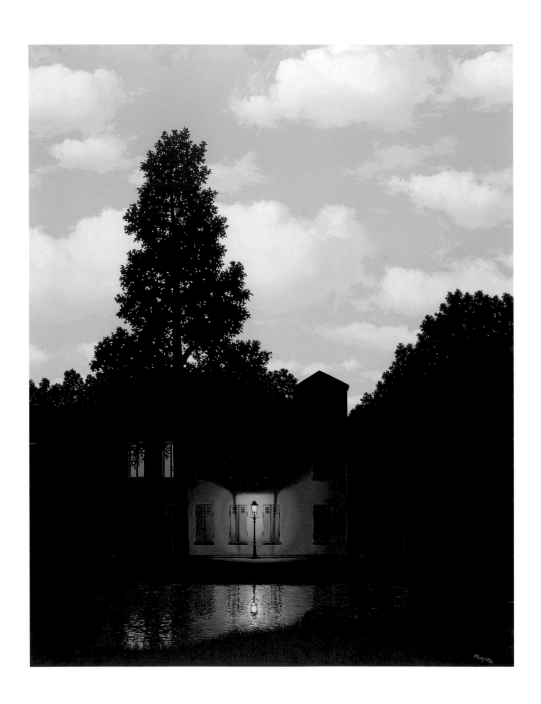

PLATE 55 *L'empire des lumières* (The Dominion of Light), 1954
Oil on canvas
57 ½ x 44 ⅞ in. (146 x 114 cm)
Musées royaux des Beaux-Arts de Belgique, Brussels

PLATE 56 *L'empire des lumières* (The Dominion of Light), 1954
Oil on canvas
80 ¾ x 55 in. (205 x 139.8 cm)
Peggy Guggenheim Collection, Venice (Solomon R. Guggenheim Foundation, New Yo

PLATE 57 *L'empire des lumières* (The Dominion of Light), 1948/1962
Oil on canvas
39 ⅜ x 31 ½ in. (100 x 80 cm)
Esther Grether Family Collection

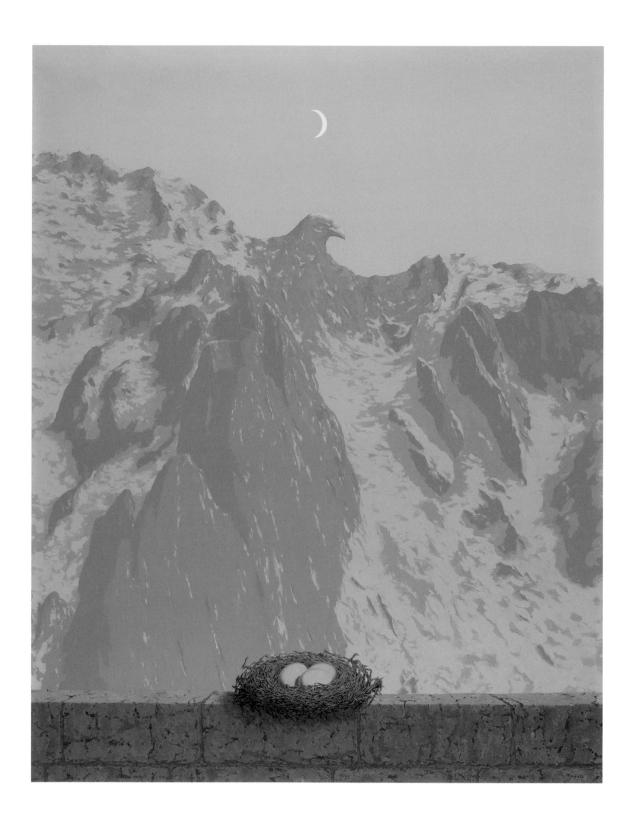

PLATE 58 *Le domaine d'Arnheim* (The Domain of Arnheim), 1962
Oil on canvas
57 ½ x 44 ⅞ in. (146 x 114 cm)
Musées royaux des Beaux-Arts de Belgique, Brussels

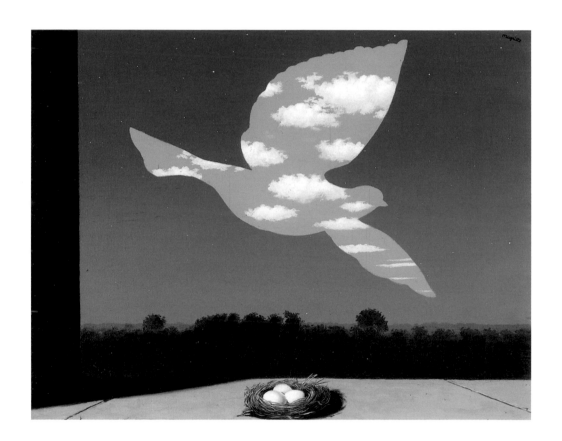

PLATE 59 *Le retour* (The Return), 1940
Oil on canvas
19 11/16 x 25 9/16 in. (50 x 65 cm)
Musées royaux des Beaux-Arts de Belgique, Brussels

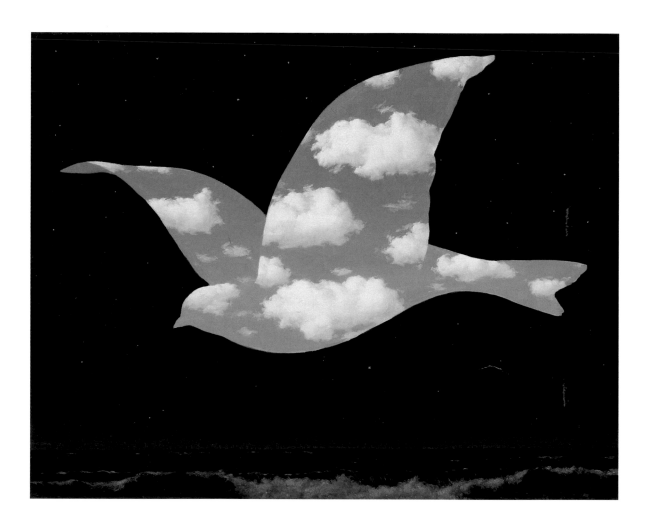

PLATE 60 *Le baiser* (The Kiss), 1951
Oil on canvas
28 ⅝ x 35 ³⁄₁₆ in. (72.7 x 89.4 cm)
The Museum of Fine Arts, Houston, gift of an anonymous donor

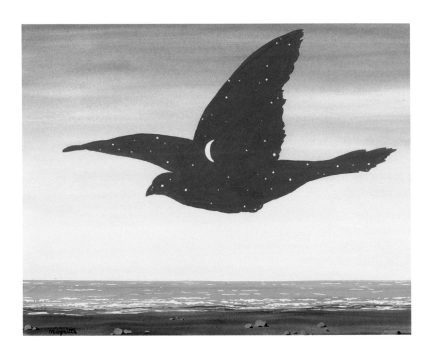

PLATE 61 *Le baiser* (The Kiss), ca. 1957
Gouache on paper
10 ⅝ x 13 ⁵⁄₁₆ in. (27 x 33.8 cm)
Private collection

141

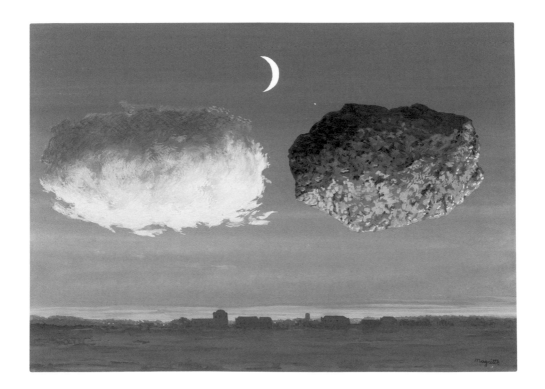

PLATE 64 *La bataille de l'Argonne* (The Battle of the Argonne), 1964
Gouache on paper
11 ¼ x 16 ⅛ in. (28.5 x 41 cm)
Private collection

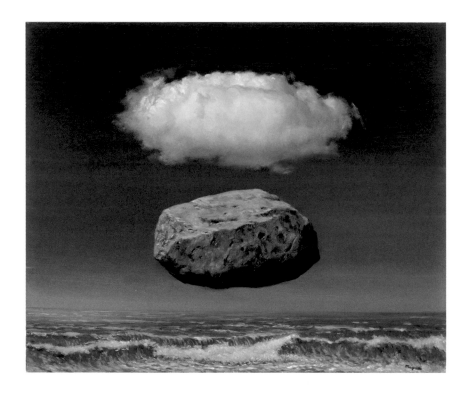

PLATE 65 *Les idées claires* (Clear Ideas), 1955/ca. 1958
Oil on canvas
19 ¹¹⁄₁₆ x 23 ⅝ in. (50 x 60 cm)
Koons Collection

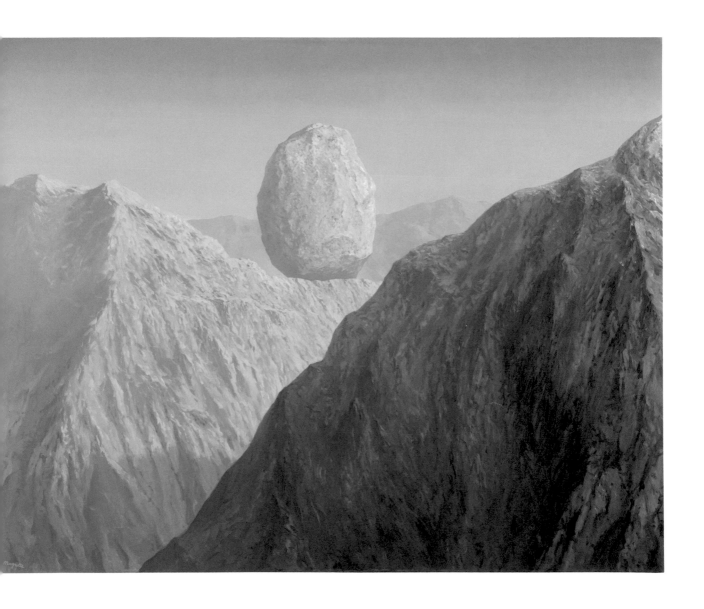

PLATE 66 *La clef de verre* (The Glass Key), 1959
Oil on canvas
51 ³/₁₆ x 63 ¾ in. (130 x 162 cm)
The Menil Collection, Houston

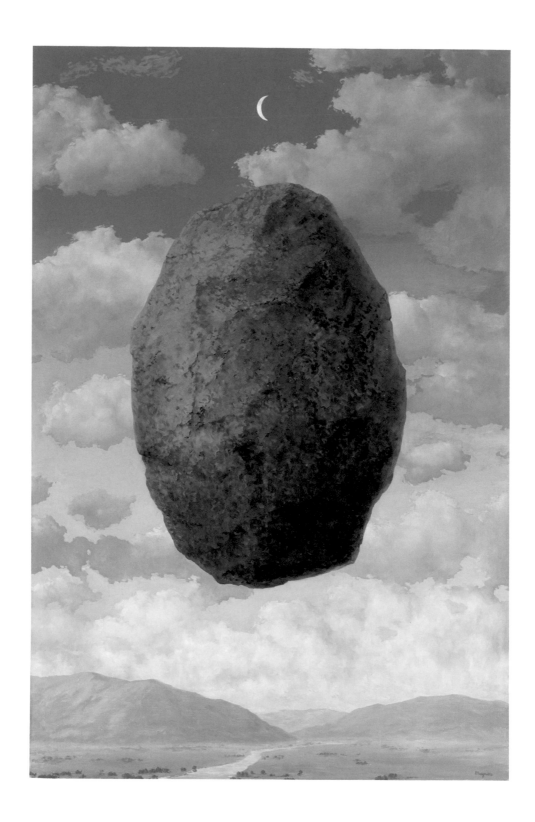

PLATE 67 *Le sens des réalités* (A Sense of Reality), 1963
Oil on canvas
67 15/16 x 45 11/16 in. (172.5 x 116 cm)
Miyazaki Prefectural Art Museum, Japan

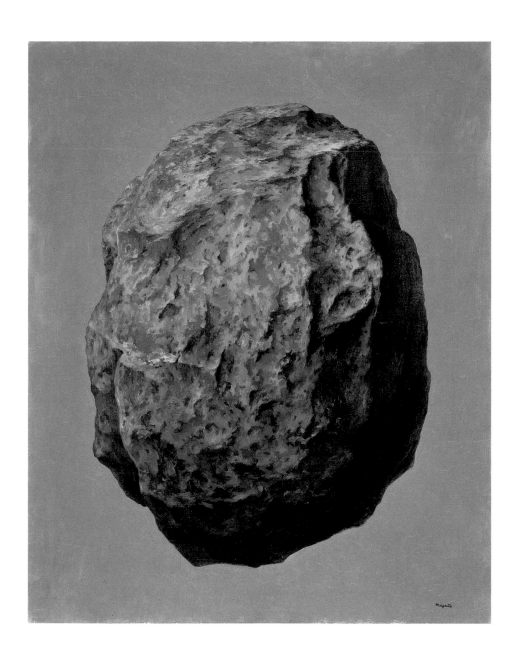

PLATE 68 *La voix active* (The Active Voice), 1951
Oil on canvas
39 ⅜ x 31 ½ in. (100 x 80 cm)
Saint Louis Art Museum, gift of Mr. and Mrs. Joseph Pulitzer Jr.

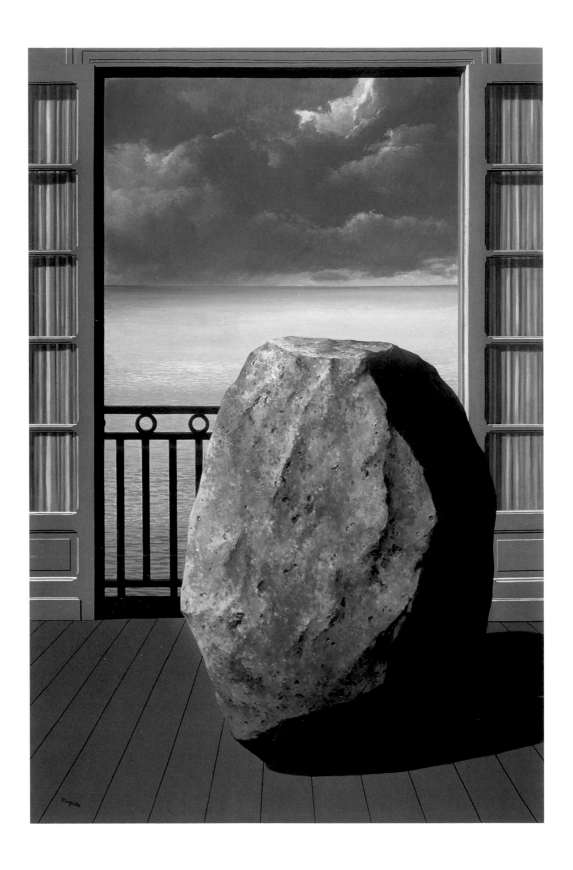

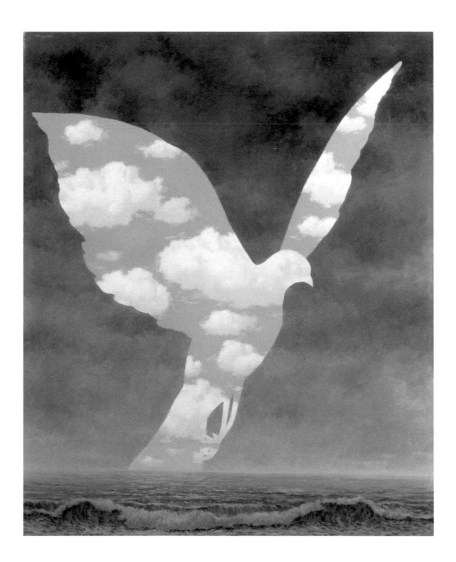

PLATE 69 *Le monde invisible* (The Invisible World), 1954
 Oil on canvas
 77 x 51 ⅝ in. (195.6 x 131.1 cm)
 The Menil Collection, Houston

PLATE 70 *La grande famille* (The Great Family), 1963
 Oil on canvas
 39 ⅜ x 31 ⅞ in. (100 x 81 cm)
 Utsunomiya Museum of Art, Japan

WORKS IN THE EXHIBITION

This list includes all works presented in the exhibition *René Magritte: The Fifth Season* and reflects the information available at the time of publication. Catalogue raisonné (CR numbers for oil paintings and gouaches or page references for drawings are also provided. See David Sylvester, ed., *René Magritte: Catalogue Raisonné*, 5 vols. (Houston: The Menil Foundation and Philip Wilson Publishers, 1992–97).

La condition humaine (The Human Condition)
(plate 14)
1933
Oil on canvas
39 ⅜ x 31 ⅞ in. (100 x 81 cm)
National Gallery of Art, Washington, D.C., gift of the
Collectors' Committee
CR 351

Eloge de la dialectique (In Praise of the Dialectic)
(plate 25)
1936
Gouache on paper
14 ¹⁵⁄₁₆ x 12 ⅝ in. (38 x 32 cm)
Musée d'Ixelles, Brussels
CR 1120

Le retour à la nature (The Return to Nature) (plate 47)
1938–39
Gouache on paper
10 ¹³⁄₁₆ x 15 ⁹⁄₁₆ in. (27.5 x 39.5 cm)
Private collection
CR 1148

Le retour (The Return) (plate 59)
1940
Oil on canvas
19 ¹¹⁄₁₆ x 25 ⁹⁄₁₆ in. (50 x 65 cm)
Musées royaux des Beaux-Arts de Belgique, Brussels
CR 485

La cinquième saison (The Fifth Season) (plate 19)
1943
Oil on canvas
19 ¹¹⁄₁₆ x 23 ⅝ in. (50 x 60 cm)
Musées royaux des Beaux-Arts de Belgique, Brussels
CR 541

La moisson (The Harvest) (plate 7)
1943
Oil on canvas
23 ⅝ x 31 ½ in. (60 x 80 cm)
Musées royaux des Beaux-Arts de Belgique, Brussels
CR 545

La préméditation (Forethought) (plate 1)
1943
Oil on canvas
21 ⅝ x 18 ⅛ in. (55 x 46 cm)
Koons Collection
CR 544

Elseneur (Elsinore)
1944
Oil on canvas
28 ¾ x 23 ⅝ in. (73 x 60 cm)
Private collection
CR 567

Image à la maison verte (Image with a Green House)
1944
Oil on canvas
23 ⅝ x 31 ⅞ in. (60 x 81 cm)
Private collection
CR 569

L'éclair (Lightning) (plate 2)
1944
Oil on canvas
21 ¼ x 17 ¹³⁄₁₆ in. (54 x 45.3 cm)
Musée des Beaux-Arts de Charleroi, Belgium
CR 577

Night Sky with Bird (plate 62)
ca. 1945
Oil on glass bottle
Height: 12 ¹⁄₁₆ in. (30.7 cm)
Private collection
CR 706

Le bain de cristal (The Cut-Glass Bath) (plate 5)
1946
Gouache on paper
19 ⅛ x 13 ⅜ in. (48.5 x 34 cm)
Private collection
CR 1215

Le plaisir (Pleasure) (plate 6)
1946
Gouache on paper
14 ³⁄₁₆ x 19 ½ in. (36 x 49.5 cm)
Collection Lucien Bilinelli, Brussels and Milan
CR 1204

L'intelligence (Intelligence) (plate 4)
1946
Oil on board
21 ¼ x 25 ⁹⁄₁₆ in. (54 x 65 cm)
Musées royaux des Beaux-Arts de Belgique, Brussels
CR 604

La voix du sang (Blood Will Tell) (plate 26)
1947
Gouache on paper
9 ½ x 7 ½ in. (24.1 x 19 cm)
Private collection, courtesy Guggenheim, Asher Associates
CR 1236

Le libérateur (The Liberator) (plate 46)
1947
Oil on canvas
39 ⅜ x 31 ½ in. (100 x 80 cm)
Los Angeles County Museum of Art, gift of William Copley
CR 630

Le lyrisme (Lyricism) (plate 3)
1947
Oil on canvas
19 ¹¹⁄₁₆ x 25 ⁹⁄₁₆ in. (50 x 65 cm)
Musées royaux des Beaux-Arts de Belgique, Brussel
CR 612

La vie des insectes (The Life of Insects) (plate 9)
1947/1948
Oil on canvas
31 ⅞ x 39 ⅜ in. (81 x 100 cm)
Musées royaux des Beaux-Arts de Belgique, Brussel
CR 655

Le mal du pays (Homesickness) (plate 30)
ca. 1948
Watercolor and gouache on paper
17 ¹⁵⁄₁₆ x 13 ¾ in. (45.5 x 35 cm)
The Art Institute of Chicago, gift of Mary and Leigh E
CR 1280

La famine (Famine) (plate 12)
1948
Oil on canvas
18 ⅛ x 21 ⅝ in. (46 x 55 cm)
Musées royaux des Beaux-Arts de Belgique, Brussel
CR 652

L'arc-en-ciel (The Rainbow) (plate 11)
1948
Watercolor, gouache, and gold paint on paper
17 ¾ x 12 ¹¹⁄₁₆ in. (45.1 x 32.3 cm)
Private collection, Switzerland, courtesy Simon Stue
Art, Geneva
CR 1275

La voix du sang (Blood Will Tell)
1948
Oil on canvas
19 ¹¹⁄₁₆ x 23 ⅝ in. (50 x 60 cm)
Private collection
CR 660

Le galet (The Pebble) (plate 8)
1948
Oil on canvas
39 ⅜ x 31 ⅞ in. (100 x 81 cm)
Musées royaux des Beaux-Arts de Belgique, Brussel
gift of Georgette Magritte
CR 656

Le mal de mer (Seasickness) (plate 10)
1948
Oil on canvas
21 ¼ x 25 ⁹⁄₁₆ in. (54 x 65 cm)
Private collection
CR 654

opiat (The Cripple) (plate 13)

canvas mounted on panel
x 19 ⁷⁄₁₆ in. (59.5 x 49.5 cm)
e national d'art moderne/Centre de création
trielle, Centre Georges Pompidou, Paris
8

ire des lumières (The Dominion of Light) (plate 57)
1962
canvas
x 31 ½ in. (100 x 80 cm)
r Grether Family Collection
4

lle captive (The Fair Captive) (plate 18)
50
canvas
x 15 ¾ in. (30 x 40 cm)
e collection
0

urbure de l'univers (The Curvature of the Universe)
63)

glass bottle
t: 11 ½ in. (29.2 cm)
enil Collection, Houston
69

ire des lumières (The Dominion of Light) (plate 52)

canvas
x 39 ⅜ in. (80 x 100 cm)
useum of Modern Art, New York, gift of D. and
Menil, 1951
3

ducteur (The Seducer) (plate 49)

canvas
s x 23 ⅝ in. (50 x 60 cm)
ia Museum of Fine Arts, Richmond, collection of
nd Mrs. Paul Mellon
9

vivant (The Survivor) (plate 27)

che on paper
x 14 ½ in. (46 x 36.8 cm)
e collection
5a

razade (Sheherazade) (plate 45)

canvas
x 11 ¹³⁄₁₆ in. (40 x 30 cm)
e collection
9

Le monde des images (The World of Images) (plate 16)
1950/ca. 1961
Oil on canvas
39 ⅜ x 31 ⅞ in. (100 x 81 cm)
Private collection
CR 937

La boîte de Pandore (Pandora's Box) (plate 31)
1951
Oil on canvas
17 ¹¹⁄₁₆ x 21 ⅝ in. (45 x 55 cm)
Yale University Art Gallery, New Haven, Connecticut,
gift of Dr. and Mrs. John A. Cook, B.A. 1932
CR 772

La voix active (The Active Voice) (plate 68)
1951
Oil on canvas
39 ⅜ ¾ x 31 ½ in. (100 x 80 cm)
Saint Louis Art Museum, gift of Mr. and Mrs. Joseph
Pulitzer Jr.
CR 758

Le baiser (The Kiss) (plate 60)
1951
Oil on canvas
28 ⅝ x 35 ³⁄₁₆ in. (72.7 x 89.4 cm)
The Museum of Fine Arts, Houston, gift of an
anonymous donor
CR 769

La chambre d'écoute (The Listening Room) (plate 21)
1952
Oil on canvas
17 ¹³⁄₁₆ x 21 ¾ in. (45.3 x 55.2 cm)
The Menil Collection, Houston, gift of Fariha Friedrich
CR 779

La trahison des images (The Treachery of Images)
(plate 43)
1952
India ink on paper
7 ½ x 10 ⅝ in. (19 x 27 cm)
Private collection
CR vol. 4, p. 156

Le coup au coeur (The Blow to the Heart) (page 50)
1952
Oil on canvas
18 ⁵⁄₁₆ x 15 ¼ in. (46.5 x 38.7 cm)
Private collection
CR 777

Les valeurs personnelles (Personal Values) (plate 20)
1952
Oil on canvas
31 ½ x 39 ⅜ in. (80 x 100 cm)
San Francisco Museum of Modern Art, purchase through
a gift of Phyllis C. Wattis
CR 773

Le domaine enchanté I (The Enchanted Domain I)
(plate 44.I)
1953
Oil on canvas
26 ¾ x 53 ⅝ in. (68 x 136.2 cm)
Museum Würth, Künzelsau, Germany
CR 791

Le domaine enchanté II (The Enchanted Domain II)
(plate 44.II)
1953
Oil on canvas
26 ¾ x 53 in. (68 x 134.6 cm)
Private collection
CR 791

Le domaine enchanté IV (The Enchanted Domain IV)
(plate 44.IV)
1953
Oil on canvas
26 ¾ x 36 ¹³⁄₁₆ in. (68 x 93.5 cm)
Private collection
CR 791

Le domaine enchanté VII (The Enchanted Domain VII)
(plate 44.VII)
1953
Oil on canvas
26 ¾ x 53 ⅝ in. (68 x 136.2 cm)
Albertina, Vienna, The Batliner Collection
CR 791

L'empire des lumières (The Dominion of Light) (plate 53)
1953
Oil on canvas
18 ⅛ x 14 ¹⁵⁄₁₆ in. (46 x 38 cm)
Private collection, courtesy Guggenheim, Asher Associates
CR 797

Les merveilles de la nature (The Wonders of Nature)
(plate 50)
1953
Oil on canvas
31 ½ x 39 ⅜ in. (80 x 100 cm)
Museum of Contemporary Art Chicago, gift of Joseph
and Jory Shapiro
CR 800

Le monde invisible (The Invisible World) (plate 69)
1954
Oil on canvas
77 x 51 ⅝ in. (195.6 x 131.1 cm)
The Menil Collection, Houston
CR 805

L'empire des lumières (The Dominion of Light) (plate 56)
1954
Oil on canvas
80 ¾ x 55 in. (205 x 139.8 cm)
Peggy Guggenheim Collection, Venice (Solomon R. Guggenheim Foundation, New York)
CR 804

L'empire des lumières (The Dominion of Light) (plate 55)
1954
Oil on canvas
57 ½ x 44 ⅞ in. (146 x 114 cm)
Musées royaux des Beaux-Arts de Belgique, Brussels
CR 810

L'empire des lumières (The Dominion of Light) (plate 54)
1954
Oil on canvas
51 ⅛ x 37 ¼ in. (129.9 x 94.6 cm)
The Menil Collection, Houston
CR 814

Golconde (Golconda) (plate 40)
1955
Gouache on paper
6 ¼ x 8 ¼ in. (15.9 x 21 cm)
Private collection, courtesy Guggenheim, Asher Associates
CR app. 28

Le maître d'école (The Schoolmaster) (plate 32)
1955
Oil on canvas
31 ½ x 23 ⅝ in. (80 x 60 cm)
Private collection
CR 818

Les promenades d'Euclide (Where Euclid Walked) (plate 15)
1955
Oil on canvas
63 ¾ x 51 ³⁄₁₆ in. (162 x 130 cm)
Minneapolis Institute of Art, The William Hood Dunwoody Fund
CR 826

Les idées claires (Clear Ideas) (plate 65)
1955/ca. 1958
Oil on canvas
19 ¹¹⁄₁₆ x 23 ⅝ in. (50 x 60 cm)
Koons Collection
CR 885

La place au soleil (The Place in the Sun) (plate 29)
1956
Gouache on paper
5 ⅞ x 7 ¹¹⁄₁₆ in. (15 x 19.6 cm)
Private collection
CR 1404

La place au soleil (The Place in the Sun) (plate 42)
1956
Ink on paper
10 ⅛ x 7 ⅝ in. (25.7 x 19.4 cm)
Private collection, courtesy Guggenheim, Asher Associates
CR vol. 3, p. 258

Le baiser (The Kiss) (plate 61)
ca. 1957
Gouache on paper
10 ⅝ x 13 ⁵⁄₁₆ in. (27 x 33.8 cm)
Private collection
CR 1433

La chambre d'écoute (The Listening Room) (plate 22)
1958
Oil on canvas
14 ¹⁵⁄₁₆ x 18 ⅛ in. (38 x 46 cm)
Private collection, courtesy Brachot Gallery, Brussels
CR 877

Les vacances de Hegel (Hegel's Vacation) (plate 41)
1958
Oil on canvas
23 ⅝ x 19 ¹¹⁄₁₆ in. (60 x 50 cm)
Private collection
CR 874

La clef de verre (The Glass Key) (plate 66)
1959
Oil on canvas
51 ³⁄₁₆ x 63 ¾ in. (130 x 162 cm)
The Menil Collection, Houston
CR 899

La découverte du feu (The Discovery of Fire) (plate 48)
1959
Gouache on paper
9 ⁷⁄₁₆ x 7 ⅜ in. (24 x 18.7 cm)
The George Economou Collection, Athens
CR 1460

L'anniversaire (The Anniversary) (plate 23)
1959
Oil on canvas
35 ¹⁄₁₆ x 45 ¾ in. (89.1 x 116.2 cm)
Art Gallery of Ontario, Toronto, purchase, Corporations' Subscription Endowment, 1971
CR 906

Le tombeau des lutteurs (The Tomb of the Wrestlers) (plate 24)
1960
Oil on canvas
35 ¹⁄₁₆ x 45 ¹¹⁄₁₆ in. (89 x 116 cm)
Private collection
CR 912

La cascade (The Waterfall) (plate 17)
1961
Oil on canvas
31 ⅞ x 39 ⅜ in. (81 x 100 cm)
Esther Grether Family Collection
CR 934

Le domaine d'Arnheim (The Domain of Arnheim) (plate 58)
1962
Oil on canvas
57 ½ x 44 ⅞ in. (146 x 114 cm)
Musées royaux des Beaux-Arts de Belgique, Brussels
CR 960

La fin du monde (The End of the World) (plate 39)
1963
Oil on canvas
32 ⅛ x 39 ½ in. (81.6 x 100.3 cm)
Private collection
CR 980

La grande famille (The Great Family) (plate 70)
1963
Oil on canvas
39 ⅜ x 31 ⅞ in. (100 x 81 cm)
Utsunomiya Museum of Art, Japan
CR 972

Le sens des réalités (A Sense of Reality) (plate 67)
1963
Oil on canvas
67 ¹⁵⁄₁₆ x 45 ¹¹⁄₁₆ in. (172.5 x 116 cm)
Miyazaki Prefectural Art Museum, Japan
CR 968

La réponse imprévue (The Unexpected Answer) (pl
1963–64
Gouache on paper
21 ⅝ x 14 in. (55 x 35.6 cm)
Collection of an anonymous charitable foundation
CR 1550

La bataille de l'Argonne (The Battle of the Argonne)
(plate 64)
1964
Gouache on paper
11 ¼ x 16 ⅛ in. (28.5 x 41 cm)
Private collection
CR 1559

La carrière de granit (The Granite Quarry) (plate 36
1964
Gouache on paper
16 ½ x 11 ⅝ in. (41.9 x 29.5 cm)
Private collection, courtesy Guggenheim, Asher Asso
CR 1557

de l'homme (The Son of Man) (plate 33)

canvas
x 35 in. (115.6 x 89 cm)
e collection, U.S.A.
9

me et la forêt (Man and the Forest) (plate 35)

che on card
x 11 7/16 in. (49 x 29 cm)
e collection, courtesy Keitelman Gallery, Brussels
2

le société (High Society) (plate 37)
66
canvas
25 9/16 in. (81 x 65 cm)
ción Telefónica, Madrid
0

eux donateur (The Happy Donor) (plate 38)

canvas
17 11/16 in. (55 x 45 cm)
e d'Ixelles, Brussels
0

This book is published by the San Francisco Museum of Modern Art in association with D.A.P./Distributed Art Publishers, Inc., New York, on the occasion of the exhibition *René Magritte: The Fifth Season*, organized by Caitlin Haskell for the San Francisco Museum of Modern Art, May 19–October 28, 2018.

Lead support for *René Magritte: The Fifth Season* is provided by Carolyn and Preston Butcher. Major support is provided by The Bernard Osher Foundation and Pat Wilson.

THE BERNARD
OSHER
FOUNDATION

Generous support is provided by Jean and James E. Douglas, Jr., Melinda and Kevin P. B. Johnson, Nancy and Alan Schatzberg, and Sheri and Paul Siegel. Additional support is provided by the Robert Lehman Foundation.

This project is supported in part by an award from the National Endowment for the Arts.

National Endowment for the Arts
arts.gov

ART WORKS.

Support for the exhibition catalogue is provided by Furthermore: a program of the J. M. Kaplan Fund.

Furthermore:
a program of the J.M. Kaplan Fund

Project manager: Kari Dahlgren
Editor: Lucy Medrich
Designer: James Williams
Image coordinator and editorial assistant: Brianna Nelson
Proofreader: Kate Norment
Translator: Fabienne Adler (text by Michel Draguet from French)
Color separations by Prographics, Rockford, Illinois
Printed and bound in Germany by Cantz

Library of Congress Cataloging-in-Publication Data
Names: Haskell, Caitlin, editor. | San Francisco Museum of Modern Art, organizer, host institution.
Title: René Magritte : the fifth season / edited by Caitlin Haskell.
Other titles: René Magritte (San Francisco Museum of Modern Art)
Description: San Francisco : San Francisco Museum of Modern Art, 2018. | Published on the occasion of the exhibition René Magritte: The Fifth Season, organized by Caitlin Haskell for the San Francisco Museum of Modern Art, May 19–October 28, 2018. | Includes bibliographical references.
Identifiers: LCCN 2018000123 | ISBN 9781942884231 (hardcover)
Subjects: LCSH: Magritte, René, 1898–1967—Exhibitions.
Classification: LCC ND673.M35 A4 2018 | DDC 709.2—dc23
LC record available at https://lccn.loc.gov/2018000123